THE
DARK TOWER

THE ART OF THE FILM

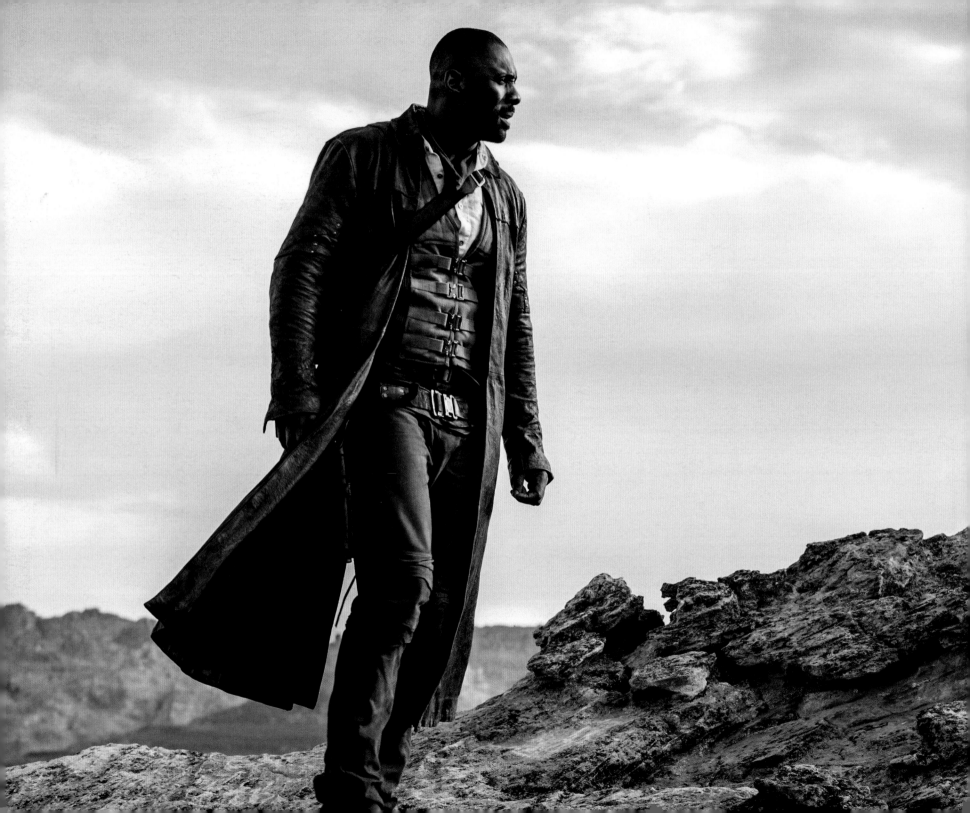

THE
DARK TOWE

THE ART OF THE FILM

Text by

DANIEL WALLACE

MELCHER
MEDIA

SCRIBNER

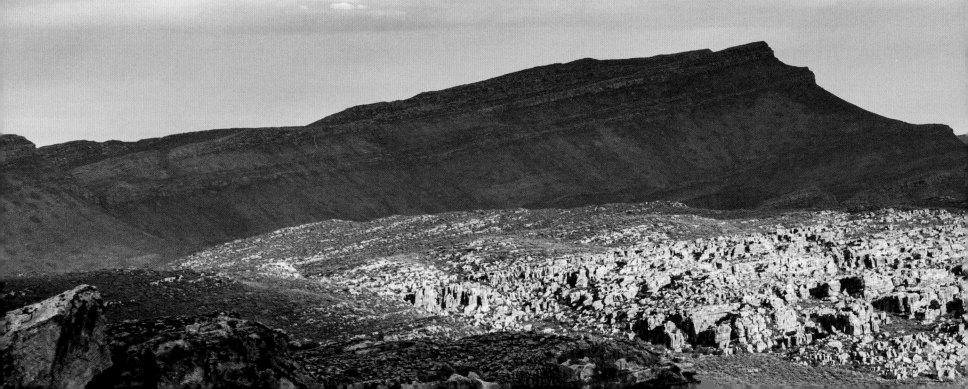

Published by Scribner
An Imprint of Simon & Schuster, Inc.
1230 Avenue of the Americas
New York, NY 10020

MELCHER MEDIA

Produced by Melcher Media
124 West 13th Street
New York, NY 10011
www.melcher.com

First Scribner hardcover edition July 2017

SCRIBNER and design are registered trademarks
of The Gale Group, Inc. used under license by
Simon & Schuster, Inc., the publisher of this work.

For information about special discounts for bulk
purchases, please contact Simon & Schuster
Special Sales at 1-866-506-1949 or business@
simonandschuster.com.

The Simon & Schuster Speakers Bureau can bring
authors to your live event. For more information
or to book an event, contact the Simon & Schuster
Speakers Bureau at 1-866-248-3049 or visit our
website at www.simonspeakers.com.

Manufactured in the United States of America

10 9 8 7 6 5 4 3 2 1

Library of Congress Cataloging-in-Publication
Data available upon request.

ISBN 978-1-5011-6445-3

Cover and Interior Design by
Paul Kepple and Max Vandenberg
at HEADCASE DESIGN
www.headcasedesign.com

CONTENTS

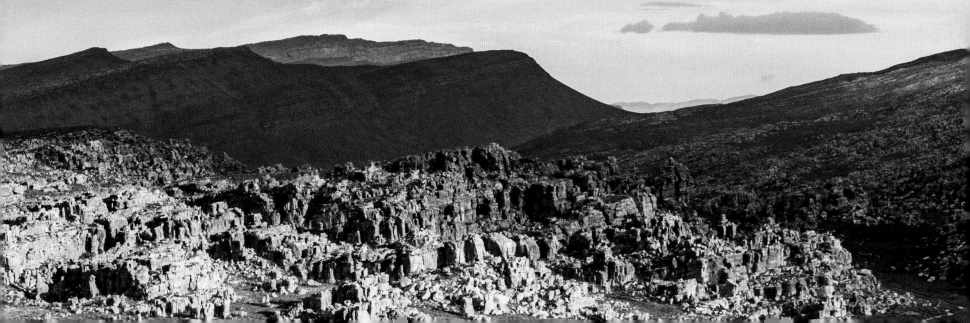

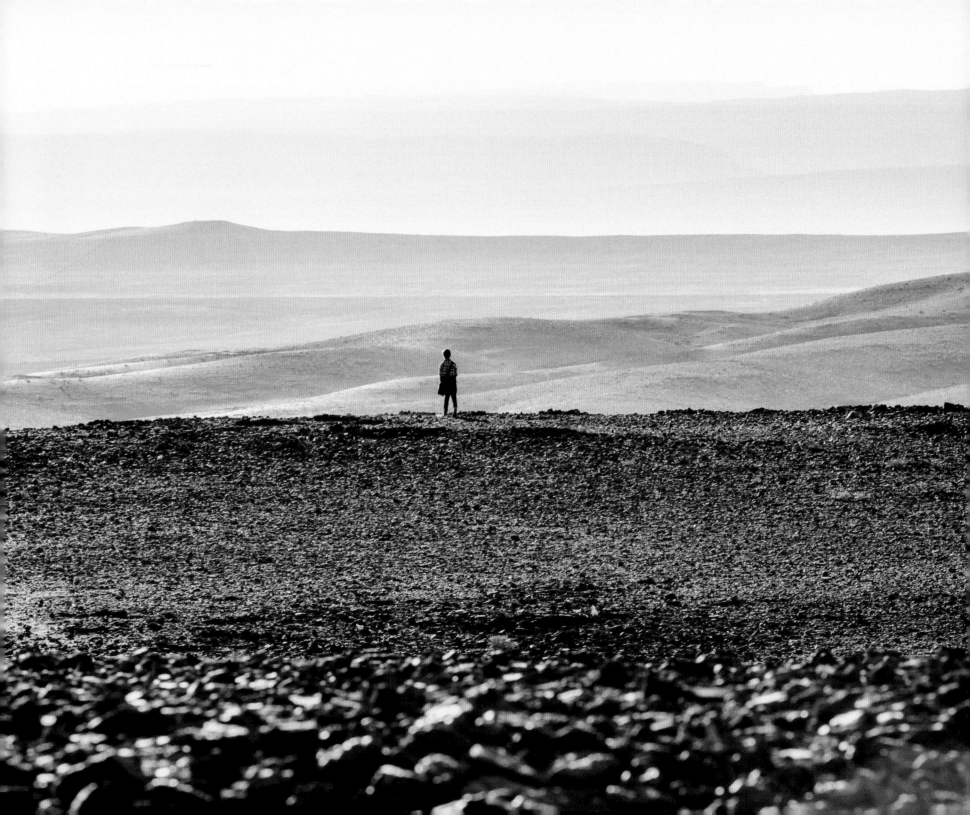

INTRODUCTION

As a child in Denmark, I was excited by horror films, but I wasn't allowed to watch any of the truly scary ones. Stephen King's books were more accessible, with terrifying, beguiling covers. Many of the English words were foreign to me, but something about the writing style and stories he created made me keep going. It was as if the books were giving me an adult's insight into how the world really worked. On some uncharted level, I felt that I finally "got it."

I desperately wanted more, and asked my librarian, "What else can you find by this Stephen King guy?" Quite a bit, as it turned out.

I read every novel and short story that King had published and stayed up to speed as new stories were released. I first heard *The Dark Tower: The Gunslinger* as an audiobook read by King himself, and I grew obsessed with Roland's quest, impatiently following the story to its conclusion many years later. What I loved most about the Dark Tower saga were its characters, and secondly, the way it adhered to the age-old rules of epic fantasy while simultaneously breaking down genre borders.

There are so many worlds and ideas to convey in *The Dark Tower,* and that was the tricky part of making our film; the part that involved the most head-scratching. Our basic premise was always: Can we make it simple? Our "lean and mean" script is very Jake and Roland–centric, and takes ideas from several different books while allowing plenty of room to continue the story we know and love in later films.

I am deeply in love with *The Dark Tower*. This film is the first standalone story in what will hopefully become an epic saga. We did our best to stay true to its tone, its core ideas, and the emotions that the Dark Tower saga instills in all of us.

—NIKOLAJ ARCEL,
Director, *The Dark Tower*

PART I

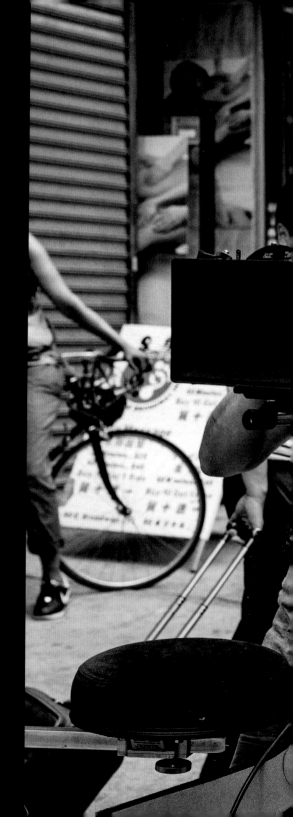

Director Nikolaj Arcel came to the Dark Tower universe with a unique visual style
and an abiding love for the source material.

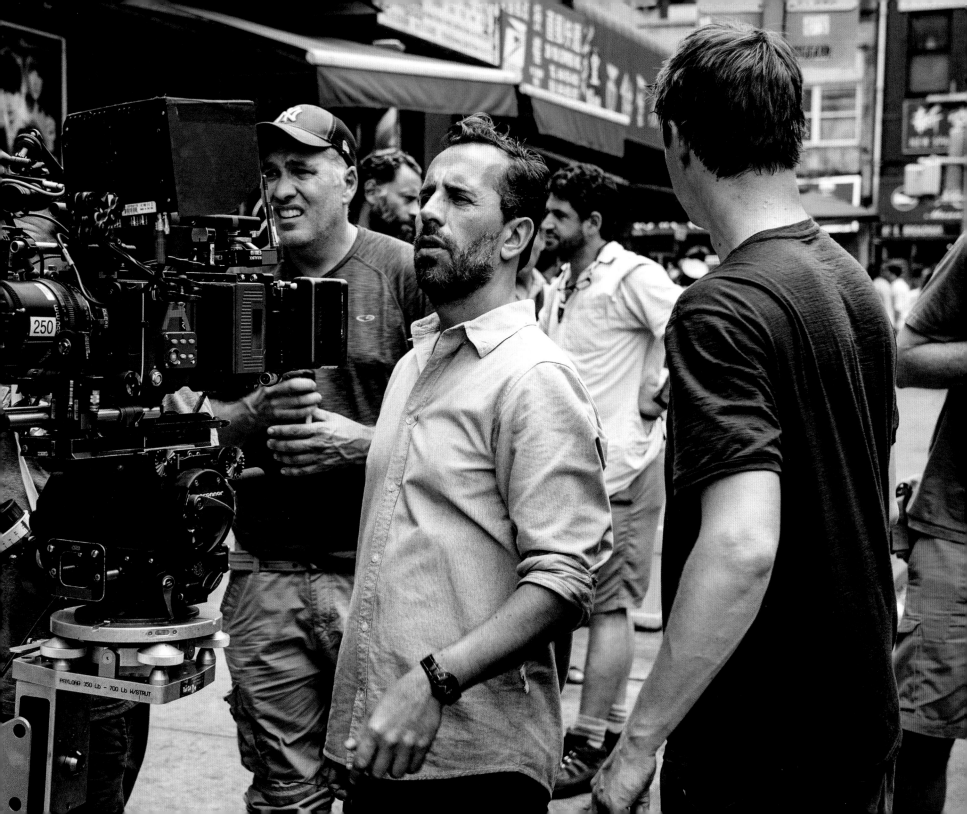

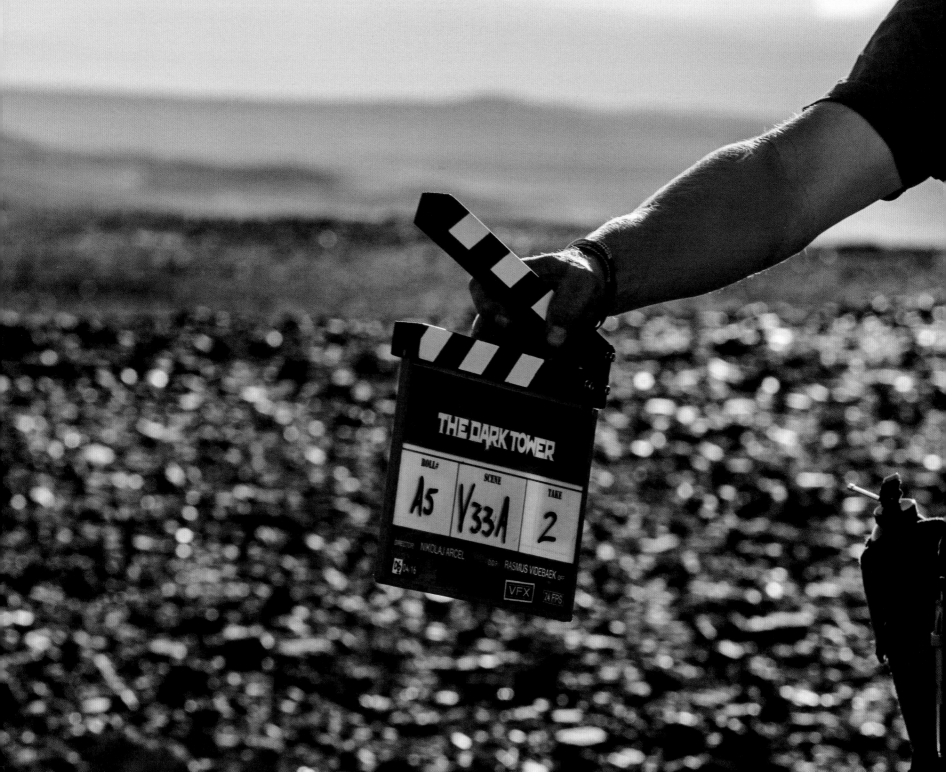

THE PATH TO THE TOWER

It is Stephen King's magnum opus—and considering King's acclaimed and voluminous output, that's saying something. What we now call the Dark Tower saga took root in 1970, when King, then an undergraduate at the University of Maine, penned the opening line to the short story "The Gunslinger":

The Dark Tower prose saga is now complete and encompasses seven core novels, numerous related writings, and a series of comic books that bear King's imprimatur as creative director. During the tale, Roland draws nearer to the enigmatic Tower and assembles a sort of sheriff's posse—his *ka-tet*—by recruiting recovering

rows from fantasy, Westerns, comic books, pulp adventures, and postapocalyptic sci-fi—to name only a few sources.

For moviemakers who think big, the desire to adapt this audacious adventure for the big screen has proven tempting. It has also been terrifying.

"Stephen King has always struck a chord with me," explains Akiva Goldsman, an award-winning screenwriter who championed the saga's cinematic potential within Hollywood for more than a decade. "There's just something about how he sees the world that is exactly like a child's imagination—those whispers and things behind walls that make sense to the little kid that lives in all of us."

Goldsman purchased *The Gunslinger* during its first-run release. He devoured each subsequent Dark Tower installment while simultaneously turning over ideas in his head on how best to bring the saga to a wider audience. Eventually he found fertile ground for development with Imagine Entertainment's Ron Howard, and creative concepting could finally begin in earnest.

"The MAN IN BLACK *fled across the desert,* and THE GUNSLINGER *followed.*"

Inspired by Robert Browning's 1855 poem "Childe Roland to the Dark Tower Came," King explored romantic themes of duty, sacrifice, and destiny in a series of short stories originally published in *The Magazine of Fantasy & Science Fiction.* A hardcover novel, collecting and reworking the periodical installments, appeared in 1982. That book was *The Gunslinger,* and it became the first volume of a modern-day epic.

The Gunslinger's sparse narrative follows its titular hero across an alien yet familiar world, a grim place that is said to have "moved on." Nearly all the novel's action is centered on three characters: Roland, the laconic Gunslinger; Walter, the elusive Man in Black; and a boy named Jake, who is plucked from our own reality.

junkie Eddie Dean and civil rights activist Odetta Holmes (later known as Susannah Dean).

The Dark Tower is the terminus of their quest. The magical edifice sits at the nexus of six energy beams and anchors all the realities that exist in the space-time continuum, even fictional realities, as King makes clear in later volumes—in which he even appears as a character in the narrative. The preservation of the Tower is an urgent mission, for its destruction would mean the end of order and the rise of the mad god known as the Crimson King.

What stokes the ardor of the Dark Tower's teeming fan base? Take your pick: the believably flawed characters, the family bonds shared by the *ka-tet,* or the feverishly imaginative worldbuilding. The series' genre-bending appeal bor-

Opposite: A clapboard marks the start of shooting in the arid Tankwa Karoo region of South Africa, an environment chosen to evoke the stark alien wastelands of Mid-World.

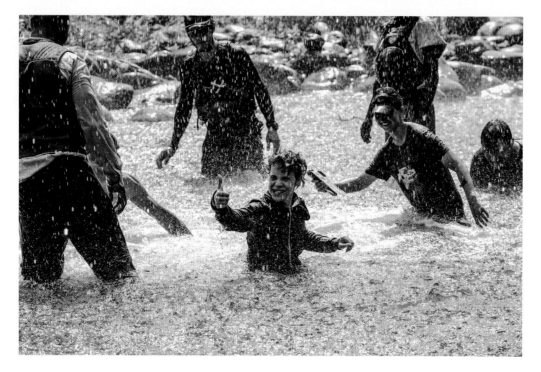

REFLECTIONS

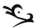

"I had started pitching it to Ron way back on the set of *A Beautiful Mind,*" remembers Goldsman. That 2001 film, which brought Oscar gold to both Goldsman and Howard, told the story of a gifted person who begins to question his own reality. "I was waxing rhapsodic about why this was a thing that we should do. He asked me if I knew how to [film] it. I said, 'Sure, how hard can it be?' Then I looked at it, and I thought, 'This is much harder than I realized.'"

The Dark Tower's vast narrative sweep led Goldsman and Howard to conclude that this story might be too big to tackle in a single medium. "I thought that some of the material was so personal that it was better suited to being fleshed out on television," says Howard. "Was there a way we could make adventure movies on the big screen, and do interesting character aspects from the books on television? We took it to Stephen King, and he thought it was really cool to experiment in that direction."

Collaboration with King was critical in the planning stages. As the creator and the spiritual godfather of the Dark Tower series, King's feedback carried immense weight.

"We found Stephen to be very open," says Howard. "He said, 'I'm open to an exploration of what this universe means to you, and I'll tell you when I don't like something. I feel like I owe it to you to give you as much freedom as possible while still preserving the fundamental integrity of the novels.'"

A multimedia approach involving both movies and television helped compartmentalize the story's scope, but none of the planning would matter if the Dark Tower saga didn't launch with a bang. Goldsman and collaborator Jeff Pinkner turned out script after script for the movie they hoped would kick-start a franchise, yet every script proved maddeningly unmanageable. The common flaw? Biting off more lore than any audience could be expected to chew.

Imagine Entertainment's Brian Grazer, executive producer, recalls the dead ends of that early phase. "We originally thought of it as a three-hour movie," he says. "There were endless amounts of detail and characters, but it was thought of by the studios as being too epic in the economics and too epic in the level of detail."

Movie studios expressed interest, temporarily buoying the film's prospects before eventually moving on. "We started at Universal with a very different movie," says Grazer. "It was a malaise of details and mythology and an extended cast. But instead of concluding that they [Universal] were right, we remained on our journey to make that movie. We took that very big version to Warner Bros., but it eventually got to a place where even they didn't quite get it."

Goldsman remembers the deep-cut details of those overstuffed, passed-over scripts. "There

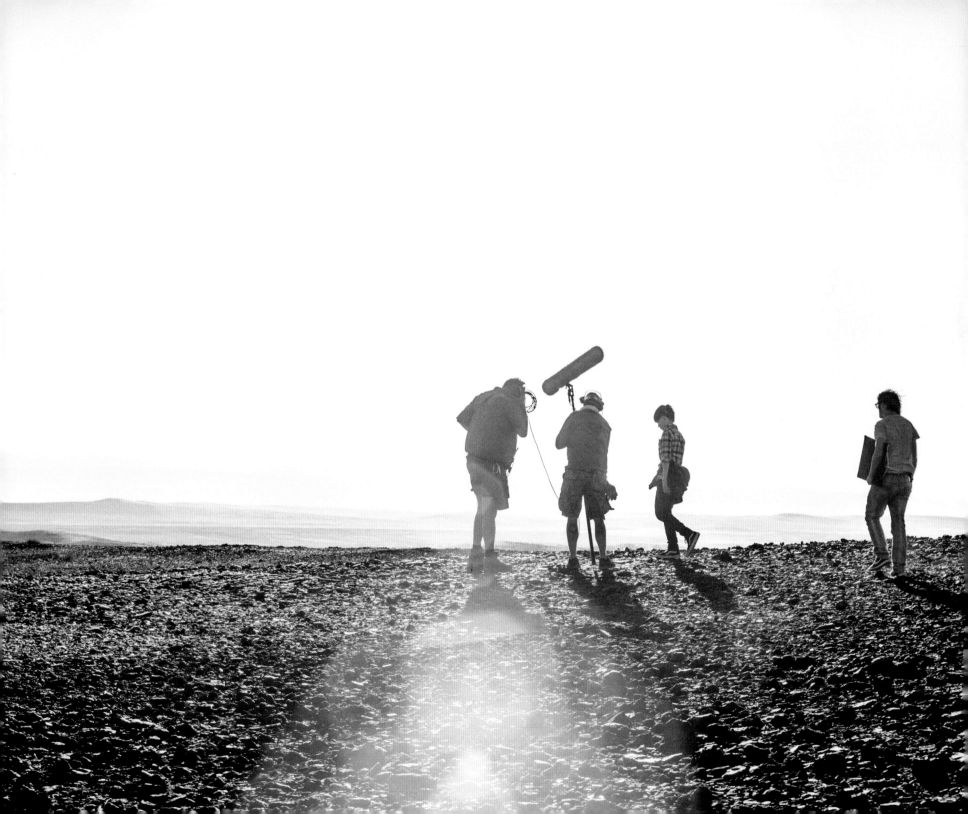

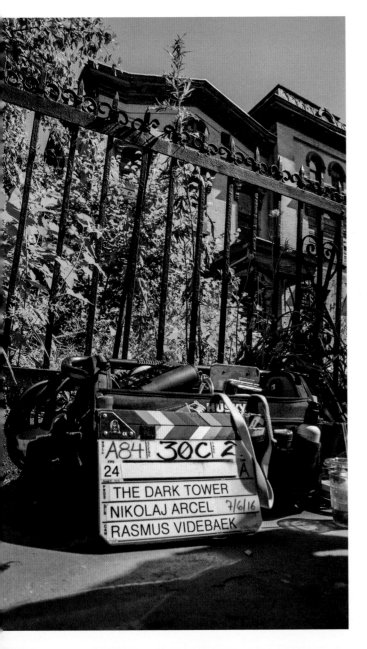

was a big, cybernetic bear in the first scene, and that was already knocking people back," he says. "Jake entered into a world already populated by Eddie and Susannah. Further down was the city of Lud and the Tick-Tock Man. We started too hard and too fast."

Admits Grazer, "We didn't know what form it should take."

Enter independent studio Media Rights Capital (MRC), which saw a character-centric path toward a more grounded, self-contained film. "You don't have to make a giant special-effects story, and you don't have to introduce the full 'ka-tet,'" says Howard. "We could make it the story of Jake and Roland. Much closer to the first book, which is very minimalist, and almost like a tone poem."

The new script drew upon *The Gunslinger*'s character dynamics, but it also needed to explain the saga's larger plot mechanics. One adjustment was foregrounding the plot element of the psychic children who are kidnapped and manipulated on the orders of the Crimson King.

"We felt that was a good movie idea, because it put Jake in another kind of danger when kids in general were threatened," says Howard. "It also allowed us to better understand the crisis. If the Tower came down, it would be a disaster for all of existence."

The new script was a leaner, tighter, and stronger introduction to the Dark Tower universe. "After we reapplied ourselves to building the storytelling, it became much more accessible for people who were not already into it," says Goldsman.

The movie wouldn't be a beat-by-beat adaptation of the novels, but that didn't mean it wasn't part of the Dark Tower canon. A sudden inspiration gave the filmmaking team license to position their movie as a spiritual reincarnation.

"The idea was to give Roland the Horn of Eld, which he has at the end of the final book," explains Howard. The artifact, a holy relic of Gunslinger lore, is acquired by Roland only at the conclusion of his quest in the novels. By giving Roland the Horn of Eld at the start of the movie, the filmmakers were subtly stating that this was Roland's replay—a fresh spin on the wheel of fate.

"When we tested it on Stephen King and on Dark Tower fans, it got a big grin and a nod of satisfaction," says Howard. "It says that this is another go-around in the universe. It allows us to use the language and the characters, but it liberated us from a literal adaptation."

Previous spread, left: Tom Taylor (center), who plays Jake Chambers, gives an enthusiastic thumbs-up during filming of the perilous river crossing that serves as Jake's baptism into the dangers of Mid-World.

Previous spread, right: The merciless sun casts a harsh light as the filming crew coordinates with Taylor (second from right). The landscape is lunar in its emptiness.

Opposite: On location in South Africa, Arcel and Taylor discuss a scene set in Mid-World.

Left: Filming equipment sits outside the iron-gate perimeter of a historic Brooklyn home enlisted to stand in for the exterior of the Dutch Hill mansion.

Stephen King's *Dark Tower* saga spans seven numbered novels and another related volume, published over the course of 30 years, beginning with 1982's *The Gunslinger* and ending with 2012's *The Wind Through the Keyhole*. In total, the epic runs to more than 4,000 pages and well over a million words.

SETTING A COURSE

At one point during early development, Howard planned to direct the movie himself. But shifting schedules and a change in focus led the team across the Atlantic to Danish director Arcel.

Although he had never helmed a Hollywood film before, Arcel had earned notice for directing the Oscar-nominated historical drama *A Royal Affair* and for writing the script for the original Swedish version of *The Girl With the Dragon Tattoo*. Arcel's eye for visual storytelling made him an unexpected but smart choice for *The Dark Tower*—and besides, Stephen King had basically taught him English.

"I was twelve or thirteen years old when I noticed a paperback in the library with a creepy bandaged hand on the cover," Arcel recalls. That book was King's 1978 short-story collection *Night Shift*, and even though Arcel doubted he knew enough English to understand it, he took it home anyway.

"There was no way I could get through an adult novel that wasn't in Danish," he admits. "And even though I didn't understand more than half of what was going on, it was not like anything I'd ever read. These stories were about everything I thought was cool in the world, and at the same time they made me feel older. I had my parents buy me a pristine English-Danish dictionary, and I read everything of King's work onward, looking up every strange word. Yes, at an early age I taught myself advanced English, purely because of King."

Arcel jumped at the chance to translate one of his favorite epics to the big screen, believing as King does that true creativity isn't rooted in spectacle. "The story is a band of unlikely heroes rallying behind one man's quest to save the universe," he says. "It's a classic tale of good and evil, yet it has this anarchic feel to it, as if King allowed himself the ultimate playfulness as a writer. It couples magic with science, Gunslingers with robots, romantic fairy-tale themes with violence and sex, and mixes in elements from all of his novels and creations."

The moment Arcel came on board, he set to work refining the *Dark Tower* script in partnership with Danish writer Anders Thomas Jensen, who shared Arcel's outside-Hollywood pedigree.

"Both Nik and I come from Europe, where the budgets are completely different," says Jensen. "We can't just fly off and do a lot of artificial stuff; we have to keep it real. The story and the characters are the 'cheap' part of any movie, but they're also the most important part. Here, the core isn't in the vast mythology. It's in the emotional story between Jake and Roland."

Producer Erica Huggins embraced the notion of a "grittier, more grounded" Dark Tower. "What we were trying to create was a slice of the original books," she says. "It's all about the characters and the journey. I think we got the better movie because of it."

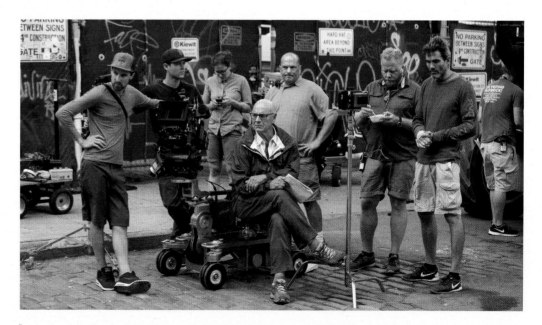

Members of the filming crew take a break between scenes. The shoot relied heavily on location filming over studio sets.

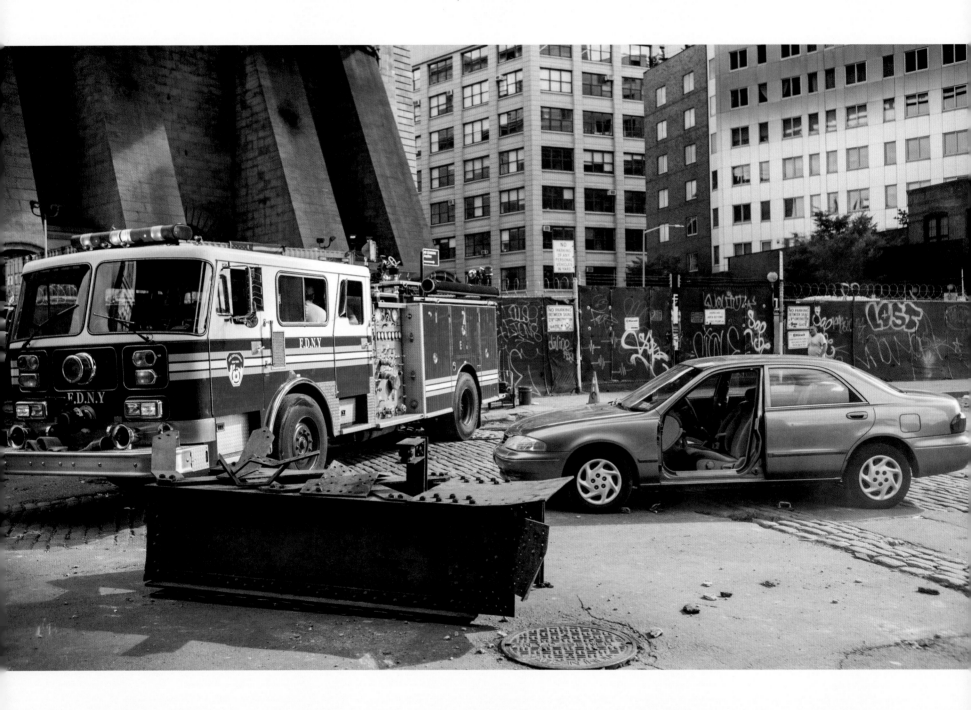

Cinematographer Rasmus Videbæk, who had an intimate understanding of Arcel's style thanks to his work on *A Royal Affair,* signed on as director of photography. "This was the first Hollywood movie Nik and I had done, and that was a big difference in the amount of resources, time, and money," he says.

Also joining Arcel and Videbæk was production designer Christopher Glass, fresh off 2016's *The Jungle Book.* These three creatives—director, cinematographer, and production designer—would translate *The Dark Tower* from scripted words to big-screen vision.

"[We] three form a triangle; [we're] in charge of figuring out how the film is going to look," explains Videbæk. "How are we going to move the camera around? How are we going to take the audience through the beats of the story? Months in advance, we were going through the script and drawing it in storyboards. We storyboarded 90 percent of the movie, so before we even started shooting we knew that these were the camera angles, this was how the camera would move, and this was the style of the scene."

Glass recalls those preproduction roundtables. "We'd go through all the beats of the movie and what we wanted to achieve, and one thing that was always at the forefront was bringing together so many different genres," he says. "How do you do that without jarring the audience visually? How do you make a cohesive visual language that is both true to the books and feels fresh?"

As soon as location scouting began, the storyboards and concept illustrations made way for on-site snapshots. G. Mac Brown helped bring real-world practicality to the production in his role as executive producer.

South Africa became home for the *Dark Tower* production crew. Cape Town had soundstages, so the crew took over one stage plus numerous warehouses around town for the construction of interior sets. The majority of the film would be shot on location in stunning mountain ranges like Tankwa Karoo National Park and Du Toitskloof Pass.

Arcel first called "Action!" in April 2016. Though the film would ultimately see release in August of the following year, at the time the production was racing toward a February 2017 debut.

The next month, Stephen King tweeted a photo of the Horn of Eld. Superimposed over the image were the words "LAST TIME AROUND."

"Using the Horn of Eld that way was our way of saying, 'What we're seeing is different this time,'" says Goldsman. "All of Stephen's worlds are connected. It's all the same elements, but rearranged."

Opposite: Emergency vehicles and automobile wrecks become substantial pieces of set dressing when creating a New York City shaken to its core by a series of cross-dimensional tremors.

Left: The crew sets up for a rooftop shoot during the NYC location filming.

Top: Videbæk (left) and Arcel on location in New York City.

Bottom left: A crew member holds up a light probe and color board during prep for a shoot taking place under moody illumination.

Bottom center: A frozen corpse—deceased resident of a parallel universe—receives a touch-up prior to its moment in the spotlight.

Bottom right: In May of 2016, Stephen King got fans buzzing when he tweeted this photo of the Horn of Eld.

Opposite: Videbæk takes command of the camera dolly as the production films in South Africa.

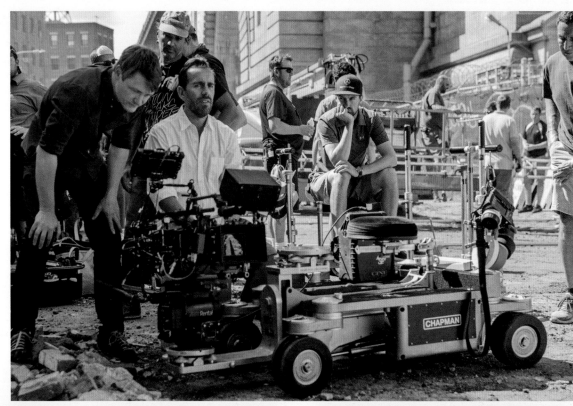

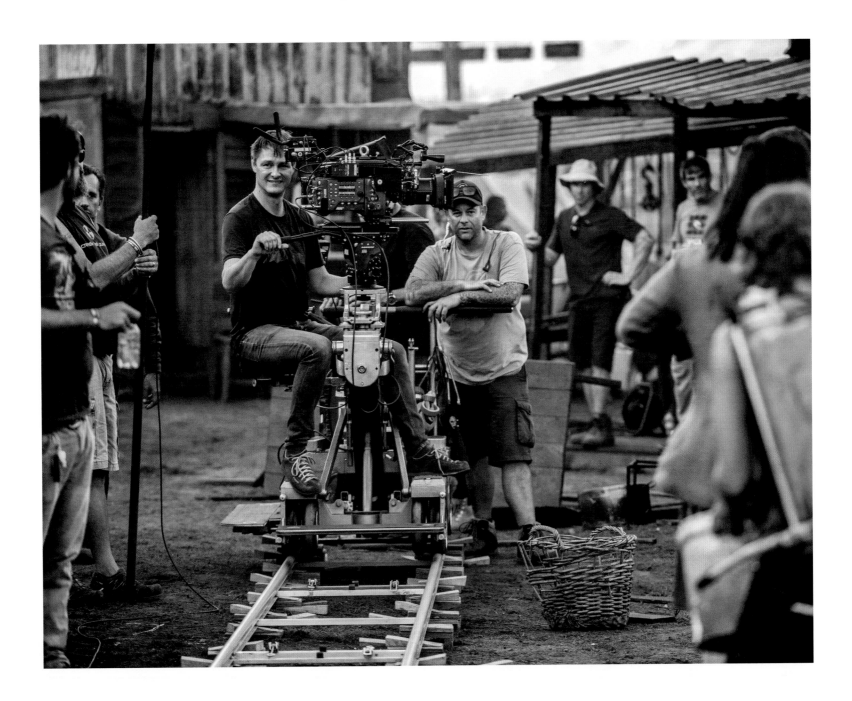

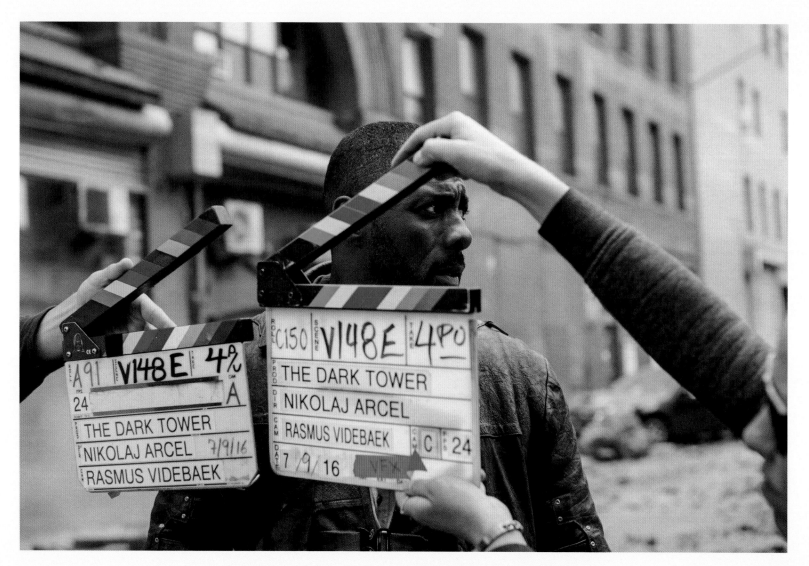

During the New York shoot, Idris Elba, who stars as Roland, awaits the call of "Action!"

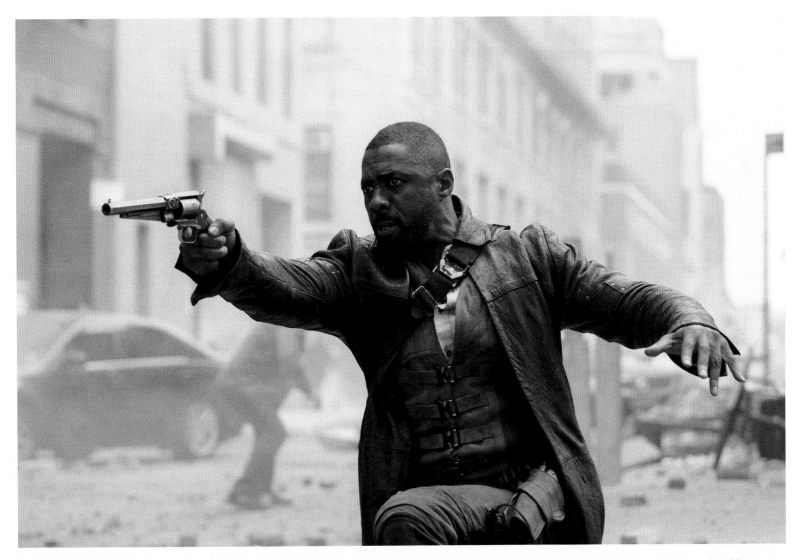

Elba takes aim with one of his twin revolvers. Because his character is a Gunslinger, such actions as drawing, firing, and reloading needed to look as effortless as breathing.

PART II

Roland the Gunslinger wields centuries-old revolvers in his war against the
supernatural forces of Walter, the Man in Black.

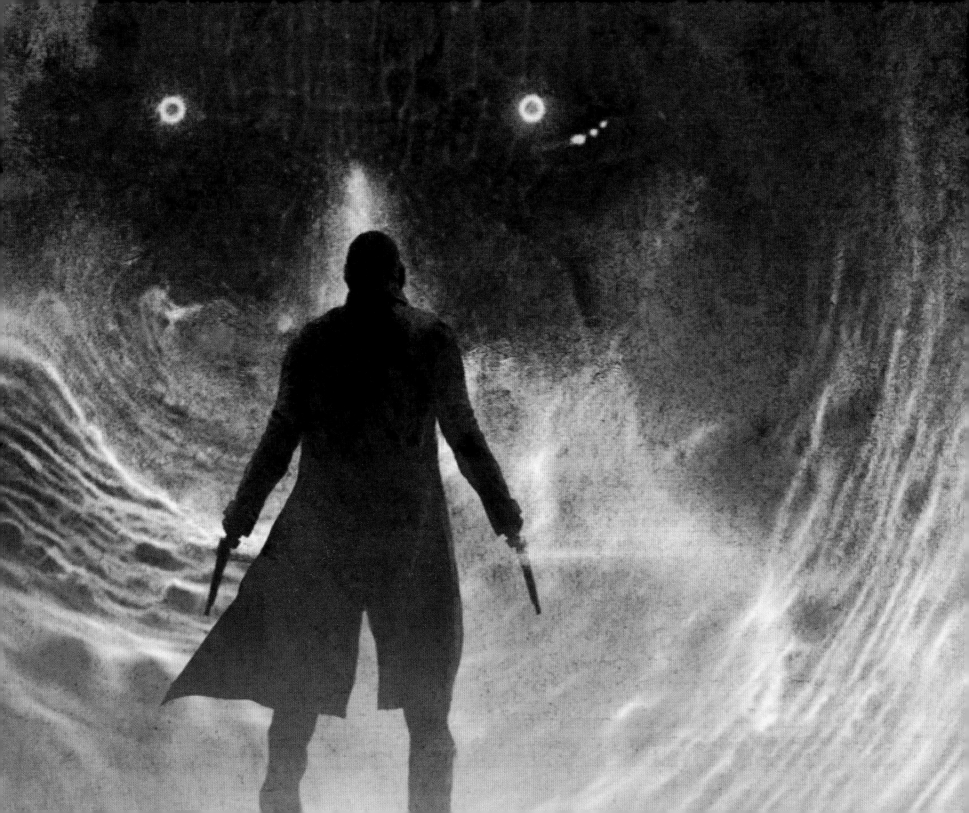

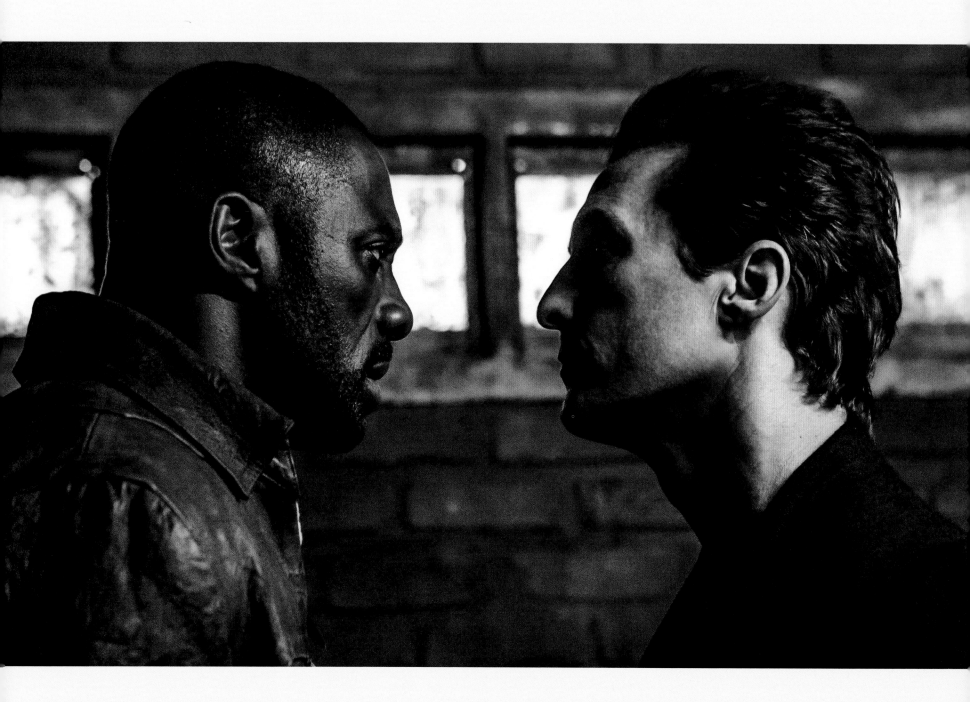

THE GUNSLINGER & THE MAN IN BLACK

Old foes and opposing forces, the Gunslinger and the Man in Black are the impulses of action and reaction that turn the wheel of fate. One of them is the last living descendant of King Arthur. The other is the immortal herald of a being even worse than Satan.

The Man in Black enjoys tormenting his opponent, and the film establishes their animosity during an early scene that depicts the downfall of the knights who once protected the Dark Tower.

A corpse-littered ravine wreathed in smoke is the setting for the Man in Black's triumph, as evil forces claim the battlefield and their leader prowls among the dead. He seeks out those just barely clinging to life, delivering their final oblivion with flame conjured from his hands.

One of the injured is Steven Deschain, a legendary Gunslinger. Steven's son, Roland, hopes to treat his father's wounds, but the two are stalked by the Man in Black in a catlike dance of predator and prey. Steven is aware of the Man in Black's power but contemptuous of him as a "prince of nothing."

The Man in Black easily eludes Steven and Roland. Ultimately, an anguished Roland walks away knowing that patience will make his eventual defeat of the last Gunslinger much sweeter.

This is the incident that throws Roland into a crisis of faith. Disillusioned, he is unwilling to continue the crusade that motivated his father, but he finds a new, more primal focus by embracing the hate he feels for his enemy.

Since this moment, the Gunslinger neglects his vow to protect the Dark Tower and doggedly trails the Man in Black on a hunt for vengeance. Where the Man in Black goes, the Gunslinger follows. But when a third force joins the mix, it carves a new track for their destinies.

Opposite: Matthew McConaughey (left, as the Man in Black) and Idris Elba (as the Gunslinger) stare each other down. Their rivalry is knocked out of alignment with the arrival of a boy played by Tom Taylor.

Following spread: The sweeping expanses of Mid-World are on display in this concept art. The carnage of a great battle is a near-fatal blow to the defenders of the Dark Tower.

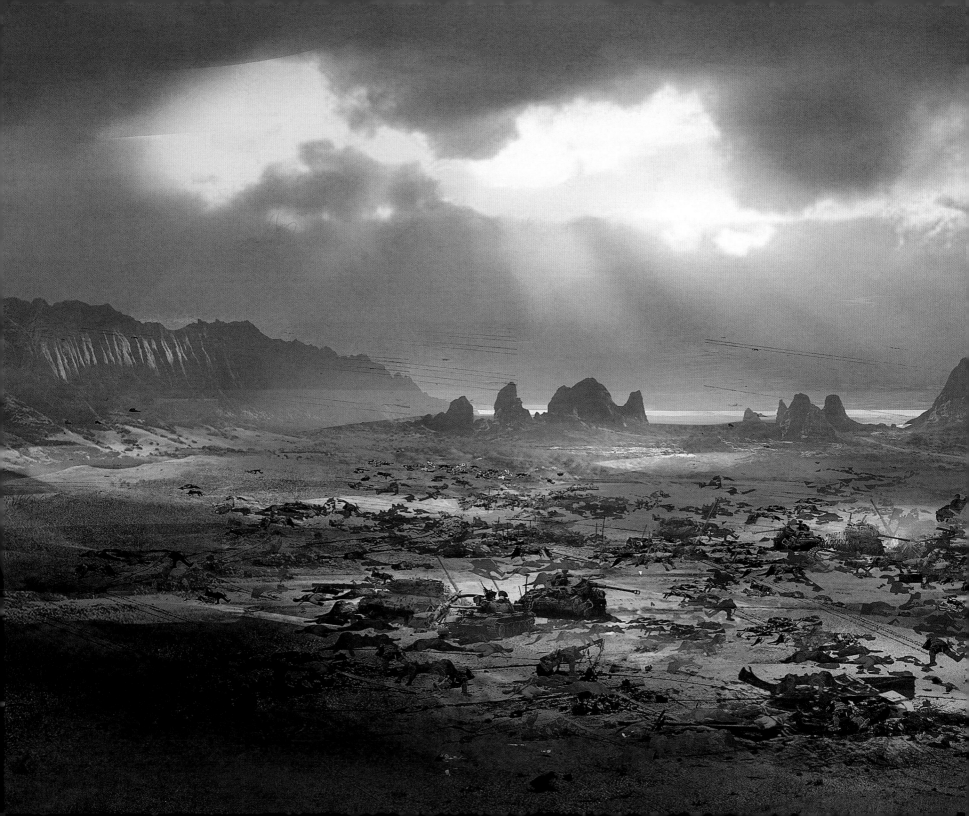

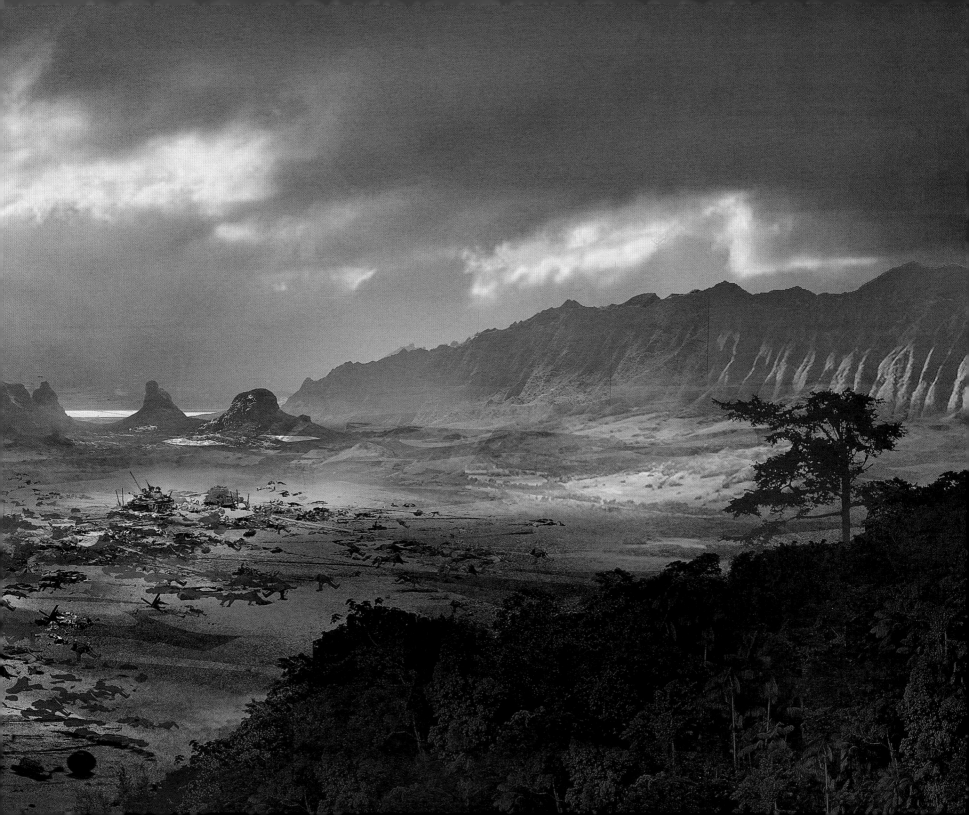

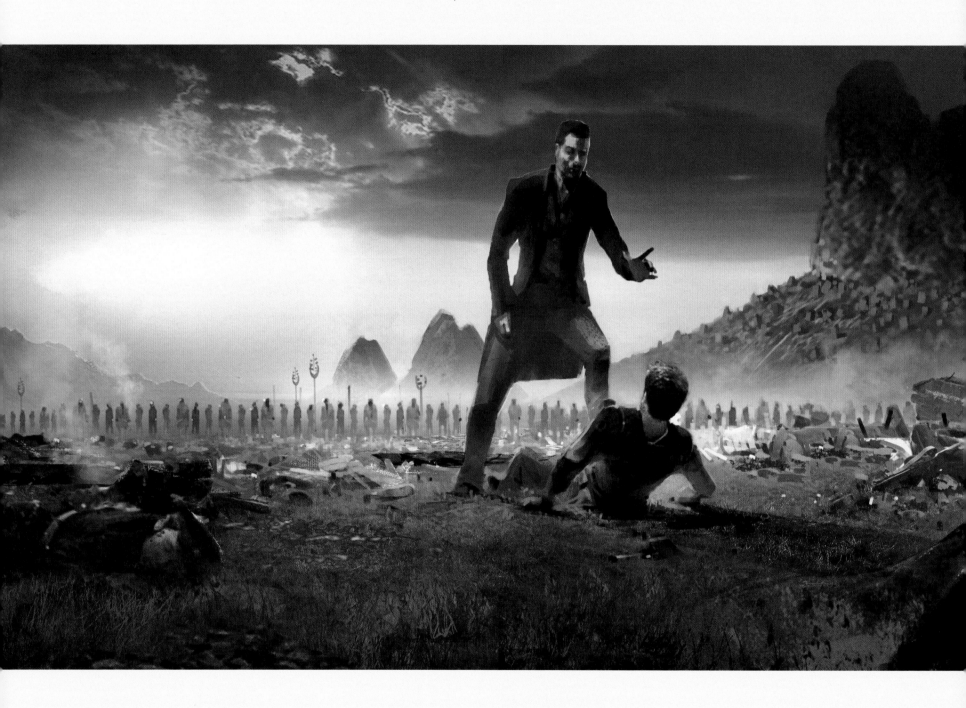

Left: In this concept art, the Man in Black, backed by his triumphant armies, leans in to speak to a wounded enemy soldier and offer the quiet oblivion of death.

Above: Filming for the opening battle scene involved careful set dressing, with atmospheric smoke effects and broken war machines in keeping with Mid-World's hard-to-define level of technological sophistication.

Following spread, left: Roland prepares to unload his revolver on the supremely confident Man in Black, but is unprepared for his opponent's powers of suggestion and scarily precognitive reflexes.

Following spread, right: The actors playing the deceased soldiers enlisted to defend the Dark Tower take a rest in between takes.

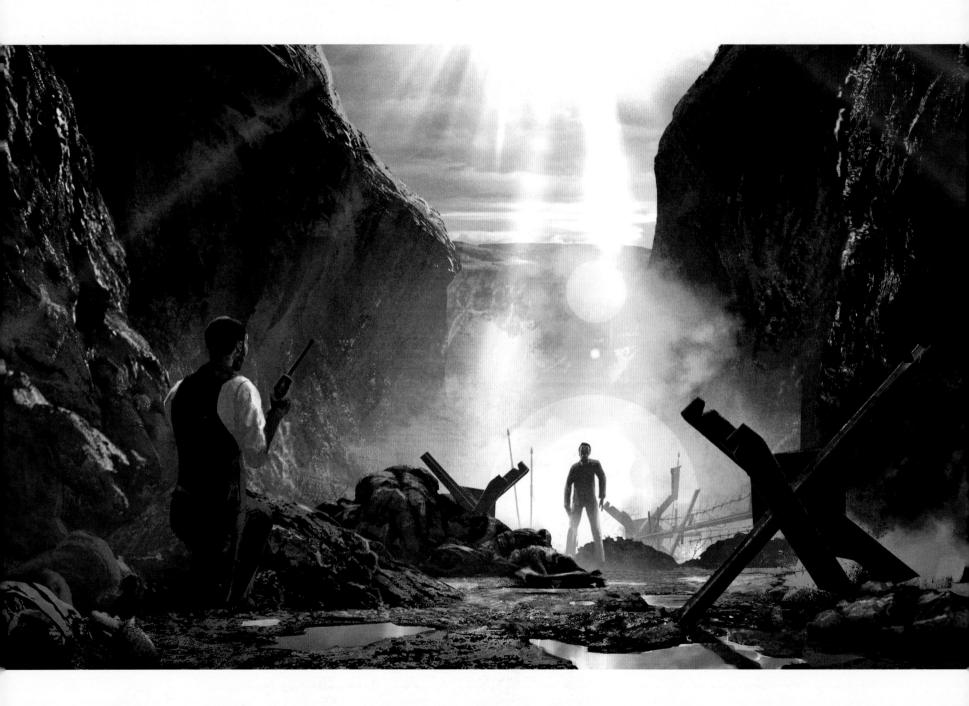

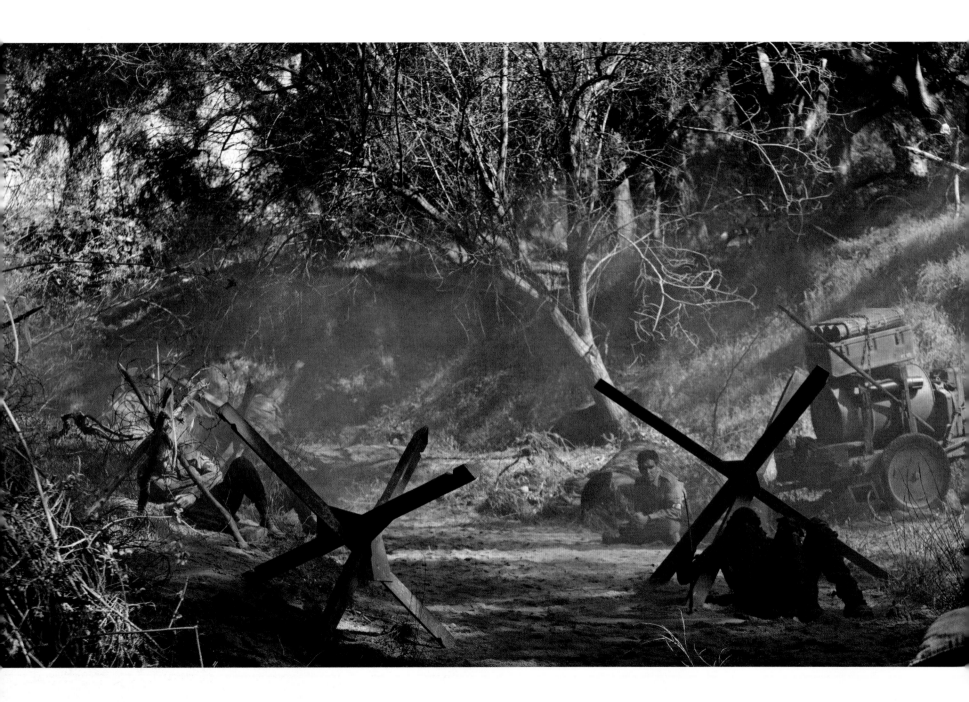

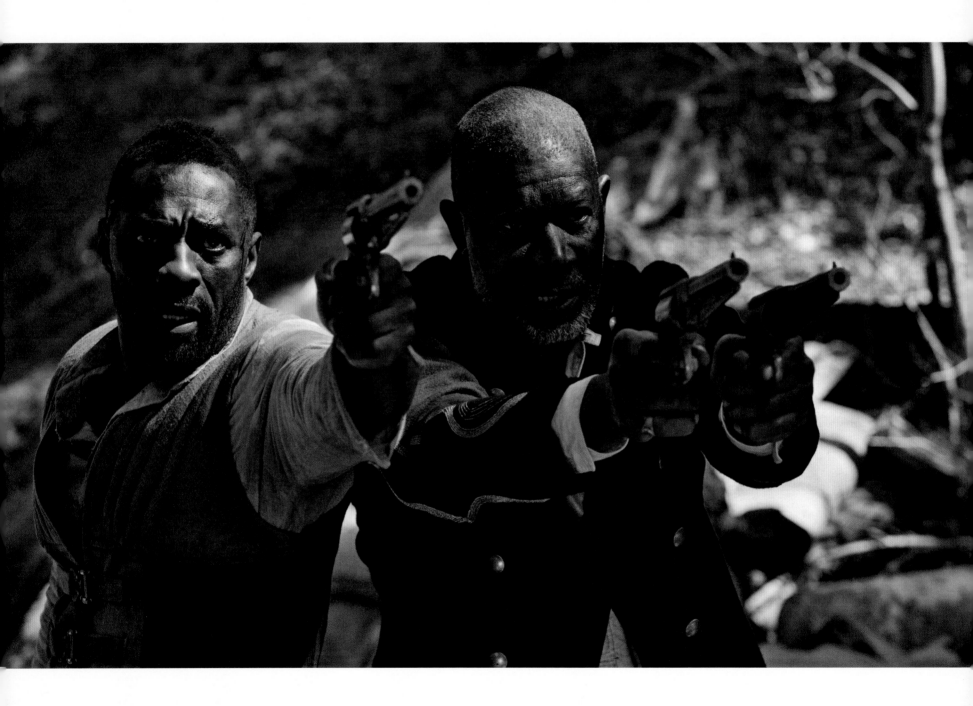

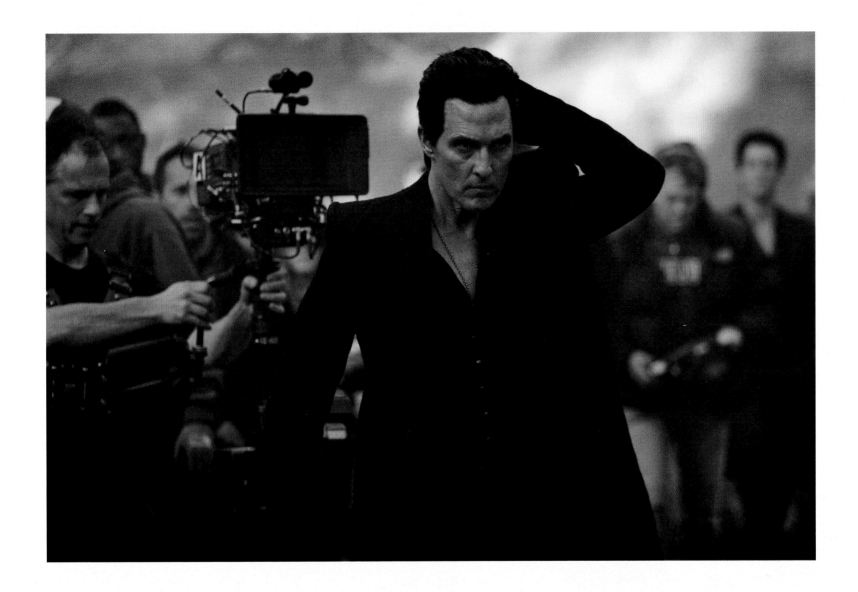

A determined McConaughey prepares to stalk the battlefield in a scene that will establish the Man in Black as cruel and unbeatable.

Opposite: With the words of the Gunslinger's Creed echoing in their minds, Roland (Elba, left) and his father, Steven Deschain (Dennis Haysbert, right), take aim against their hated foe.

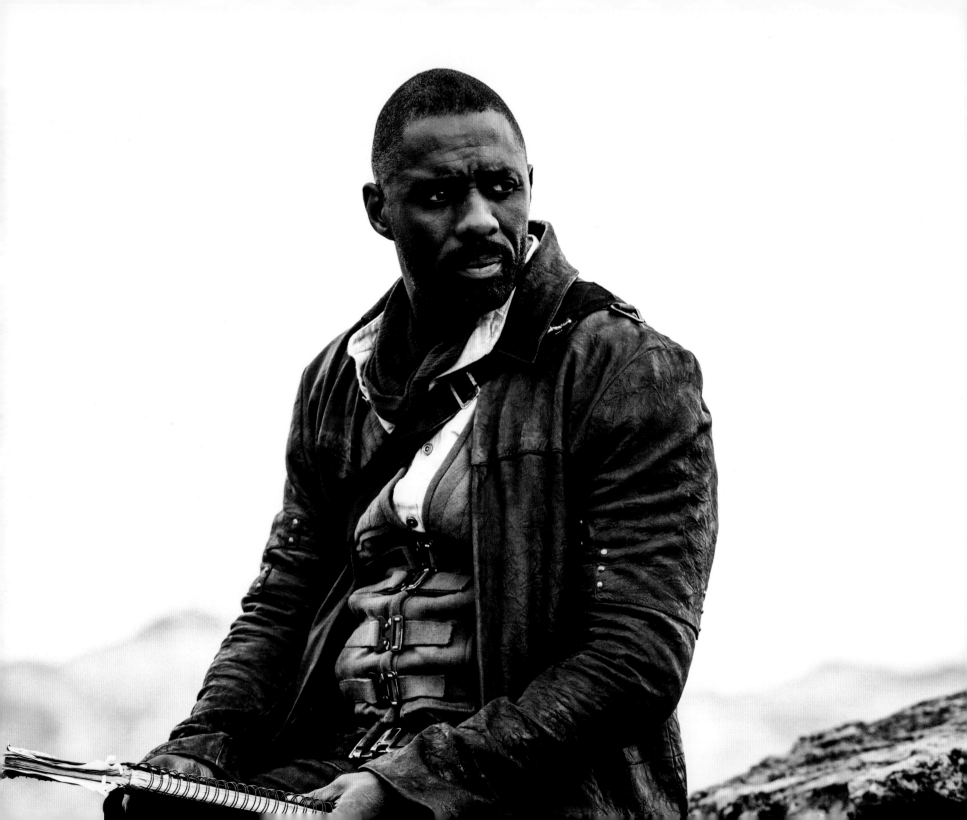

ROLAND
THE GUNSLINGER

∽

Elba plays Roland Deschain, the sole surviving member of the knightly order of Gunslingers. Their mission is the preservation of the Dark Tower—the cornerstone of the multiverse—from those who would topple it and sow chaos in the rubble. This tragedy would usher in the reign of the Crimson King, lord of demons and ruler of primordial horrors.

"Roland comes from the line of Eld, a legacy of Gunslingers put in place to protect the Dark Tower, and he is the last in that line," says Elba. The Gunslinger's role has arguably never been more critical, but Roland long ago laid down his burden. His new quest is revenge on the Man in Black, seeking cold payback for a life he will never get back.

"His heart has been blackened," says Elba. "He's basically a ghost looking for something he can't find, until Jake comes along."

Jake's arrival in Mid-World and its upending of the Gunslinger's spartan lifestyle is a theme in the first Dark Tower novel, and screenwriter Akiva Goldsman believes that the relationship holds even more power in the big-screen interpretation.

"We wanted a Roland who was more available in his motivation," he says. "He doesn't say much, so we needed an engine for his connectedness with Jake and his disdain for him. We needed him to reject intimacy and then choose it. Roland lost the person he loved. He's wounded, staggering across the landscape of the narrative. He's slightly broken so that he and Jake could have a relationship cemented out of mutual need."

Because the Gunslinger is the central figure of the entire Dark Tower saga, the character's casting took center stage during early attempts to produce a movie version. Stephen King described Roland as a close match for Clint Eastwood's *Man With No Name.*

While producing 2007's *American Gangster,* Brian Grazer found himself struck by Elba's star power, even in a cast that included heavy hitters like Russell Crowe and Denzel Washington. "He was probably the only actor who could be formidable against that lineup," he says. "I mean, who would Denzel be afraid of?"

"Idris felt like a really interesting choice," says producer Erica Huggins, "somebody who inhabited the DNA of what the Gunslinger should be. A different way to look at Roland, but still a badass, and somebody capable of shouldering the responsibility of a Gunslinger."

Adds Grazer, "Idris plays a guy who's a solo flier. He's that lone Gunslinger, definitely."

Director Nikolaj Arcel had a vision for the character, and Elba fit the bill. "Idris and I made a deal at the outset," he says. "We said, 'Let's make Roland as real as the story allows us and not some arch iteration of a cowboy.' In the books Roland is mysterious and dark, but he's also full of heart and sometimes even cracks a joke. Idris was perfect for conveying this blend: mysterious and unapproachable, yet warm and big-hearted. He is very much those things in real life."

Elba came to the role with respect for Stephen King's worlds and the people who populated them. "I was excited because he creates complex, well-rounded characters, characters that have a lot of depth," he says. "We have a young boy who discovers Roland in his dreams, and then becomes embroiled between New York and Mid-World."

In Arcel's mind, Roland's years of wandering had led to a sort of post-traumatic stress disorder. "When Jake first meets him, Roland hasn't been in touch with his humanity or his purpose for a long while," he says. "Roland is all about revenge, and Idris inherently understood that idea."

In the film, Roland has no costume changes, giving his sole outfit a critical, character-defining importance. "He's in the one costume throughout, so it's basically like a superhero costume," says costume designer Trish Summerville. "And because he's such a fierce Gunslinger, he doesn't have damage, like bullet holes or wounds. He's a bit untouchable."

Summerville considered numerous looks. "I like costumes to tell a story, but I don't like things to stand out," she says. "He's from a knightly background, and he's also a Gunslinger. It's a somewhat timeless look."

Adds Elba, "We spoke about him not being a cowboy, but being more like a knight. Some elements, like the bodysuit that looks a bit like a bulletproof vest, came from discussions that this is a knight in shining armor."

Summerville elaborates on her costuming philosophy: "We wanted to add little pieces that he got along his journey. The pieces aren't all the same color, and there's a lot of wear. His vest has bindings that are more futuristic and timeless instead of vintage buttons, mixing textures with leathers and woolens and subtle details that could be from any time, as a mash-up of all these worlds."

Arcel found himself micromanaging the costume for shot-by-shot continuity. "You'd be surprised how much worry goes into the smallest things, like Roland's bag," he says. "Every other scene becomes, 'Where's the bag?' It looks great, and we made the right choice, but it was a logistical nightmare."

If clothes do indeed make the man, Idris Elba found that suiting up as the Gunslinger was a head-to-toe immersion into Mid-World. "When I was a kid, I wanted to play [as a hero]," he says. "And now here I was with this crazy costume and doing this incredible work. It's like a living playground of your imagination."

Previous spread, left: Concept art of Elba in the role of Roland Deschain, the last Gunslinger.

Previous spread, right: Elba's on-set attire didn't change much from the earliest costuming studies. The selection of clothing and its muted hues was dictated by practicality.

Opposite: Unsure if the new arrival is one of the Man in Black's tricks, the Gunslinger points his weapon at a potentially deadly threat.

Following spread, left: Roland and Jake begin as strangers, but during their trek across Mid-World, they form a bond that will grow into an unbreakable partnership.

Following spread, right: The Gunslinger instructs Jake in the art of marksmanship. The act of taking an apprentice is a sign that Roland has accepted Jake into his *ka-tet*—a term for people whose futures are bound together by fate.

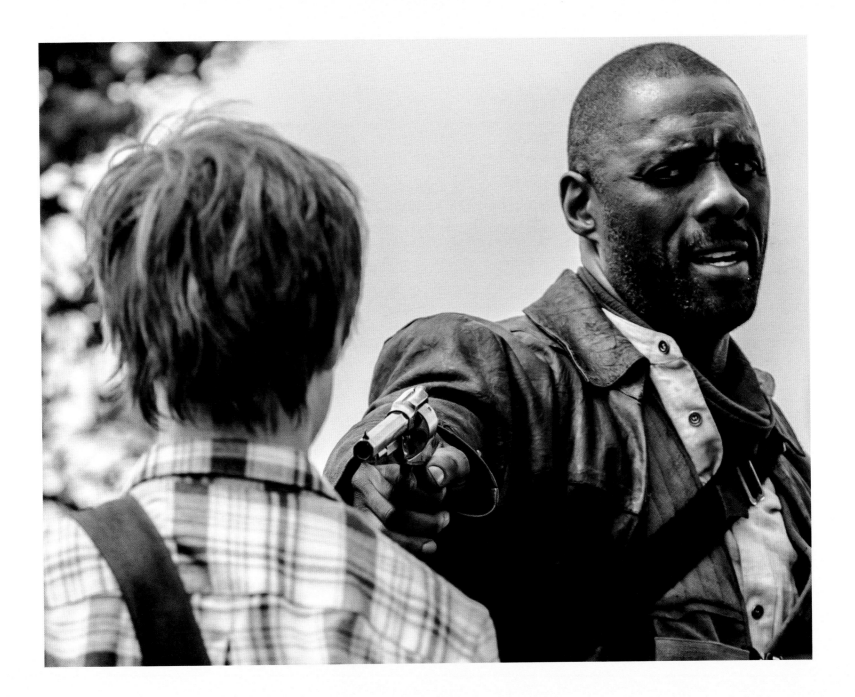

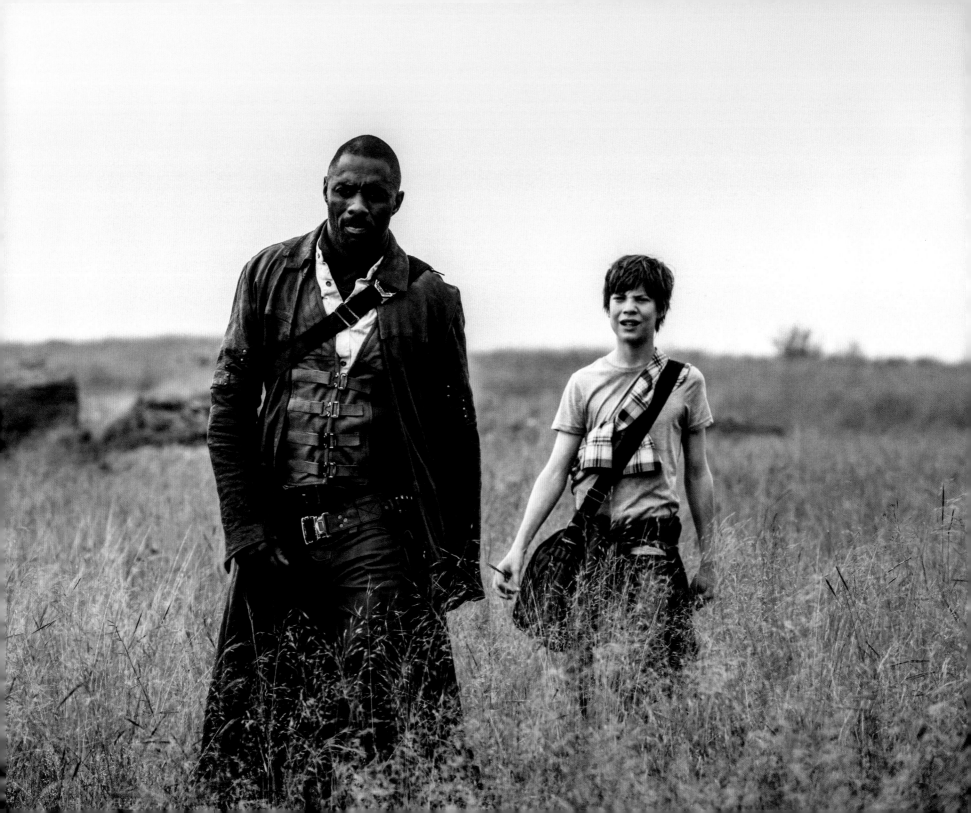

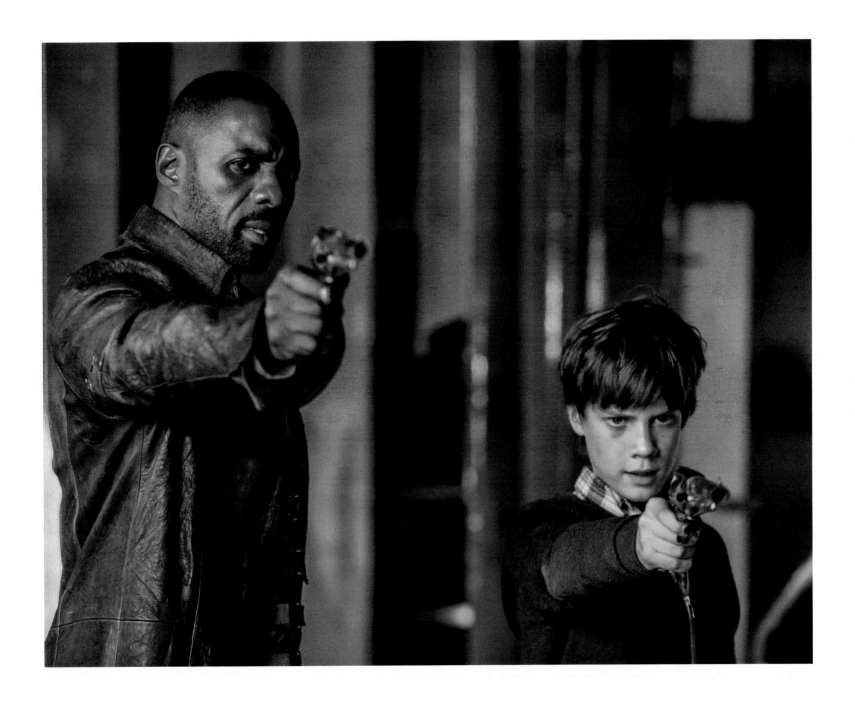

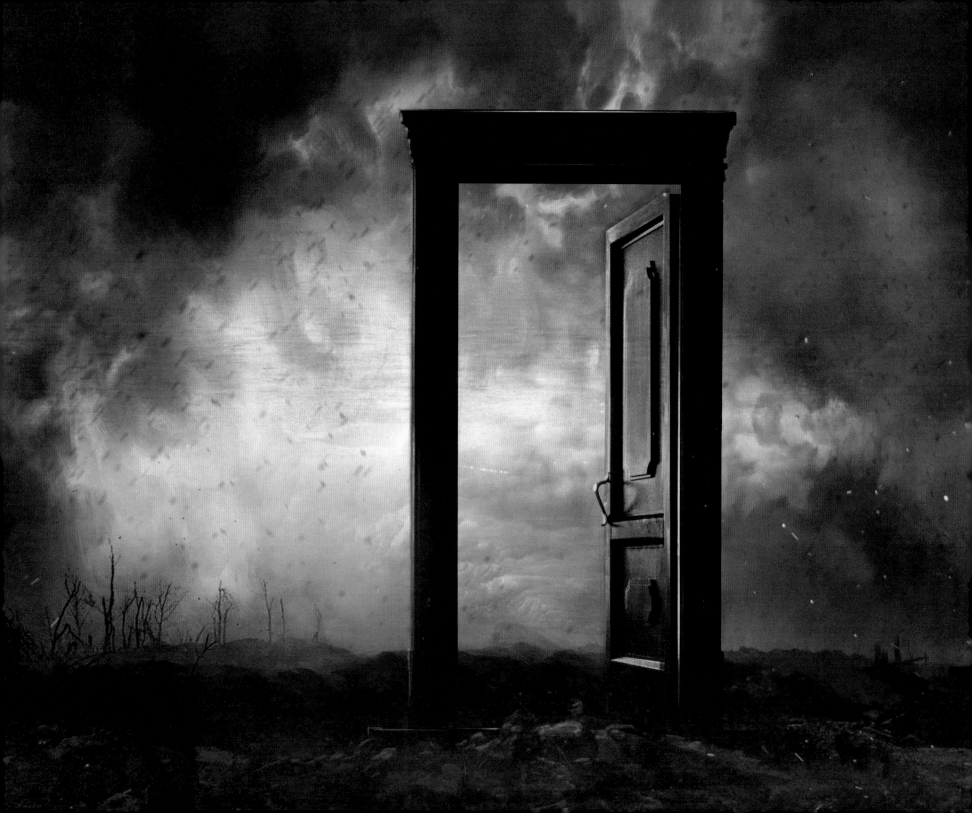

DOORWAYS OF PERCEPTION

Mid-World is a place where science rubs shoulders with
mysticism and undeniable religious miracles. Strange por-
tals provide passageways to shadow dimensions including
our own New York City, though in the Dark Tower novels
they are sometimes summoned through vision-quest
spellcasting or appear suddenly as incongruous construc-
tions of fate. A free-standing doorframe occasionally
crops up during the Gunslinger's literary journey, and
provides a means for him to gather the members of his
ka-tet from across time and space.

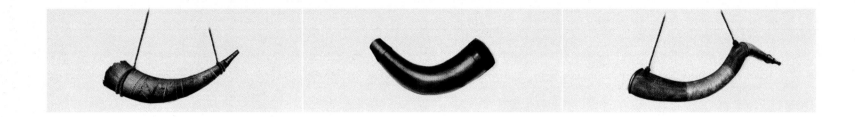

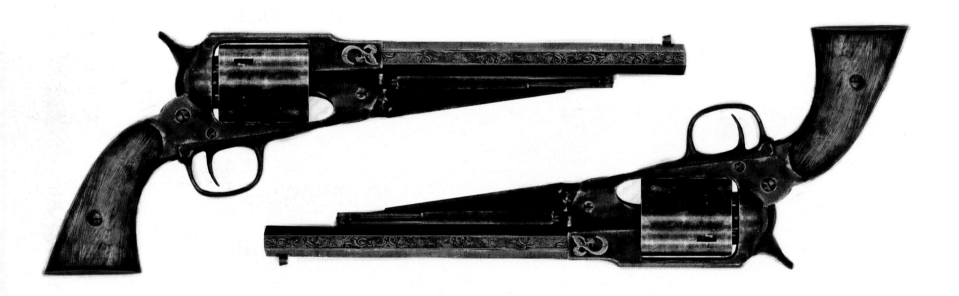

THE GUNSLINGER'S GUNS

No props came under as much scrutiny as Roland's twin revolvers. When your protagonist is known as the Gunslinger, you'd better create some seriously impressive guns.

"My first job was to ensure that Roland's guns were the six-shooters from the novels and not some futuristic iteration," says Arcel. "I always thought that was a badass notion, that he has these ancient guns to battle monsters."

Roland's weapons are centuries-old relics, passed down through generations of Gunslingers. Their grips are made from sandalwood; their barrels were cast from the steel of Excalibur, Arthur's holy sword. Elba recognized the importance of the guns to the character's mythic resonance. "Although he hasn't been a Gunslinger for a very long time, he's still the last in that line," he says. "He's not a cowboy, he's a Gunslinger, and his guns are made from Excalibur."

As with most hero props, the devil was in the details. "The design questions kept us up at night," admits Arcel, "such as the Mark of Eld on the side, or the runes described in the books. How should they look? How faded should they be?

"We kept changing the guns until the last minute."

Opposite: Various studies for the Horn of Eld, Roland's iconic twin revolvers, and a practical yet decorative dagger.

Right: A holstered pistol does not remain at rest for long. With Roland's reflexes, he can draw with lightning speed and fire with deadly aim.

Following spread, left: The "hero prop" versions of the Gunslinger's revolvers. The Mark of Eld can be seen on the side, a testament to their origins in the Mid-World equivalent of the Arthurian legend.

Following spread, right: Roland's bag and the mystical Horn of Eld.

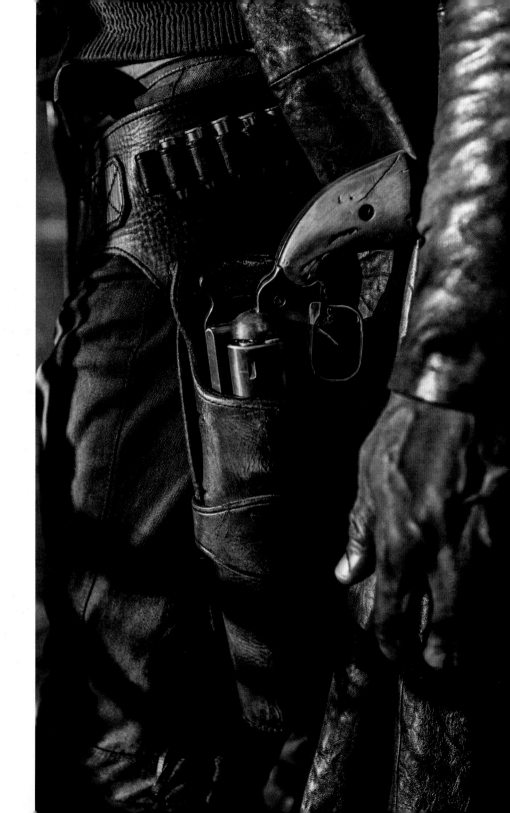

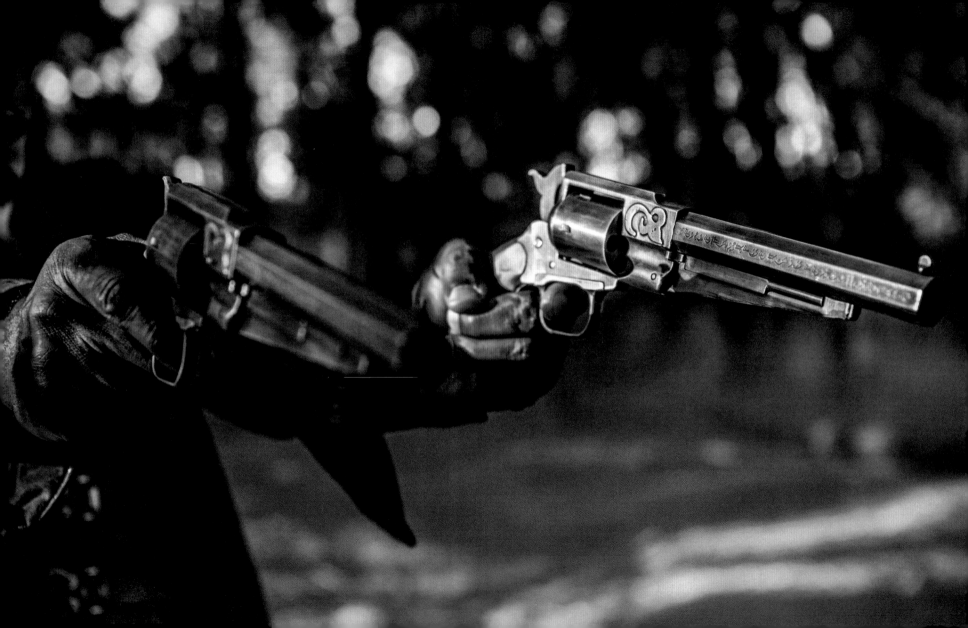

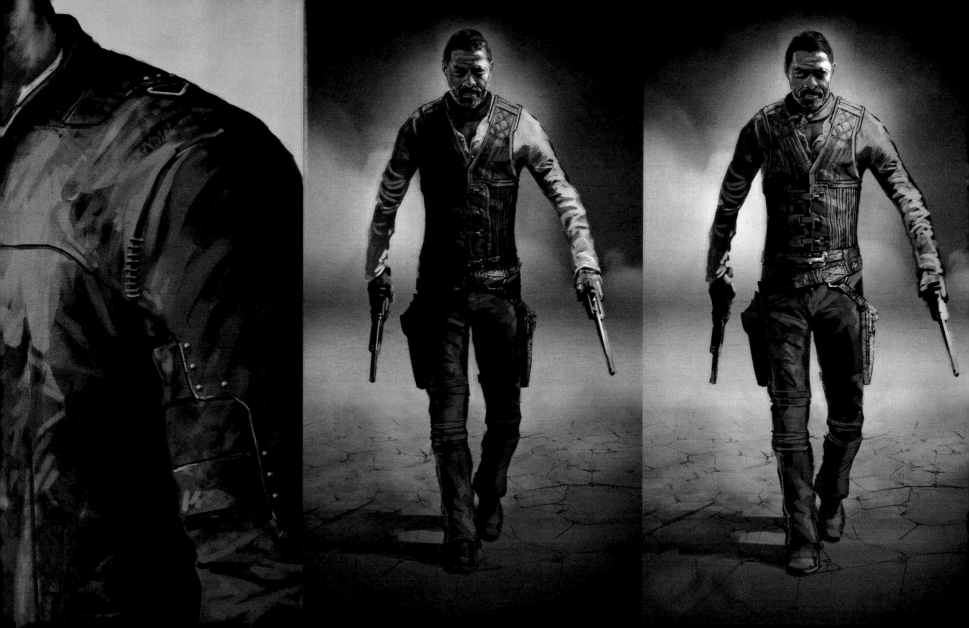

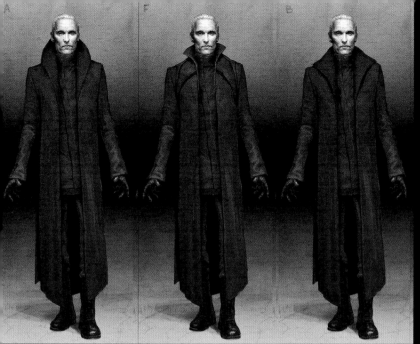

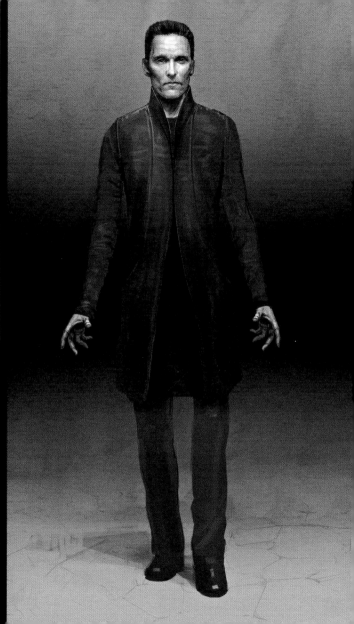

CLOTHES MAKE THE MAN

The Gunslinger and the Man in Black are mortal foes,
yet their subdued attire evinces a similar matching min-
imalism. The costuming treatments for the Gunslinger
explored both monochromatic and contrasting shades,
and a close-up shows how pieces of fabric could resemble
segments of plated armor. The Man in Black went through
numerous iterations of a draping overcoat resembling
the cloak of an evil acolyte—fitting vestments for a herald
of the Crimson King.

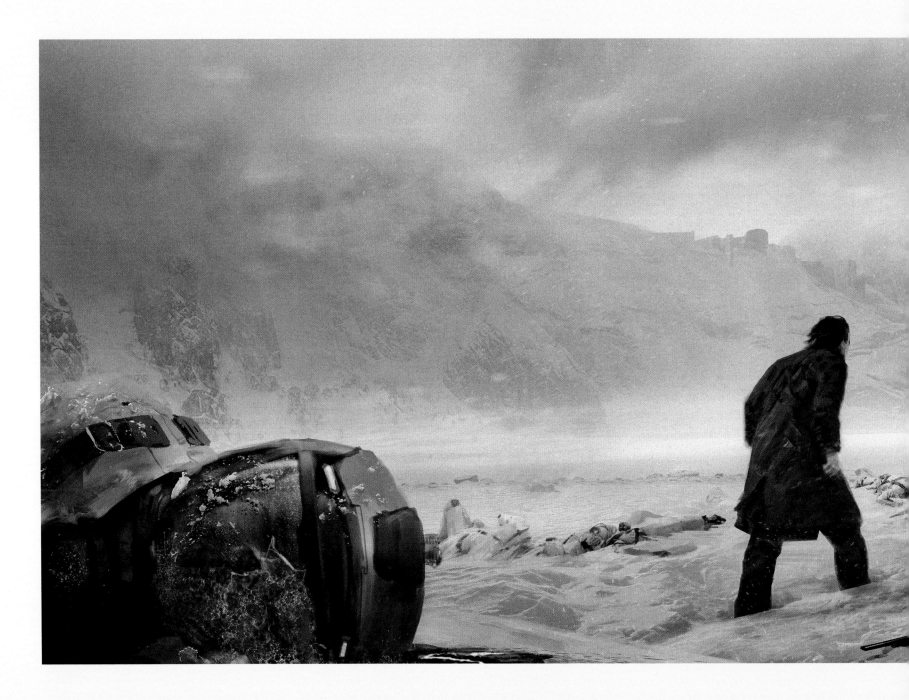

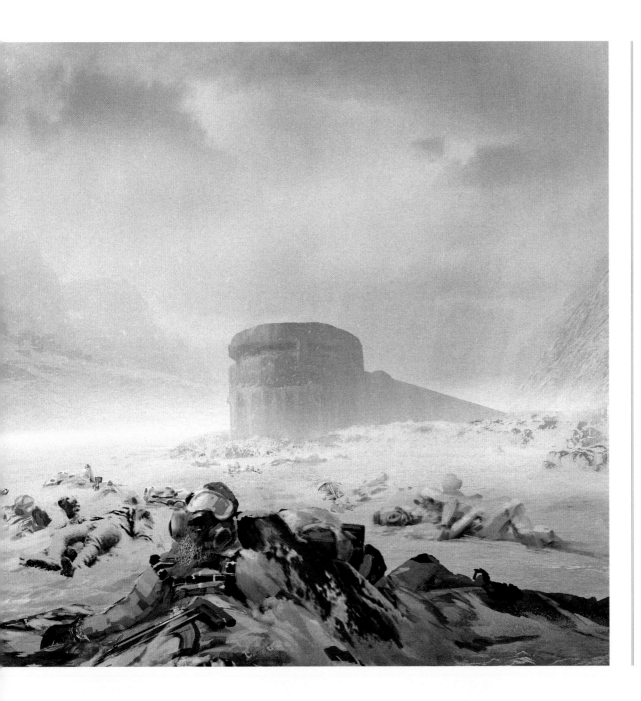

In a scene cut from the film, the Man in Black strides purposefully back to the portal that will carry him home, through snowy wastes littered with the bodies of the fallen.

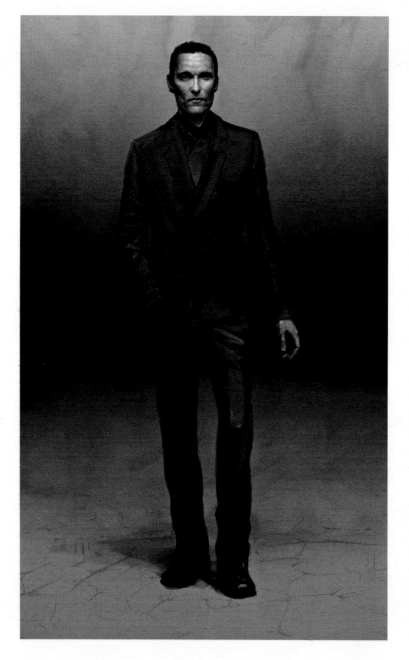

This costume study for the Man in Black settles on a sharp look, with a dark-hued suit and a matching black shirt. Summerville decided against a necktie, evoking both a sense of breezy casualness and the confidence of a man unafraid to confront the blood-sucking vampires in his employ.

WALTER, THE MAN IN BLACK

McConaughey is the Man in Black, the right hand of the mysterious Crimson King. He has an irresistible power of suggestion—one he has no compunctions about using. Known to some as Walter, the Man in Black seeks to fulfill his master's ambition by breaking the beams of the Dark Tower.

"Within the story, the Man in Black is actually very difficult," explains writer Anders Thomas Jensen. "Roland and the Man in Black have this almost endless backstory, and in some weird sense he is Roland's fate. He's inside Roland's mind in almost every scene. Strong villains are good, but when they're as strong as the Man in Black it can be a problem. You have to reduce his abilities to make it a more equal fight."

McConaughey delighted in playing a villain whose menace was conveyed solely through charm. "I love words and linguistics," he says. "Walter is a silver-tongued soothsayer. Sometimes he's quite verbose, while other times he says little and 'leaves the truth in the asker's kitchen.' Walter exposes people's hypocrisies and lets them condemn themselves. I approached him as a man with worldly and timeless knowledge, and as quite a humorist. I enjoyed having no constraints."

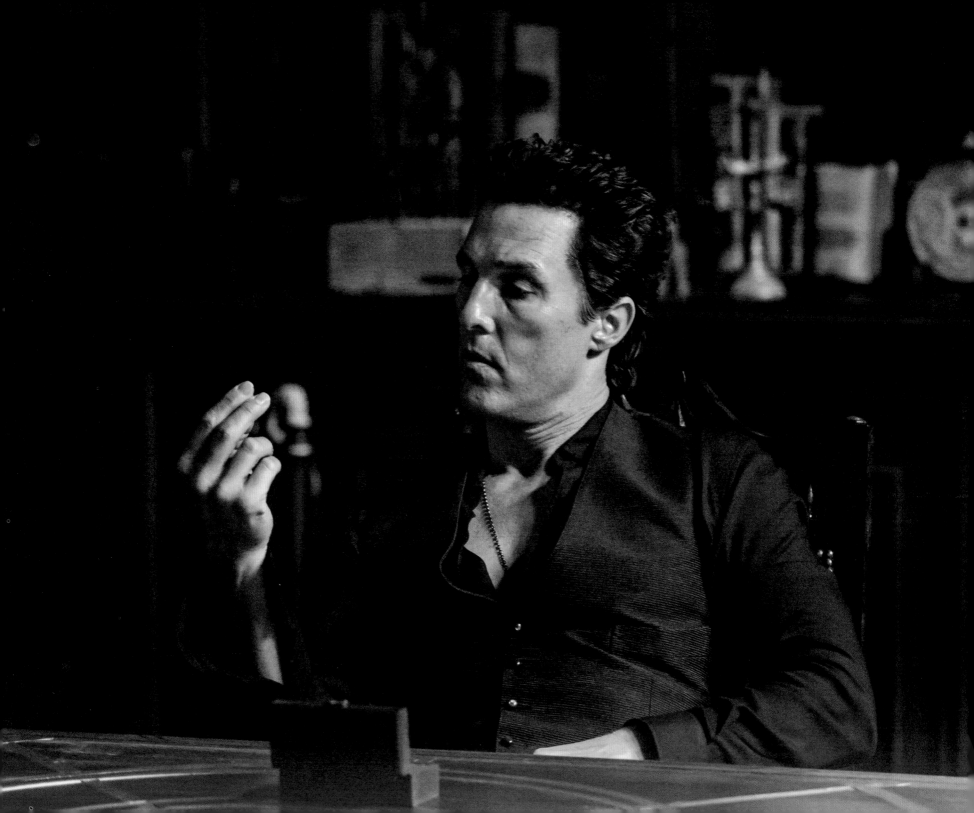

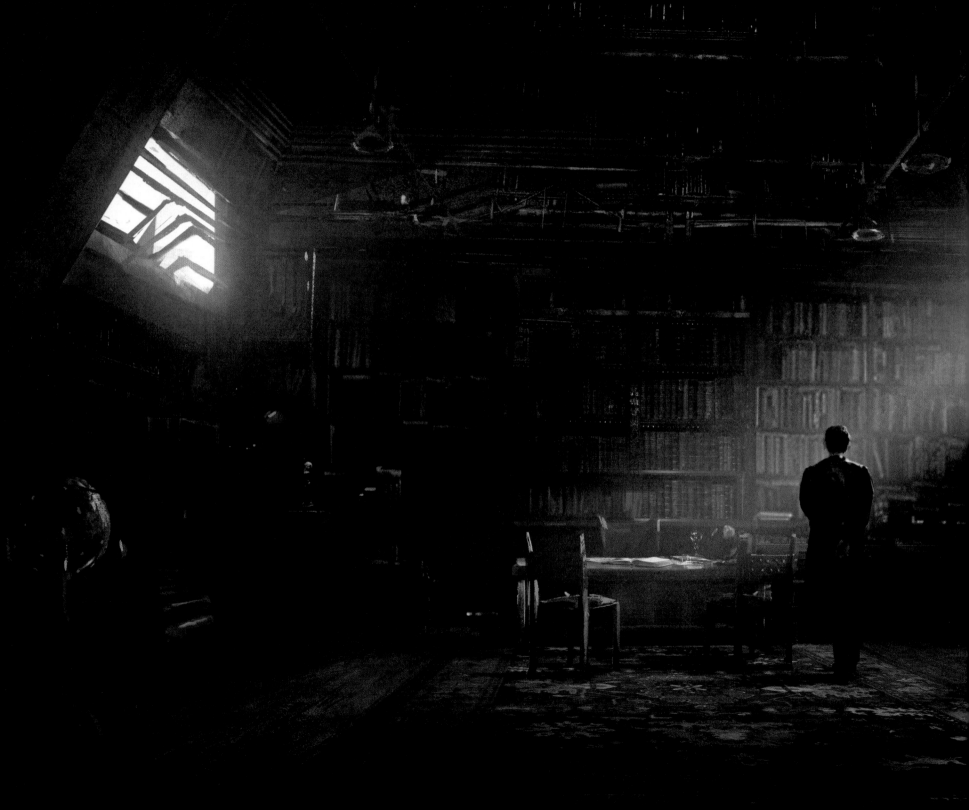

Others in the production spoke highly of McConaughey's uncompromising drive. "As an artist, he's intensely willful and very verbal," says Grazer. "When he's passionate about something, he's the most persuasive person you'll ever meet."

Huggins agrees. "He's incredibly smart and sharp. I think the part spoke to him because having a witty and scary villain at the center is a tribute to the material."

Arcel notes that McConaughey came prepared. "When he arrived on the set, he already had a completely polished approach, with tons of ideas for how to make the Man in Black a three-dimensional villain. When you're working with actors of this caliber, you try to not be too controlling. Letting them follow their own instincts usually brings pleasant surprises."

Elba intentionally avoided McConaughey until their first scene together, seeking to strike the right tone for their on-screen antagonism. "It was great for our actual chemistry," Elba says. "The Man in Black is one of Stephen King's great characters. He has all these weird sayings and idiosyncratic behavior that someone like Matthew just eats up. On-screen he looks incredible; he has this twinkle in his eyes. He's a likable bad guy."

For ages, the Gunslinger and the Man in Black have pursued each other in a dysfunctional, codependent dance. "It's a wonderfully twisted relationship," explains McConaughey. "I want Roland to engage me in the epic battle of good versus evil, but simultaneously want him to die by his own humiliation. It's a tightrope Walter walks: to bait Roland and keep him alive, full of hate and revenge. Yet my obsession with Roland is just the thing that could get in the

Walter's study is a repository of items collected during his travels. The bookshelves are packed with volumes, and artifacts both sophisticated and macabre are tucked into dark corners.

Following spread, left: Walter calls his chief lieutenants to attention in a room decorated with trophies from dead worlds. Pimli (left) is from our Earth; Tirana is a disguised reptilian comfortable with the uneven culture of Mid-World.

Following spread, right: Walter has long kept a steady hand on the Breaker Central operation, but the emergence of a boy with psychic powers hailing from one of the many mirror universes represents a variable that's more difficult to control. Here, he locks Jake into a chair and wires his brain to a psychic harvester.

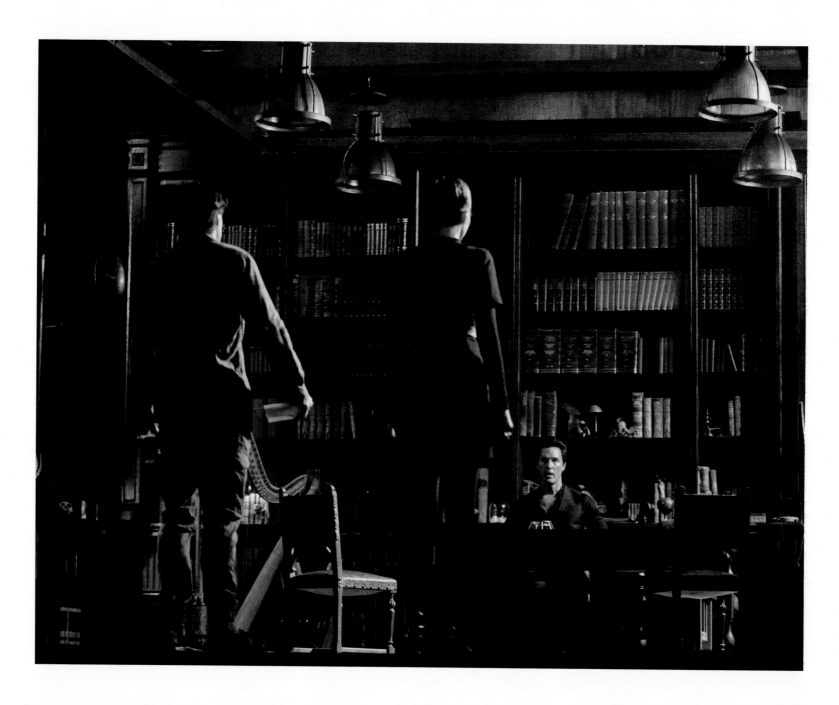

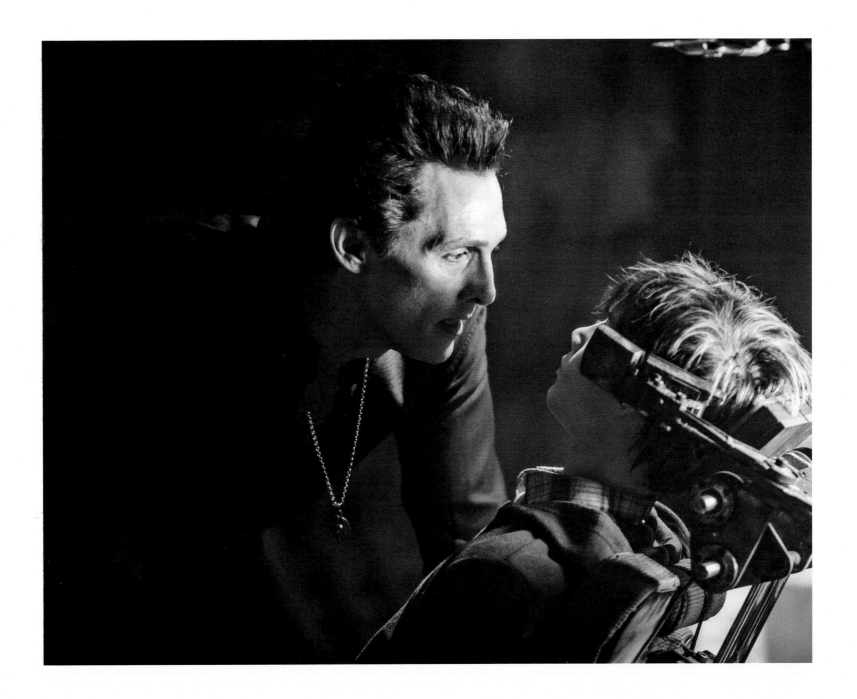

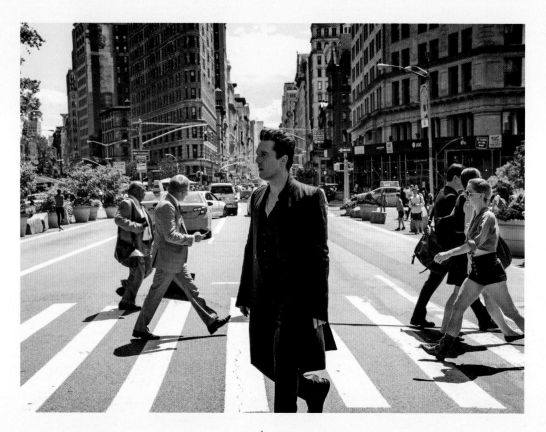

THE MAN COMES AROUND

Walter is at his most confident on the streets of New York City, where everyone is a puppet and only he can see the strings. Even the wealthy and powerful will abandon their modesty and sense of self-preservation with a simple spoken command. Walter intends to wipe clean this weak realm, aided by such tools as an otherworldly doorway and a string of orbs imbued with magic.

way of my mission to topple the Tower. It's perverse, but Walter believes he can have his cake and eat it too."

The Man in Black controls a portal that links Mid-World with New York City. When he emerges in the metropolis of eight million people, he can't help but indulge himself by using his power to persuade others.

"Walter loves New York," says McConaughey. "To be back in 'field work' is a buzz. A field trip, a vacation. To hit up my favorite spots, my old stomping grounds, and follow through on

what could be a very important lead in a young 'shiny' boy named Jake. New York is so full of life, and life asks too much of men. New York is fertile ground for Walter to be entertained."

The Crimson King stays offscreen, but his shadow looms constantly over the proceedings. McConaughey believes that Walter simultaneously loves, venerates, and fears the unseen entity, while housing quiet ambitions of his own. "I think Walter secretly plans to overthrow the Crimson King once he's seated next to him," he confesses.

For the Man in Black, Summerville eschewed the Gunslinger's vintage practicality in favor of breezy modernism.

"He's a bit more fashion-forward and conscious of how he looks," she says. "We kept his silhouette broad-shouldered and slim through the waist. He has a long coat with a bit of texture and ripple to it, a high dramatic collar, and long angled sleeves that cover most of his hands. It keeps his silhouette very dramatic."

Summerville knew that outfitting a character named "the Man in Black" wouldn't offer much in the way of color variety, but she didn't find the monochromatic look restrictive. "We used different textures to get depth between the shirt, the pants, the vest, and the jacket," she says. "And layering pieces, so he has something to take off.

"I couldn't put him in a tie," she continues. "Matthew and I really gravitated toward the idea of Walter in an open-necked shirt in the scenes where he goes into a club with the vampires. I liked the idea of his neck being exposed, almost as if he's daring anyone to go after his throat. He can tempt the vampires because he's secure in who he is."

HIDDEN TECH

A rendering of the interior of Walter's study (below) helped the production crew conceptualize the space's potential and its limitations. Not far from Walter's desk is a dimensional gateway that allows instantaneous travel to any realm of its master's choosing. "That portal is more of an 'über portal,'" says Glass. "It's a bit bigger and it's cleaner. It's more kept up because they maintain it."

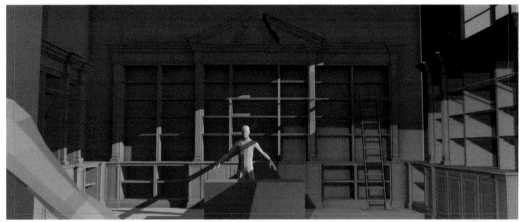

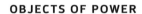

OBJECTS OF POWER

In the books, these polished stones—imbued with power but cursed to bring sorrow to those who use them—are known as Maerlyn's Rainbow. "These spheres are the things [Walter] is collecting from parallel worlds, and each one has a different power," explains production designer Christopher Glass. "There are thirteen of them in all, and by the time of our movie he has collected seven or eight." In the film, the stones allow the Man in Black to remotely keep tabs on the goings-on inside the Manni village and to astrally project himself through space to confront Roland inside the gun shop. The orbs rest inside a sliding-panel chest for safekeeping.

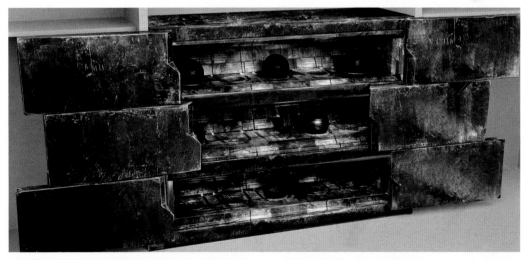

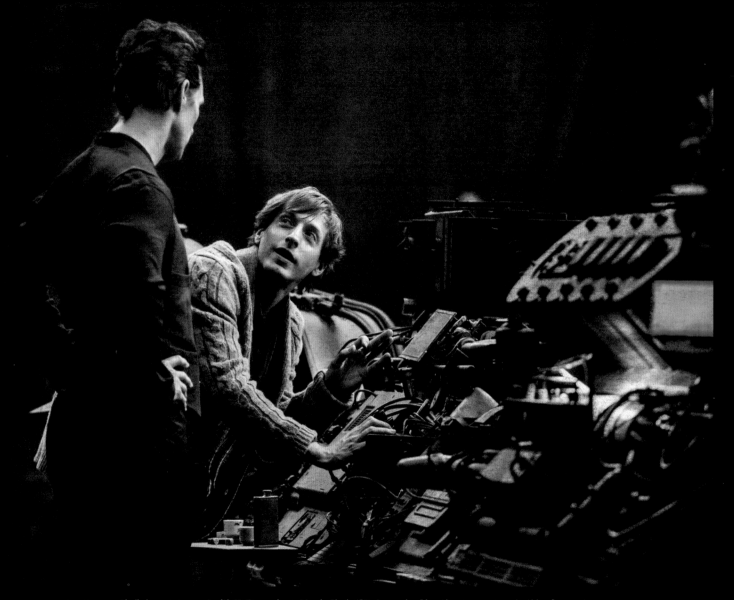

Fran Kranz as Pimli shares a moment with McConaughey's Man in Black. "[McConaughey] has the strongest work ethic of any actor I've ever worked with," says Kranz. "He doesn't waste any usable minutes in order to make the scene better."

By design, Walter's hair, makeup, and wardrobe were always understated. A near-omnipotent entity
like the Man in Black would have no need to advertise his power.

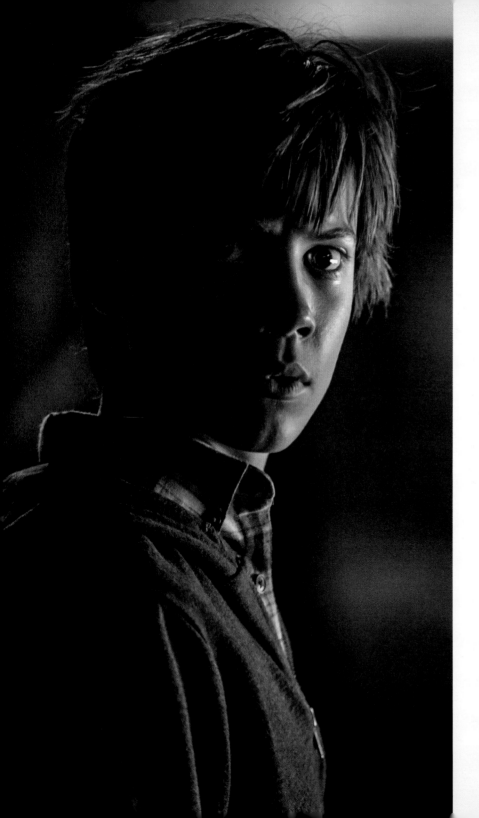

JAKE CHAMBERS

Jake is a young teenager living in New York, but fate has chosen him for a role he can't possibly understand. His psychic aptitude, or "shine," burns incredibly brightly.

Driven by nightmares he can't explain, Jake pursues the Gunslinger. Driven by the thought of nabbing an all-star psychic, the Man in Black pursues Jake. This disruption to what was once a binary relationship between the Man in Black and the Gunslinger roils the Mid-World status quo.

"He was an ordinary boy who was experiencing some strange stuff," explains Taylor, who plays Jake. "He was just an ordinary kid, and suddenly his world is flipped."

Arcel found working with Taylor to be his favorite part of the shoot. "This kid is an acting genius at the age of fourteen, and he doesn't even realize it," he says. "He's fun-loving and the sweetest soul you'll ever meet, but when the cameras roll he slips effortlessly into character. He's given me some of the strongest performances I've ever had in any of my films."

Roland eventually takes Jake under his wing, but not without reluctance and suspicion. "Roland thinks this is one of the Man in Black's tricks," says Elba. "In his mistrust, he doesn't quite believe him. The relationship is standoffish in the beginning, but ultimately Roland is not a dead soul." The actors' relationship helped convey this growing bond. "Tom and I really got on, and we utilized our chemistry on-screen."

Taylor as Jake Chambers.

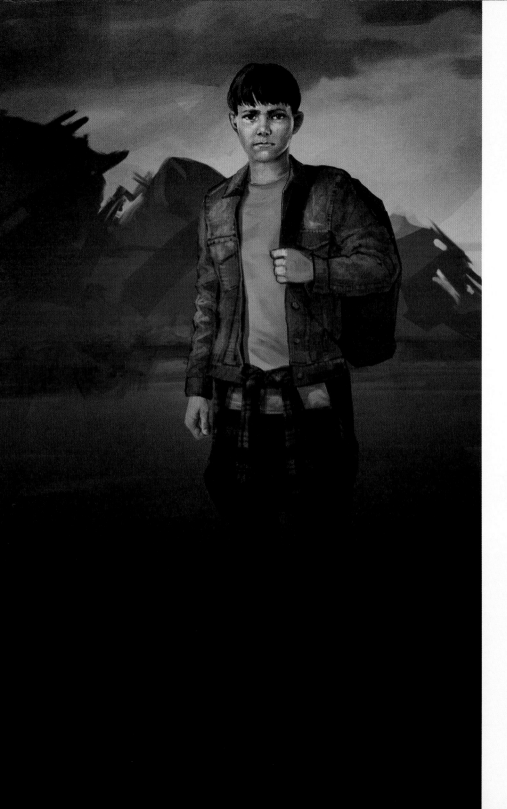

Hair and makeup supervisor Nadine Prigge sought to give Jake an aura of normality, shot through with streaks of psychological trauma. "I wanted it to feel that he didn't fit in, that he was a little on the outside of everything," she says. "The bad dreams, the visions, I wanted that to read on his face, and I used makeup to create that distressed look. But once he traveled into Mid-World and met the Gunslinger, it was a place that he understood. So, as his journey evolved, I gave him more color and opened everything up. I took the streaks away around his eyes and gave him a suntan."

For Summerville, Jake's attire needed to emphasize his innocence when contrasted with the harsh surroundings of an alien realm. "We tried to make him more vulnerable, because of the nightmares he's been having," she says. "I layered his clothes a bit, like a security blanket, so he didn't feel exposed to the world. I wanted their costumes to help show the difference between Roland's and Jake's worlds."

Mid-World is full of hardship and danger, but Taylor feels that it's a far more welcoming place for Jake than the city that raised him. "He was picked on, his parents don't believe him, and he's been waking up every morning to these nightmares and visions," he says. "He finally sees a place where the visions mean something. He's nervous, but he's excited too. He's finally come to a place where his visions can be answered."

With no time to prepare for his Mid-World ordeal, Jake is clad in everyday Earth clothing as if he had been suddenly waylaid on his way home from school, as seen in this conceptual study for Jake's costume.

P A R T I I I

The natural beauty of the South African wilds helped evoke the

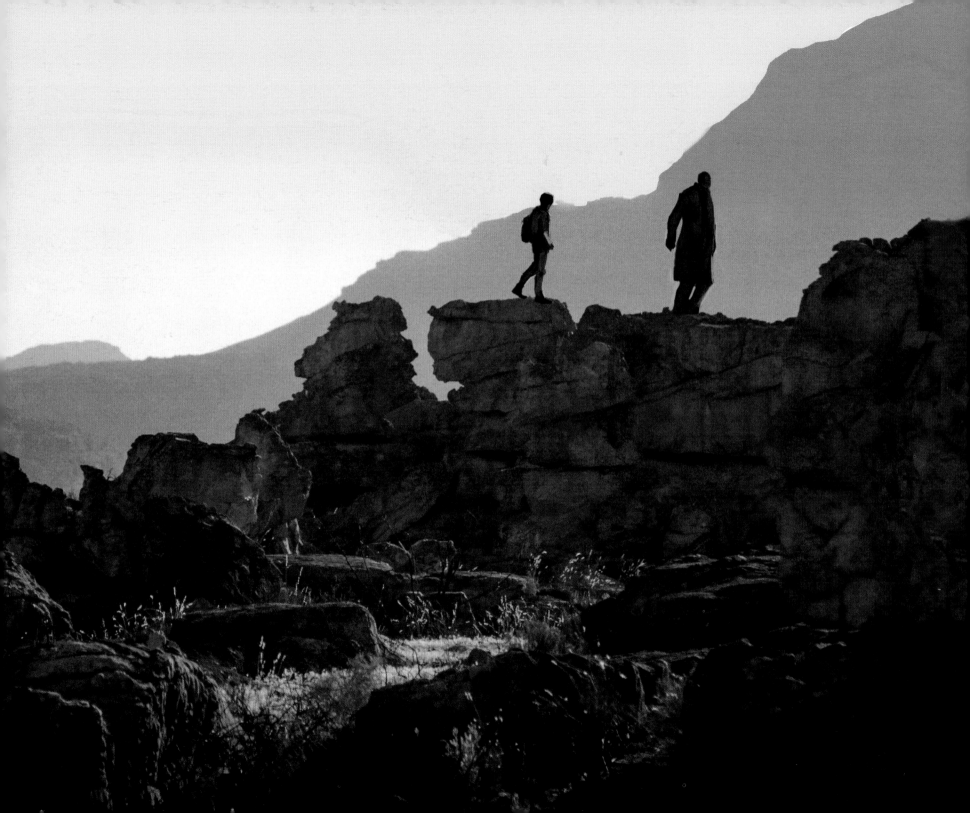

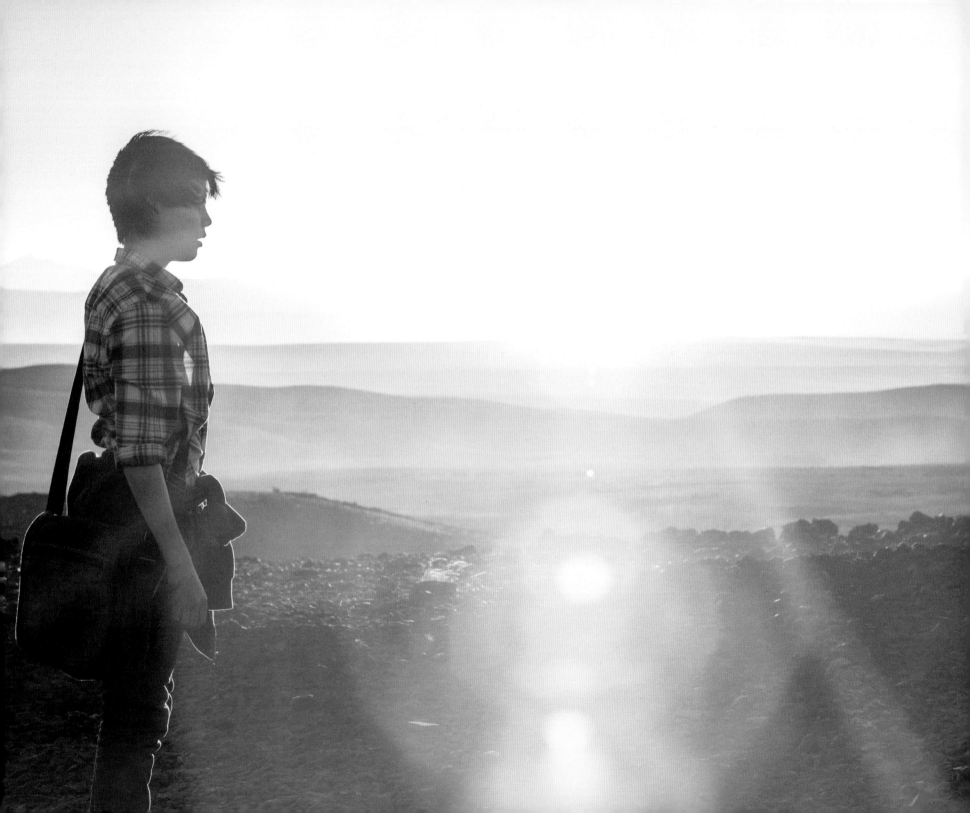

MID-WORLD

The Dark Tower is a stake that stabs through all realities and anchors them in place. Yet the Dark Tower exists on a tangible, physical plane of its own, though its geographic location is not easily fixed amid its world's uncharted continental wastes.

This place is Mid-World. It is a proud realm that houses the Dark Tower and the six beams radiating from the Tower's peak—each beam a buttress that braces order and rationality against the entropic forces of primordial chaos. But most people in Mid-World don't know anything about that. They pick out their hard existences amid the relics of the long-vanished Old Ones, whose harvesters, monorails, and dimensional portals have been rusting for centuries.

Some Mid-Worlders believe in the legend of the Gunslingers. They celebrate the heirs to Arthur Eld—the King Arthur of legend. Those heirs pledged their pistols to defend the Dark Tower against the cataclysmic might of the villainous Crimson King. Other Mid-Worlders are more cynical. Mid-World is a hard place, they say. While it may have once held wonders, those days are long past. In their judgment, *the world has moved on.*

For the filmmakers, Mid-World presented both a puzzle and an opportunity.

"What I love about Mid-World is precisely what is most dangerous about it," says screen-writer Akiva Goldsman. "In terms of genre, it is its own object. There's a hard sci-fi, postapocalyptic component; there's a magical fantasy component; and there's human drama. Once you're inside it, it expands to fit. But what you call it, I don't know."

Mid-World couldn't feel too alien or too alienating. And while many modern blockbusters choose to digitally custom-craft their settings from CGI building blocks, the filmmakers didn't want audiences to lose that sense of quiet recognition. Instead, real-world locations would serve as Mid-World's stand-ins.

"The whole journey through Mid-World was shot in South Africa," says director of photography Rasmus Videbæk. In the film, Jake arrives in Mid-World's Mohaine Desert and crosses a river and a forest before reaching a mountain village. "We had one unit that flew up to Kruger National Park in the north to shoot the river crossing. We shot the mountain and the forest far outside of Cape Town. We shot in the middle of the desert, five hours by car from the nearest farmhouse."

Executive producer G. Mac Brown adds, "We jumped right into South Africa and found it was a great place to work. We weren't following a blueprint. There really wasn't anything built like this before."

As the crew set up camp and took over a handful of Cape Town studios, the arriving cast members stepped into settings that sometimes shocked them with their stark beauty. "It was the farthest away I'd been from England," admits Tom Taylor. "You see this sort of scenery on TV, but it's nowhere near the same as going there. It's like you come out of your normal life or come out of your box, and you wake up beneath a mountain."

For Idris Elba, the environs felt like the perfect setting for the Dark Tower saga. "South Africa is such a beautiful part of the world," he says. "They call it 'God's Window.' And when Stephen King described Mid-World, Nik and his team brought it to life."

This was the true test facing director Nikolaj Arcel: whether he could, in a few months, at the southern tip of the African continent, bottle the essence of what made the Dark Tower a global phenomenon.

"It was the toughest shoot I've ever been on," says Arcel. "Telling such a sprawling, rich story in less than two hours is tough, not to mention building not just one but several worlds. Thankfully, South Africa was perfect for Mid-World.

"I have a feeling people will think we created much of it with CGI, but we didn't. It's basically all real."

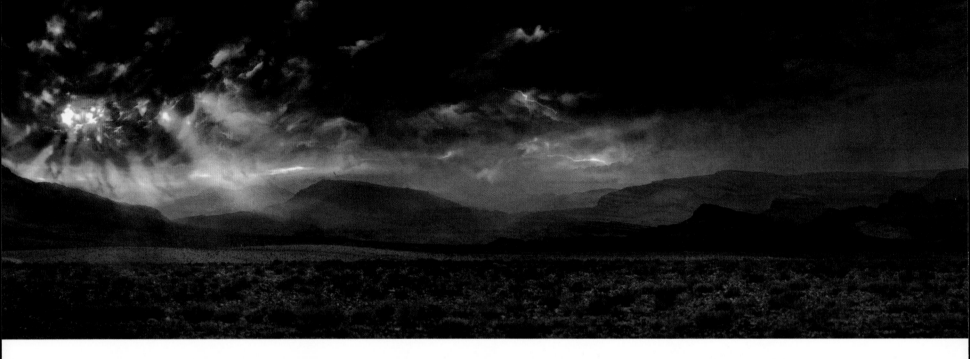

MOHAINE DESERT

𝓎

After Jake survives his brush with the demon in the Dutch Hill house, he finds himself atop the tableland emptiness that is the Mohaine Desert. The harsh, otherworldly environs are a startling contrast to the snug blocks of residential Brooklyn.

"It's perfect, because it looks like Earth but also as if he's landed on another planet," says production designer Christopher Glass. "There's both otherworldliness and familiarity."

Tankwa Karoo National Park, one of the driest areas in southern Africa, took on the role of Mid-World's wasteland. The Karoo region receives fewer than ten centimeters of rainfall each year, and humans long ago declared it unfit for habitation.

"We couldn't find anything we liked close to Cape Town, so we just kept driving," says Brown. "The scout who was taking us finally said, 'We're really too far out—we can't even get gas now!' But when we got out there, it was different from anything we'd seen before. It was different from anywhere else in the world."

Hundreds of tents popped up, forming a makeshift mini-city to house the production crew. The sweltering shoot lasted several days.

"We had Jake [Taylor] in a massive dust storm," says special effects supervisor Max Poolman. "We bombarded the poor kid with a huge amount of dust and wind. We really blew him to pieces."

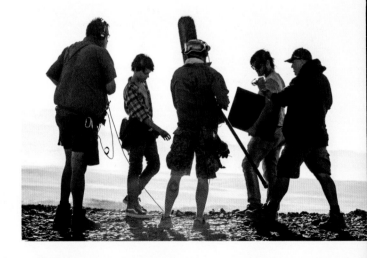

 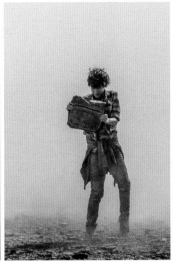 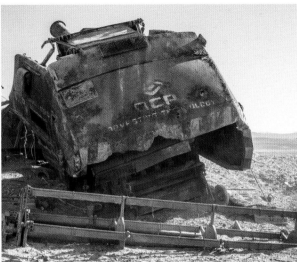

For Taylor, the sudden shift in environment proved to be a genuine shock. "When I got the job, I thought we'd be in Cape Town in a studio, acting in front of a green screen," he says. "The week we got there, they said, 'You're going to the Karoo and it's going to be a sandstorm.' I got sand in my eyes; I couldn't see what was going on. It was a crazy experience."

It isn't long before Jake finds evidence of civilization, though it's not exactly what he—or the audience—expects. "The first thing we see is the harvester," says Glass, referring to the sunburnt shell of a robotic combine half-buried beneath a scree of grit and pebbles. "We took a real harvester and augmented it with robot arms, and changed shapes to alter its visual language."

The lonely harvester provides an early example of one of Glass's design principles for Mid-World: Technology must be futuristic, yet at the same time look impossibly ancient. "Imagine tech

three hundred years in the future," he says, "but the tech itself is actually two hundred years old. It's all history and relics."

Brown followed the same mantra when sourcing the parts needed to build the harvester and other positronic antiques. "Mid-World mechanicals were clearly things we couldn't buy," he says. "And if it doesn't exist on this Earth, it has to be built. We rebuilt them, restructured them, and aged them. It was a lot of found objects, which took a lot of work, but it was cheaper than building and designing from scratch."

Tankwa Karoo possesses a natural alien beauty and required very little embellishment. Visual effects are used sparingly—for the twisting dust devils on the horizon and the double moon that fills the night sky. "We touched up some shots to add an otherworldly quality," says visual effects producer Cari Thomas. "Just to remind us we're not on Earth anymore."

Opposite, top: Storm clouds gather over the desolate expanse of the Mohaine Desert in this concept piece.

Opposite, bottom: In Tankwa Karoo, Taylor preps for one of the first scenes of his shooting schedule.

Top left: Taylor vanishes among the dust whirls whipped up by the crew.

Top center: Displaced in space and time, a confused Jake tries to get his bearings.

Top right: The sun-baked skeleton of a robotic harvester bears the logo of North Central Positronics—a subtle tie-in to the larger world of the Dark Tower series.

BONES OF THEIR ANCESTORS

The presence of dying and decaying relics like the robotic harvester is proof that Mid-World is a place that has "moved on," as the Gunslinger puts it. Of the original builders, there is no trace. Though what happened to them is unknown, they may have brought about their own downfall by promoting technology as a replacement for mysticism. Glass describes it as "old, dead tech." Explaining that the crew walked a tightrope between making things recognizable and ensuring they weren't too Earth-like, Brown remarks, "You can look at ten artifacts and five of them would be obvious, so that's too clear. But with the other five, you'd think, 'Well, it could be from this, or it could be from that.'"

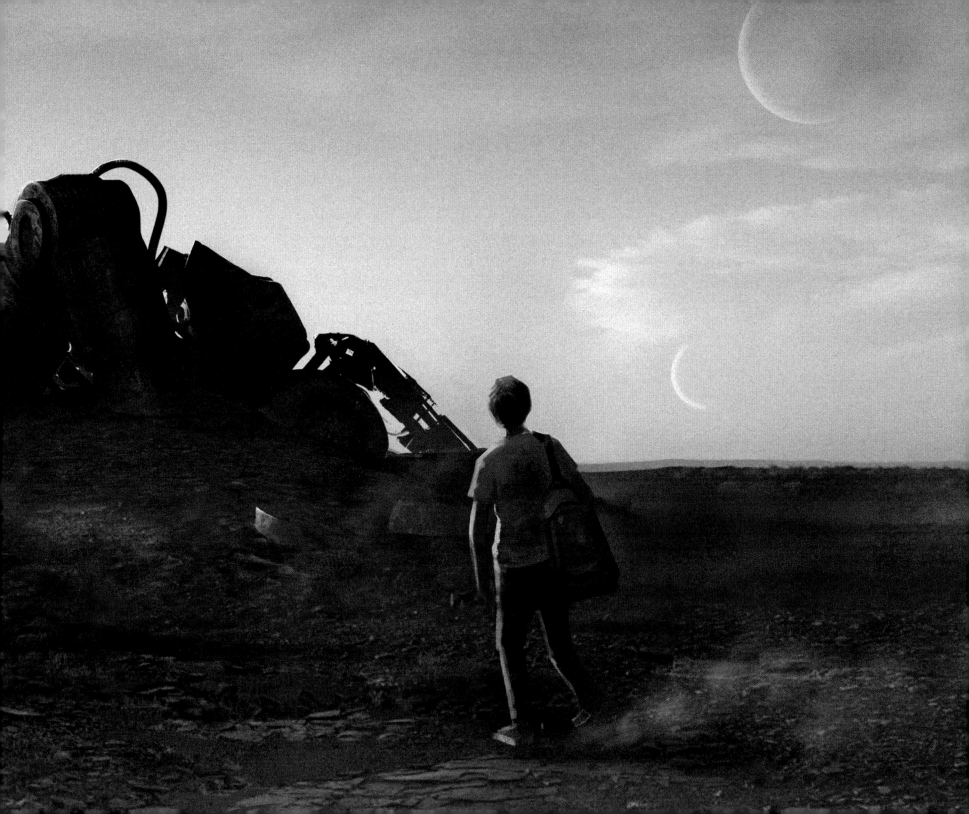

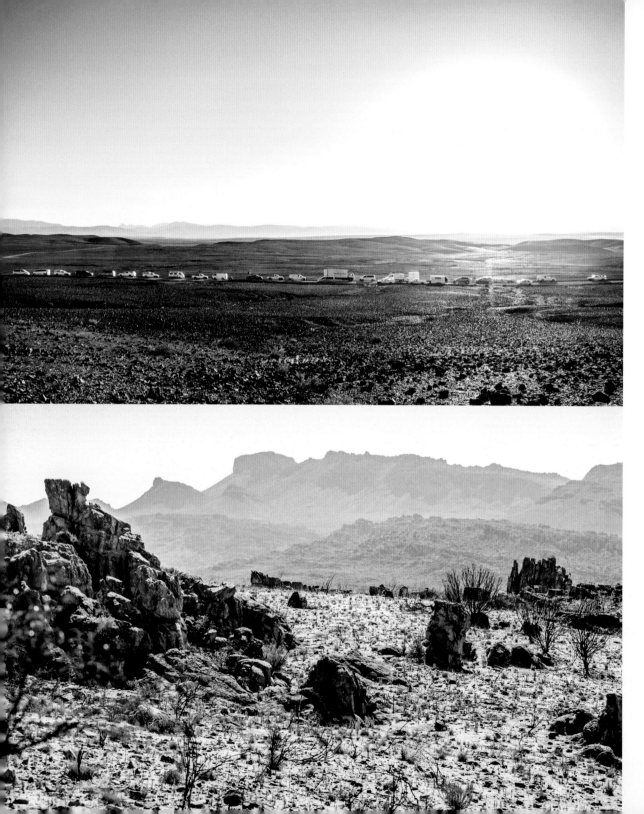

Top: A caravan of support vehicles ferried the crew into the heart of Tankwa Karoo, hours from any sign of civilization, to film the Mohaine Desert sequences.

Bottom: The desert's flat tableland broke into rocky scrabble and sparse but tenacious plant life wherever the geography swelled and jutted. The diverse terrain and high-elevation angles offered many options for shooting.

Opposite: The crew navigates some rocky terrain. The jarring shift from New York City to Mid-World needed to feel dramatic, and Tankwa Karoo sold the contrast through its barrenness and quietude.

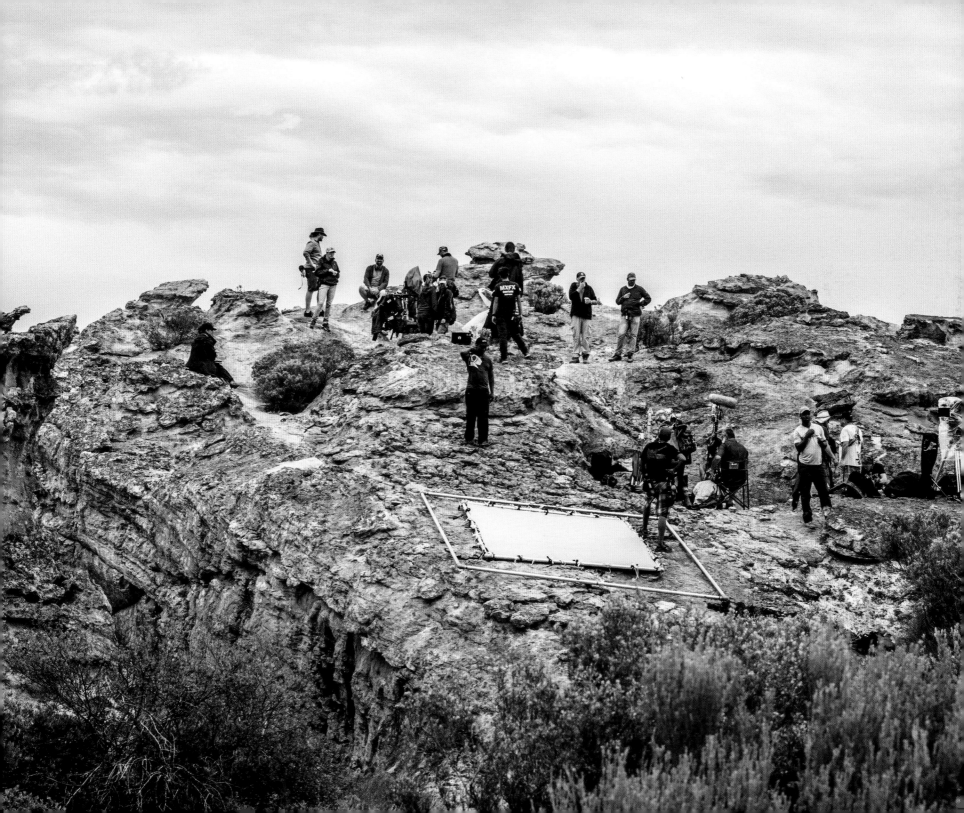

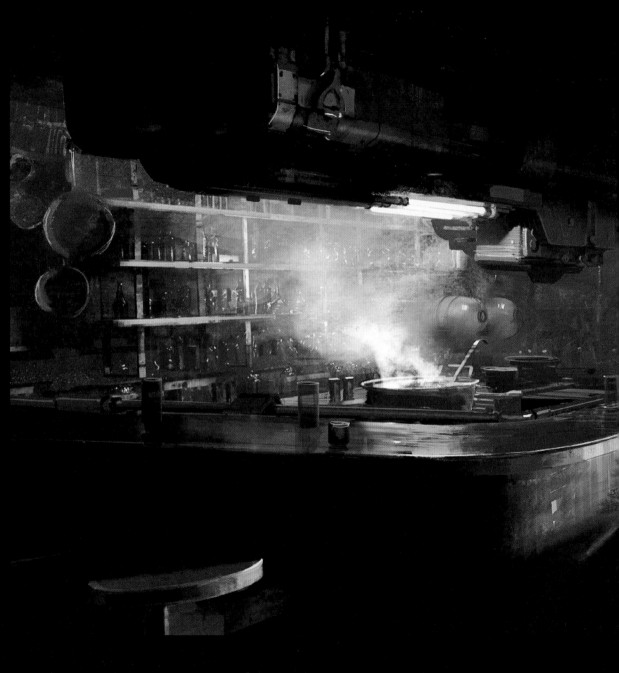

WELCOME, TRAVELERS

In a scene that didn't make the final cut, a diner serves as Jake's first confirmation that he's not alone in Mid-World. The utilitarian oasis offered up a design challenge for Glass, who wanted its aesthetic to carry some degree of subliminal familiarity. "Do you do a literal '50s diner that now looks broken-down?" he says. "We opted for something that looked more like a Mid-World version instead. It might be a temporary structure, something that was prefab, and it's been there for who knows how long."

Another major design challenge was the furniture. "We manufactured the tables and chairs from scratch," says Glass, "and we based them on prison furniture. Things like chairs can be difficult to design. There's an uncanny valley where either you've seen it in real life or it's too over the top."

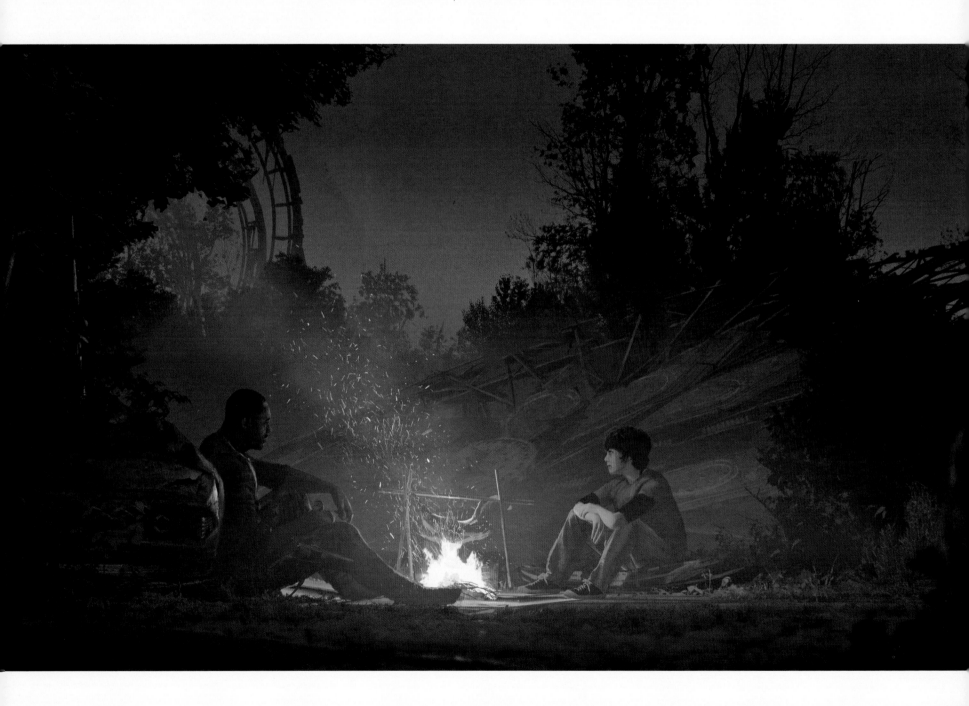

ABANDONED THEME PARK

ᛉ

The Mohaine Desert terminates in rocky scrub at the base of a mountain range. It is here that Jake catches up with Roland the Gunslinger. It isn't long before the palette of the landscape shifts from burnt brown to a lush, deep green.

It's an indicator of vitality in what was a previously lifeless realm, yet the forest houses plenty of ghosts. Roland and Jake make camp beneath the rusted bones of an amusement park—a relic from another time.

"The past had *some* good times, before the world turned," says Glass, but he notes that the decaying thrill rides now seem like warnings. "It's ominous, a sign of something bad. It reminds me of Chernobyl. It shows that there was a disaster."

Videbæk used the spare illumination of the nighttime forest to paint a vignette with light and shadow. When Elba saw the footage, he felt his jaw drop. "Rasmus made it look like a moving graphic novel," he says. "It looked incredible. It looked like someone had drawn it."

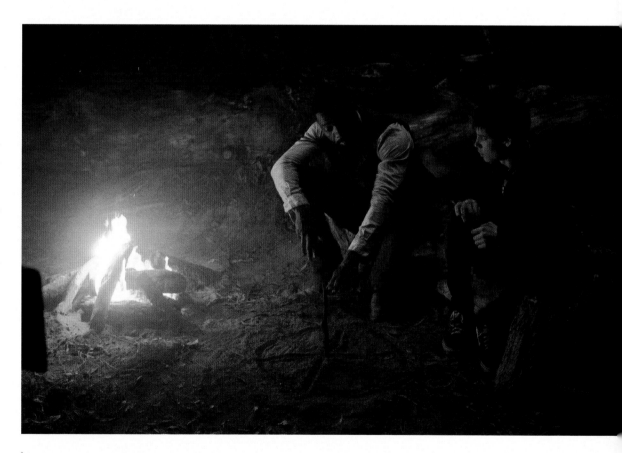

As the darkness grows deeper, the Gunslinger and Jake try to build an emotional connection around a campfire's glow. The faces of Roland and Jake are illuminated by the orange flames in this shot (above), which came to life as a near-perfect match to the original concept art (opposite).

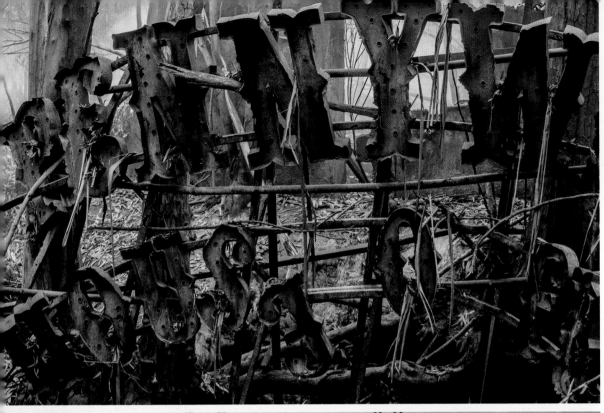

SILENCE ON THE MIDWAY

Top: Rusted letters have lost their color and now sit decaying in the fairgrounds. It is a marquee filled with a sense of foreboding.

Bottom: Taylor's Jake Chambers pushes his way through the centuries-old ruins. The fight against the crimson creature that takes place in this space required a physical performance from Taylor and his stunt double.

Opposite: Swings dangle from their perches high overhead, resembling vines—or nooses.

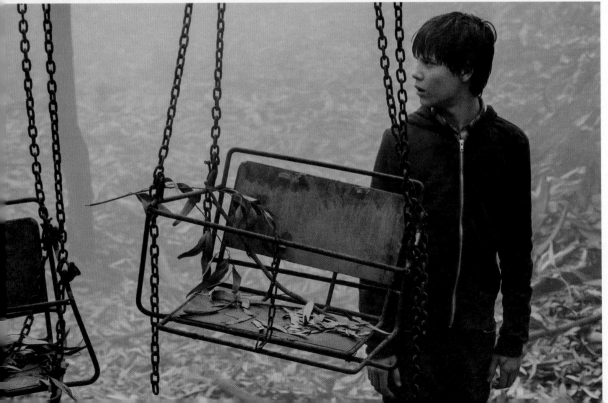

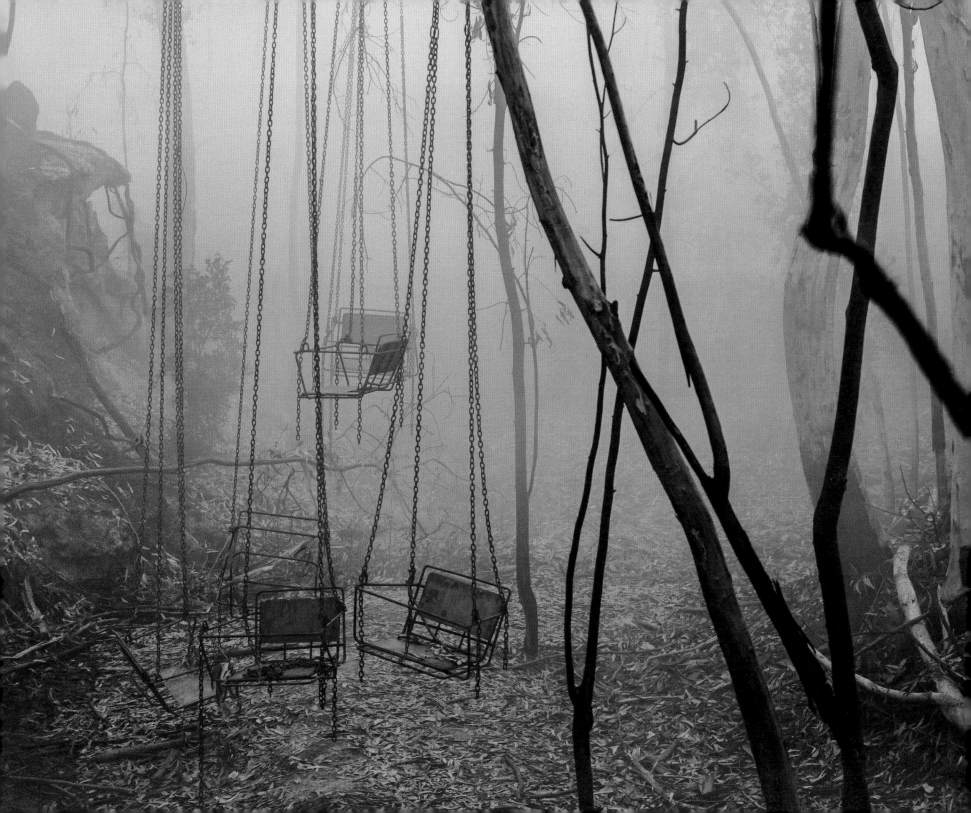

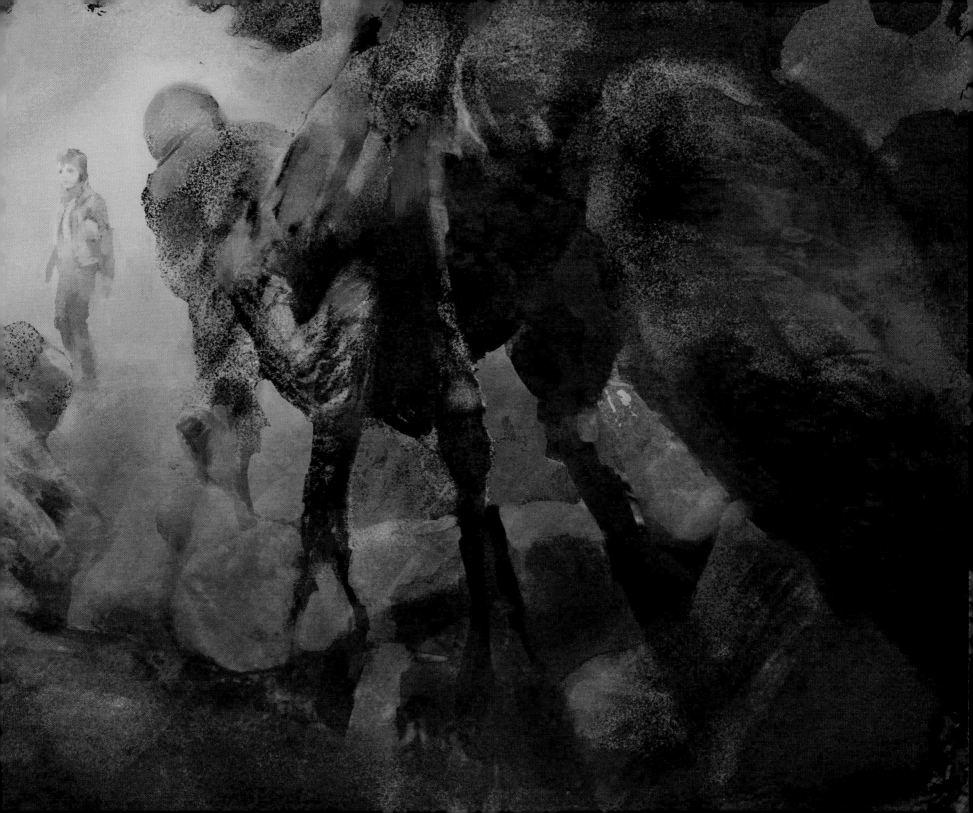

MAGIC MIRROR

The swirling eddies seen in this concept
art (right and previous spread) herald
the emergence of the "thinny" that Jake
discovers near the abandoned amusement
park. The thinny links Mid-World with the
unimaginable terrors unleashed by the
Crimson King. Visual effects supervisor
Nicolas Aithadi called the thinny one of his
most difficult design challenges, due to
the lack of any conceptual analogue in the
real world.

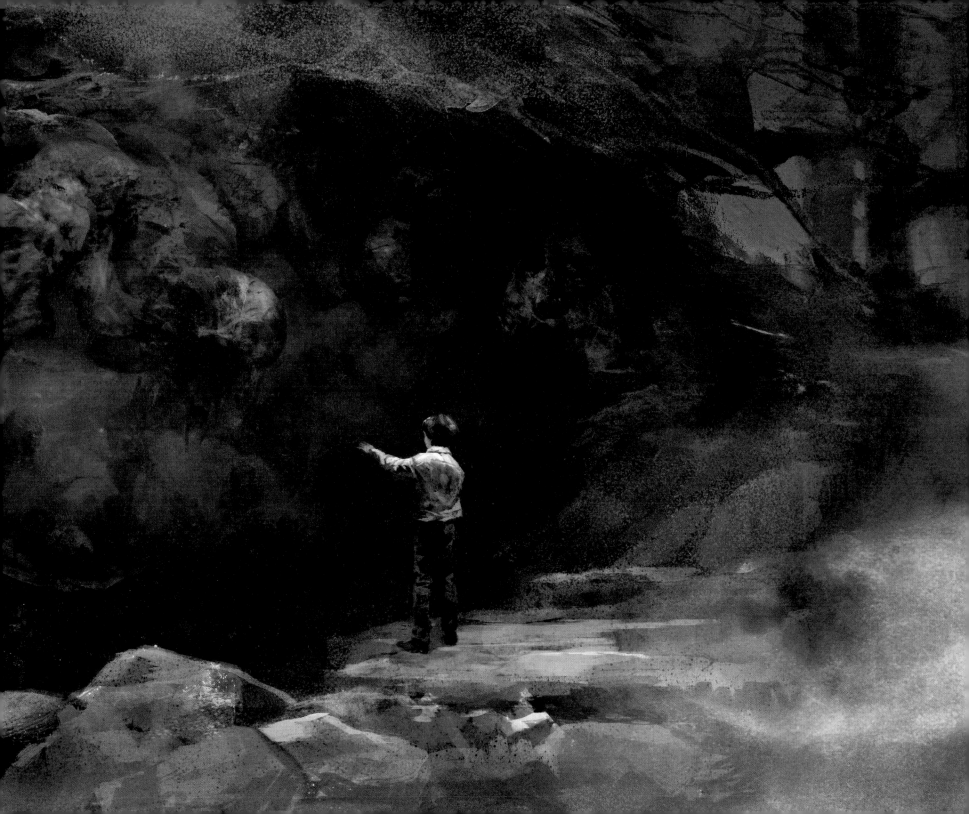

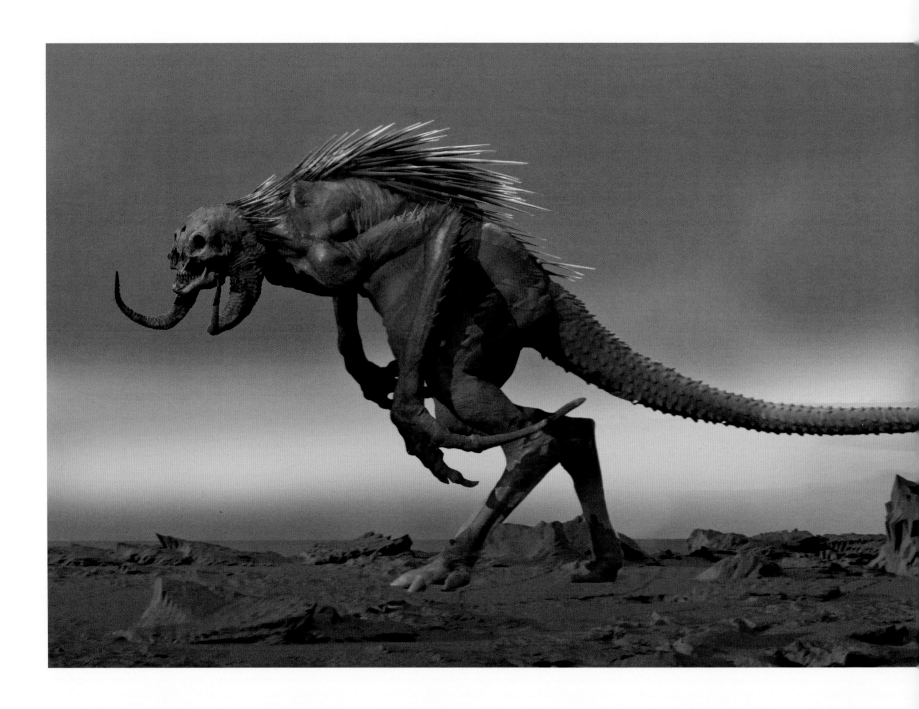

THE CRIMSON CREATURE

They've been wrung out from long days of travel, but Roland and Jake don't get a chance to relax at their forest encampment. Demons from another dimension attempt to spill into Mid-World through a paper-thin stretch of space-time—a phenomenon known as a "thinny."

Most of the monsters don't make it; the Gunslinger plugs them full of lead after they disturbingly take the forms of Jake's late father and of Steven Deschain. But one spawn of pandemonium slips through the thinny undetected: the "crimson creature."

"The design of the creature started back in preproduction with the first sketch," says Aithadi. "We wanted to create something that you wouldn't look at and say, 'Oh, that reminds me of that other creature.' Something creepy and ugly, but intelligent. It was important that it wasn't just a monster. It had a brain and a purpose."

The crimson creature's weird anatomy meant that it was always conceived as a fully digital effect. During filming, the actors who needed to interact with the creature relied on a colorfully suited stand-in.

"It looked a bit funny, but one of the things we used was a stuntman dressed in blue and wearing a cyclist helmet," says Aithadi. "He had a pole on the helmet and a tennis ball on top of the pole. Because the finished creature would be about seven to eight feet tall, we wanted to make sure that Idris's eyeline was accurate."

The crimson creature lurches across a blasted moonscape in this rendering.

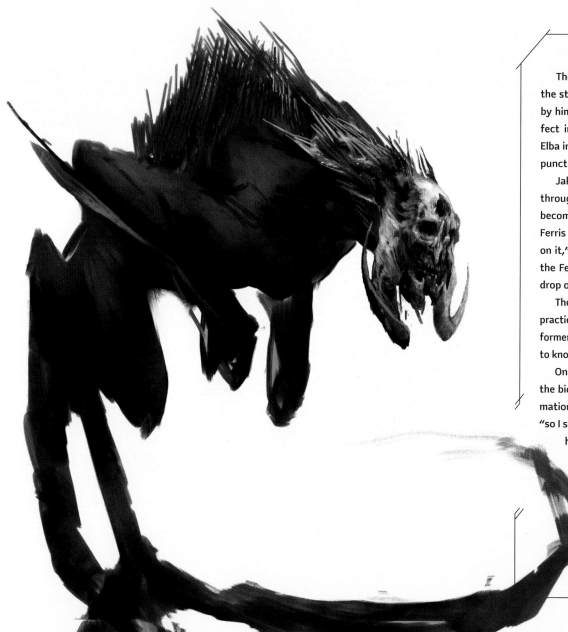

The crew filmed two versions of each shot, one that included the stuntman and one in which Elba repeated the same actions by himself. The two shots could then be patched into one perfect image. Additionally, the crew hung wire rigs to suspend Elba in the air and simulate the violence of the creature's body-puncturing attacks.

Jake doesn't fight the creature, instead leading his pursuer through the guts of the abandoned amusement park, which becomes a three-dimensional obstacle course. "We rigged the Ferris wheel to make it move every time the creature would jump on it," says Poolman. "When Jake jumped into the carriages of the Ferris wheel, we had to get it moving and get the door to drop out of it."

The whole effort required close coordination between the practical effects team, the visual effects team, and the stunt performers. "It was a huge tie-in between us," says Poolman. "We had to know what had to happen and exactly when it had to happen."

Once shooting wrapped, the VFX team set to work finalizing the biology of the crimson creature and the nuances of its animation. "Its anatomy kind of looked like a bat," says Aithadi, "so I started thinking about what kind of weird dynamic it could have for its movement."

Ultimately, Aithadi found a video of a vampire bat crawling across the ground on its injured wings. "It was extremely creepy," he says. "And it felt completely adequate as inspiration for our creature. We imagined that same movement, of the bat, but with the weight and power of a bear behind it."

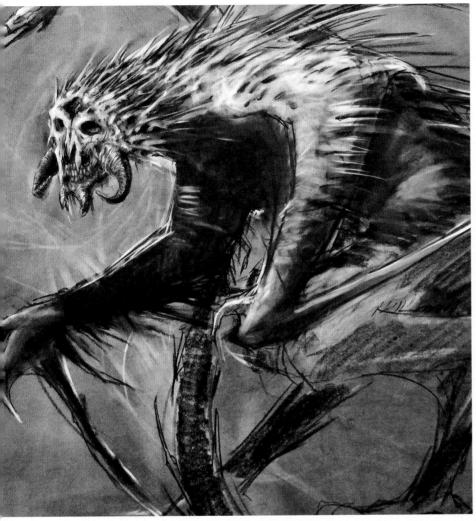

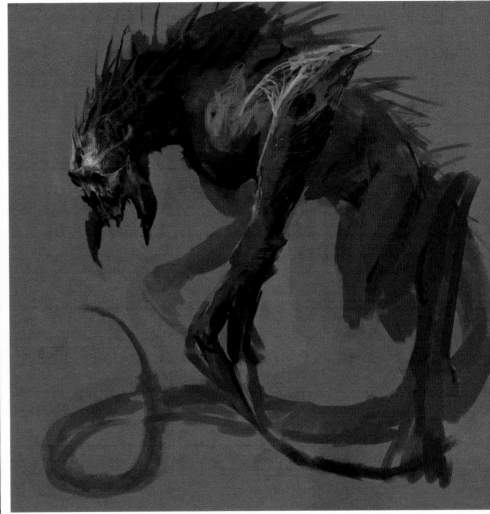

Top left: An earlier, spikier version of the crimson creature. "You have these spines on its back, like a sea urchin or some other underwater, quilled animal," says Glass.

Top right: A darker, more impressionistic take on the crimson creature. Says Glass, "It's an abomination—and a hint of the things to come if the Crimson King wins."

Opposite: "We wanted it to look demonic, but without looking like a devil," says Glass. "There's some thinking going on inside this creature's head, hence the humanoid skull, which is attached to a bat-like body."

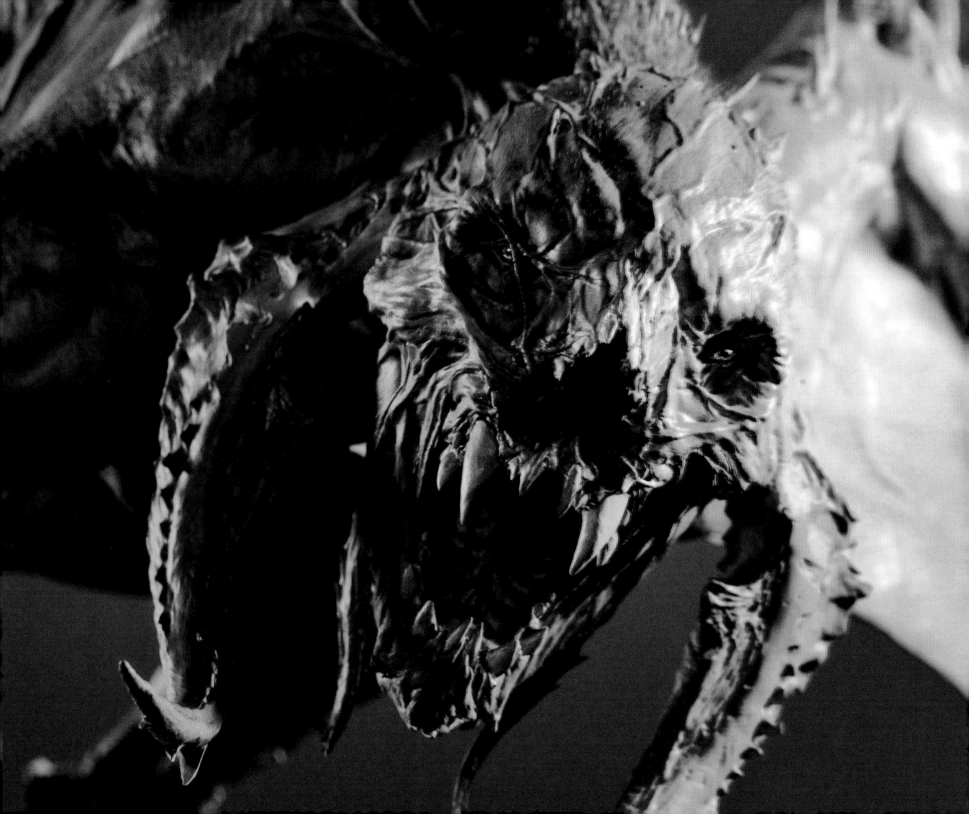

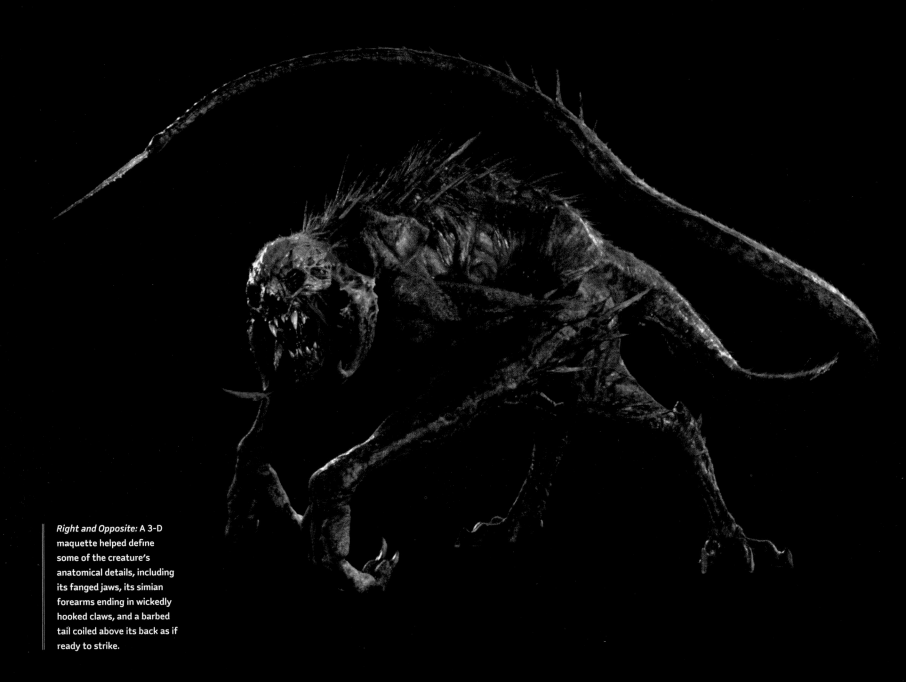

Right and Opposite: A 3-D maquette helped define some of the creature's anatomical details, including its fanged jaws, its simian forearms ending in wickedly hooked claws, and a barbed tail coiled above its back as if ready to strike.

HOMESTEADERS

Below: The look of the Manni village was a grab bag of mismatched materials, with ramshackle buildings sprouting up in the shadow of ancient constructions.

Opposite: A concept illustration of the Manni village. The settlement was designed to reflect the opportunistic, "found-object" lifestyle pursued by those who lived there.

MANNI VILLAGE

Roland has abandoned his quest for the Dark Tower at the start of the film, but there are some in Mid-World who never lost faith. The Manni are true believers who venerate the Dark Tower and the beams of reality that rest upon it. "The Manni village is nestled in a valley next to an abandoned portal hub," says Glass. "The hub is almost like the Mid-World version of Grand Central or Victoria Station, but more brutalist."

The village, by contrast, is a hodgepodge assemblage of found objects. "We imagined that the Manni have scavenged their materials," says Glass. "They've culled stuff from the natural environment using the parts that they can find. It's not a shantytown. They're a positive people, and they're making do with what they can. I wanted them to have dignity."

Location shooting for the Manni village took place in Rawsonville in the Western Cape, near the eastern mountain swells of the Du Toitskloof Pass. "It was magical," says Claudia Kim, who plays Arra, a respected Manni seer. "Every day I saw rainbows. There was something very spiritual about that space."

Kim's character is gifted with mind-reading powers, allowing her to sense Jake's psychic potential and the neglected heroism sleeping in Roland's soul. "Her strengths are purity and hope. The Manni are survivors who don't have anything, but the one thing they hold on to is the hope that there will be a savior who will save their world. She calls out the light within people," says Kim.

Costume designer Trish Summerville veered from the books—in which the Manni exhibited a Quaker-inspired severity—and clad the villagers in warm colors and eclectic fabrics. "My first questions were: 'Do they work the land? Do they have animals, and if so what type do they tend to? Do they have access to water?' So I could gauge how dirty they were."

"They're very self-sufficient," she continues. "Most of them have fifteen to thirty different fabrics, so that their clothes are all made out of these fabrics. One man's shirt could be from someone else's shirt or skirt. The older people have accessories, such as belts and jewelry, that have been handed down. Some things, like aprons and hats, are made out of woven plastic bags that they recycle."

Hair and makeup supervisor Nadine Prigge sought to give the villagers an aura of enlightenment. "Obviously they toiled the earth, but they had a softer, happier look," she says. "It was a strong contrast from the Mid-World desert. For Arra, the village seer, I tried to bring as much glow to her as possible. She was a lovely character. Beautiful, natural, and real."

That beauty is shattered when a cadre of trackers arrives in the dead of night, unleashing mayhem on the orders of the Man in Black. Poolman had the grim duty of sending the Manni

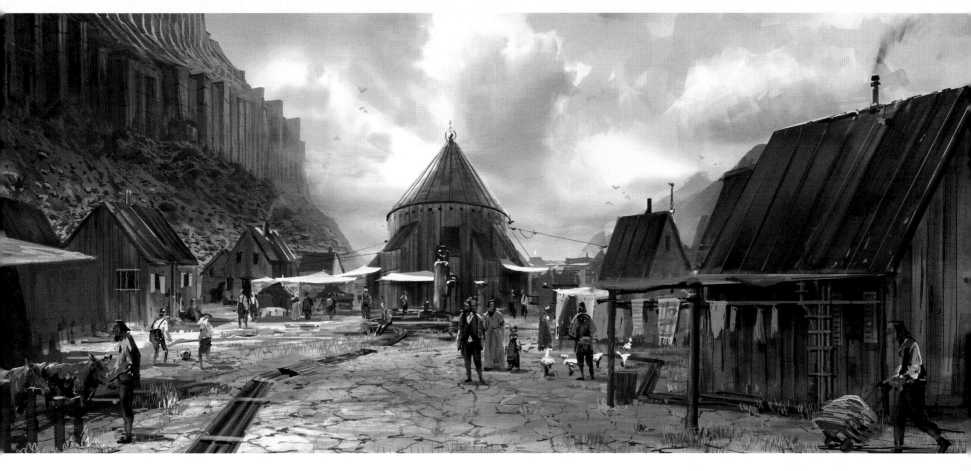

village up in flames. "When we started, the idea was that the fires in the Manni village would be heavily treated with digital effects," he says, "We thought that the practical effects weren't as big of a deal and that our involvement wouldn't be that big."

Instead, Poolman's department found itself shouldering nearly the entirety of the pyrotechnics during a nighttime shoot that lasted two weeks. "It took us five weeks just to prep the site by laying underground piping for LP [liquefied petroleum] gas," he says. "When it came time to shoot, we were using a half-ton to a ton of LP every night. We were lighting the whole scene just with fire."

The Manni village set wasn't built to handle such a high degree of heat. "It was mainly built out of timber, which was never built to deal with practical fire effects," says Poolman. "The main buildings in the village, including seven to eight main fire houses and the church, which was a massive structure—they all burned. It was like a military operation to put out all these fires."

Kim confirms that at one point her costume caught on fire, though none of the on-set personnel were ever in danger. "There were two firemen in every single structure with hoses wetting things down," says Poolman, "sometimes while we were still shooting. The church alone had twenty-six different fire points. It was a lot of heat and a lot of flame, and it was all very tricky."

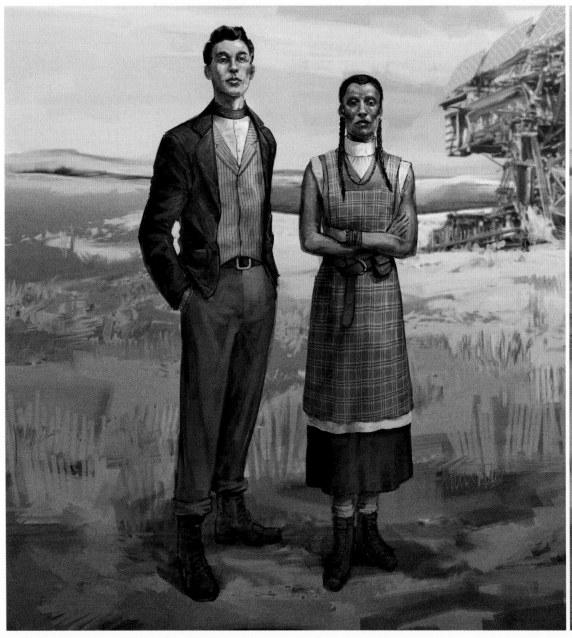

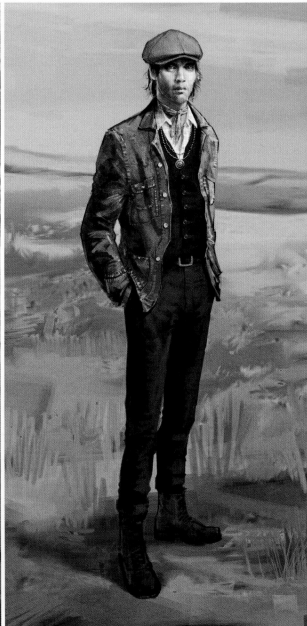

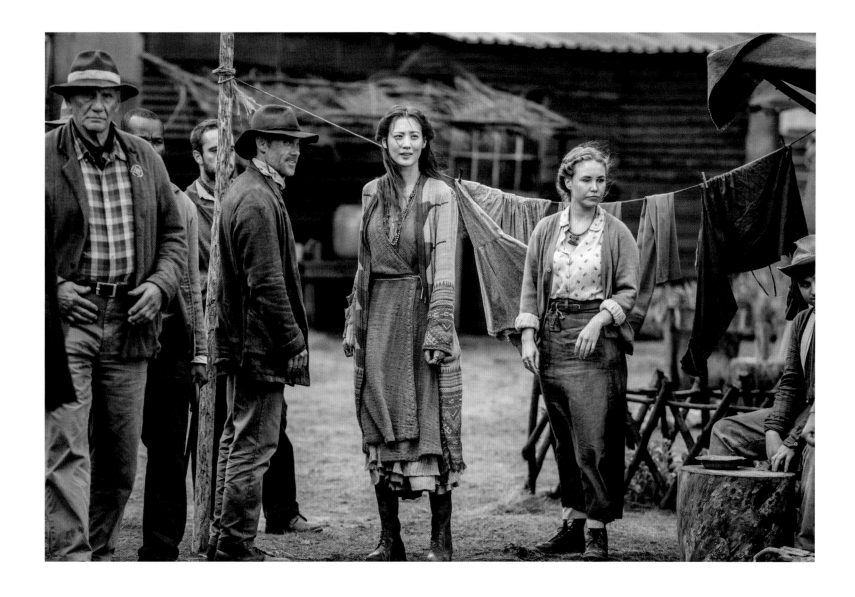

In both the concept art (opposite) and the final costuming, the Manni villagers, including Kim's Arra (above, center), wore a mix of styles and fabrics with hints of Native American and early 20th-century urban styles.

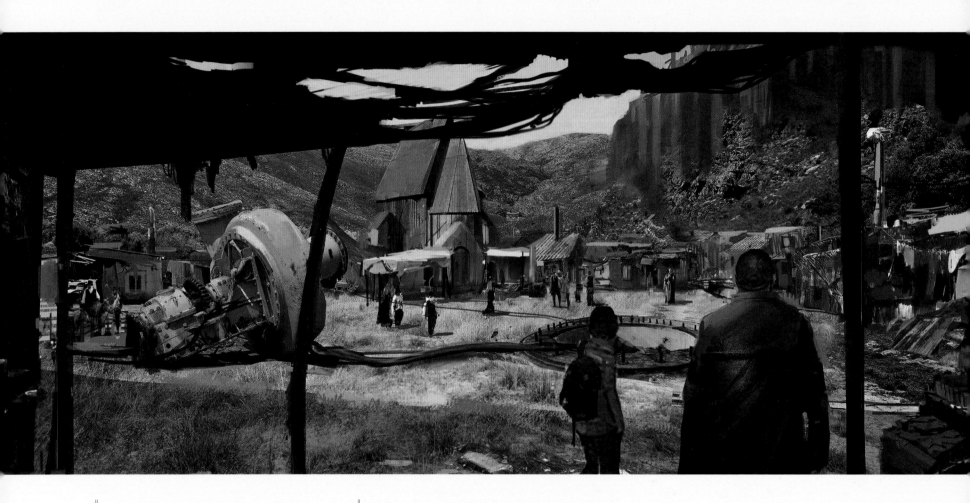

Roland and Jake arrive at the Manni village in this early rendering. Carefully maintained wooden shacks share space alongside ancient mechanical hulks.

Opposite: The Gunslinger strides the streets of the village. To the Manni, Roland is a figure worthy of respect due to his heritage as a fabled—if flawed—protector of the Dark Tower.

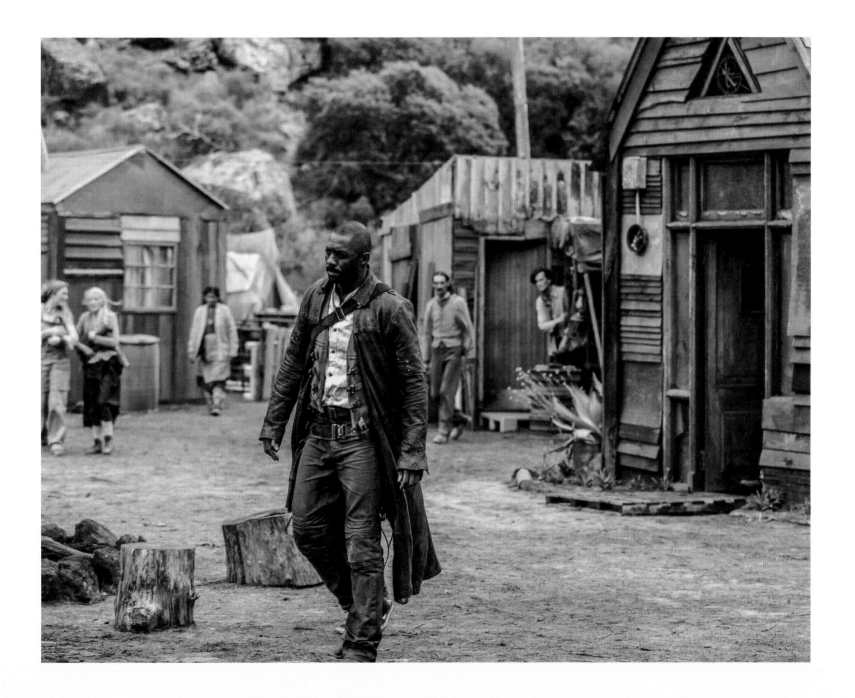

IN THE MOUNTAIN'S SHADOW

The Manni village is a refuge from the hardships of Mid-World. It's a place where belief and the bonds of community have improved the lives of the select few who dwell there. Its surroundings emphasize that charmed status, with deep greenery and high valley walls protecting the village from famine and catastrophe. "There's a colonial feel to the Manni," says Kim. "They are able to adapt, and are a combination of many different cultures and times."

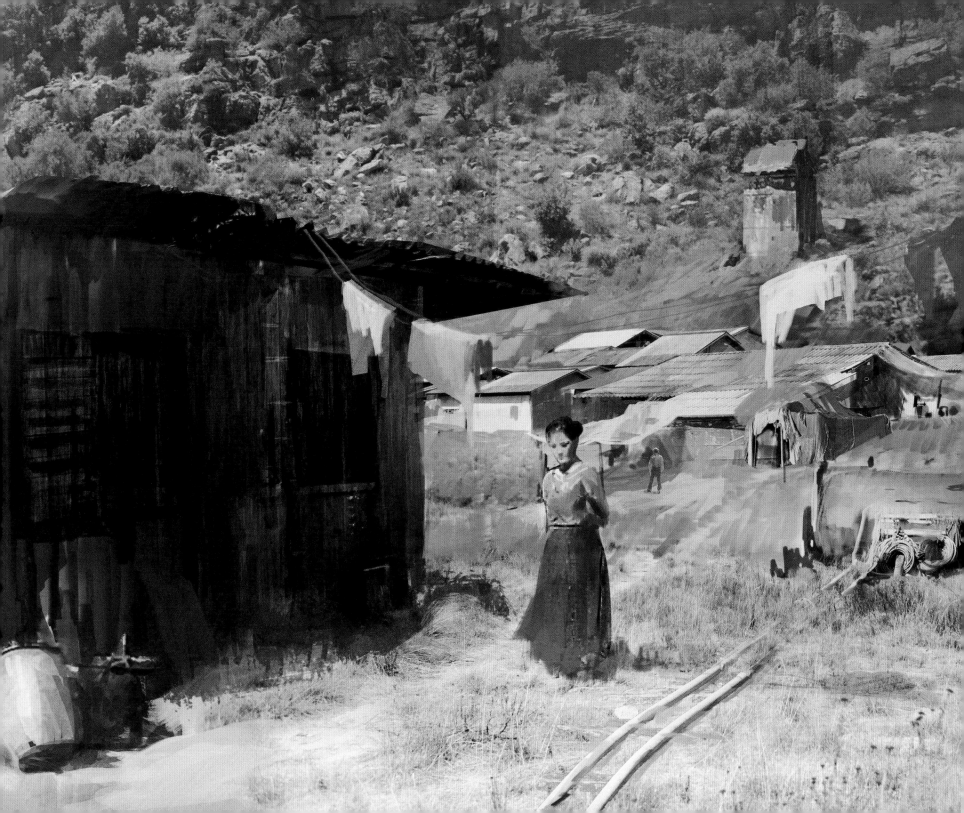

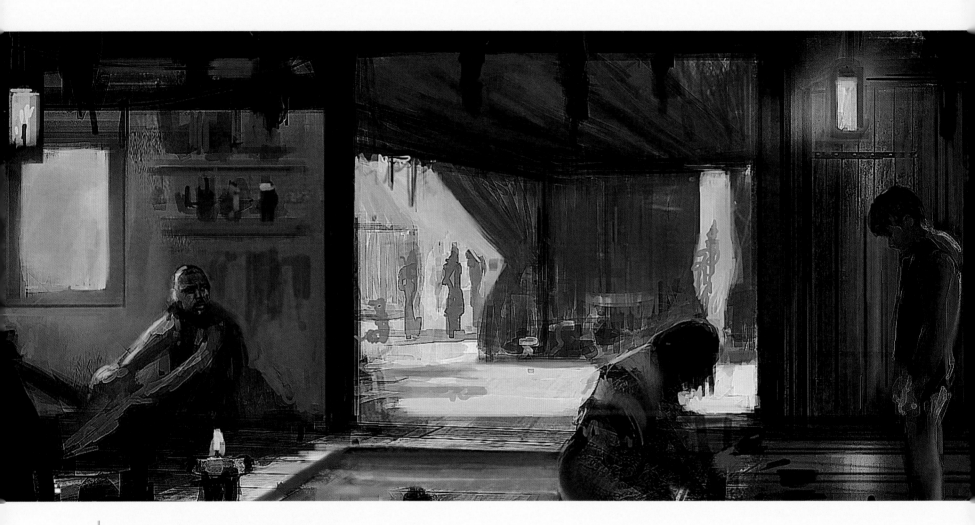

Some village interiors resemble improvised slum construc-
tions, relying on wooden planks to keep moisture at bay
and using tarps and curtains to lessen the sun's heat.

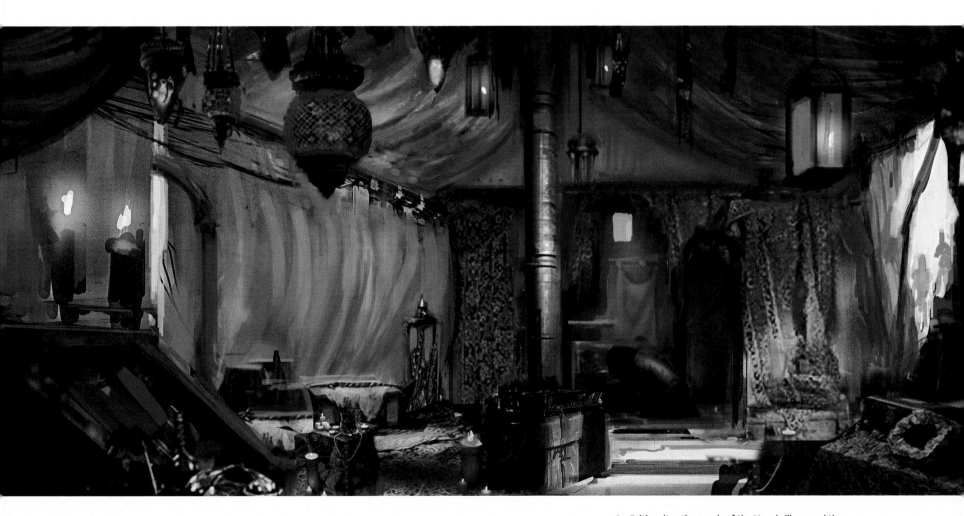

Faith unites the people of the Manni village, and they practice benign spirituality over militant dogmatism. Candles, lanterns, and intricately patterned fabrics are subtle signs of Manni religiosity.

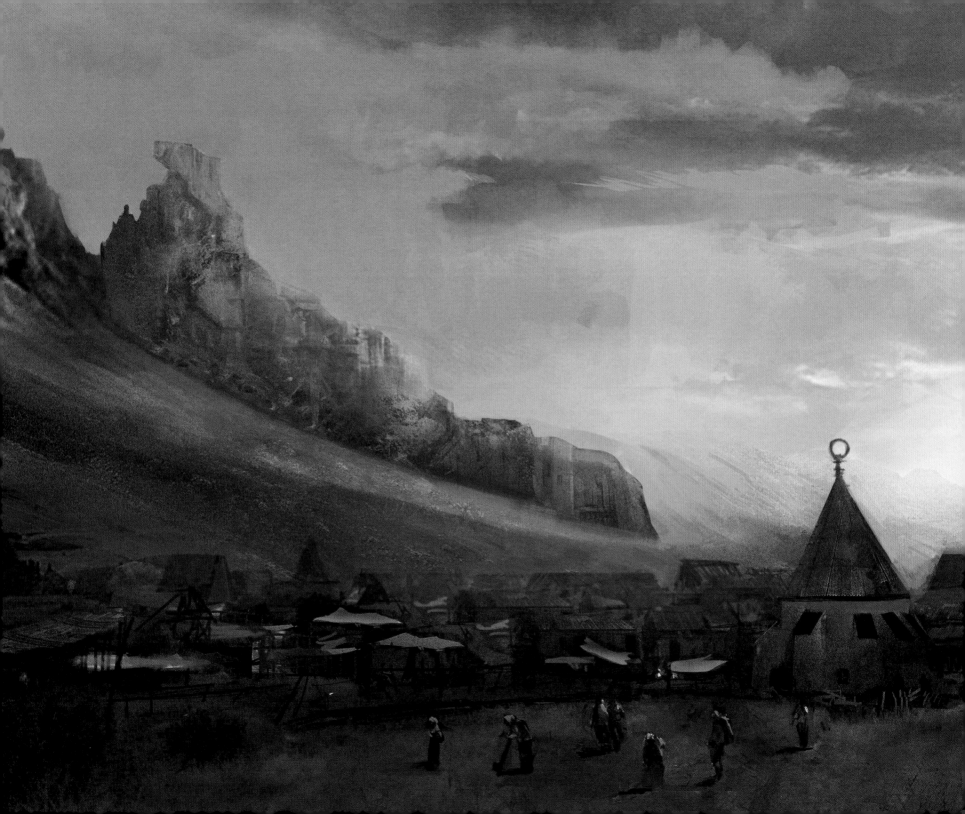

WAITING FOR THE SUN

The Manni village takes advantage of its valley's natural architecture, which provides a spectacular view toward the horizon while remaining sheltered from interlopers who would bring violence and pain. The tall structure in this concept illustration was envisioned as the central church of the faith. To the right are the ruins that house a still-functioning dimensional portal.

DEATH BY FIRE

It is apparent that the Manni have lived in relative safety for some time, but the arrival of Jake and Roland is a harbinger of sudden doom. The Man in Black sends his trackers in pursuit of his old foe, and the ensuing pyrokinetic assault is captured in this concept illustration. The use of real flames and the requirement of filming only in the dead of night presented logistical challenges for a crew that didn't want to rely on postproduction visual effects to achieve the right look.

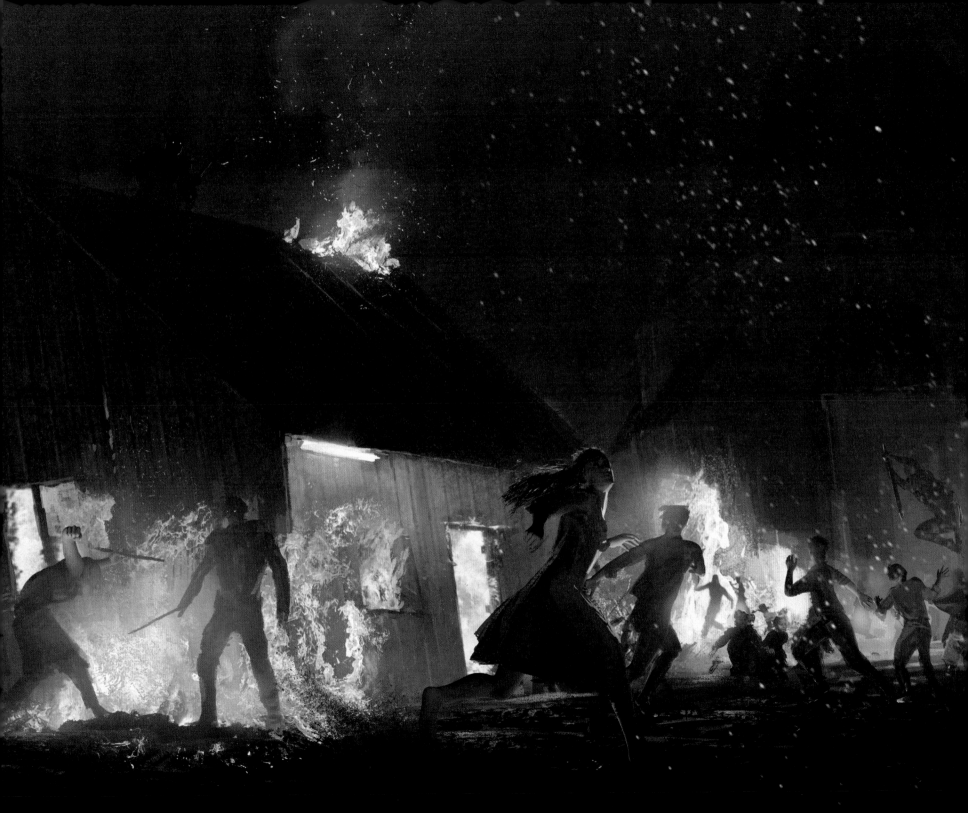

CONFLAGRATION

The trackers that raid the Manni village are Taheen, animal-headed humanoids with quick reflexes and sharp senses. Some Taheen performers wore prosthetics to complete their bestial looks, while others obscured themselves beneath wrappings and rags. Underground gas lines below the village could be activated at will, turning the mostly wooden set into a carefully controlled inferno.

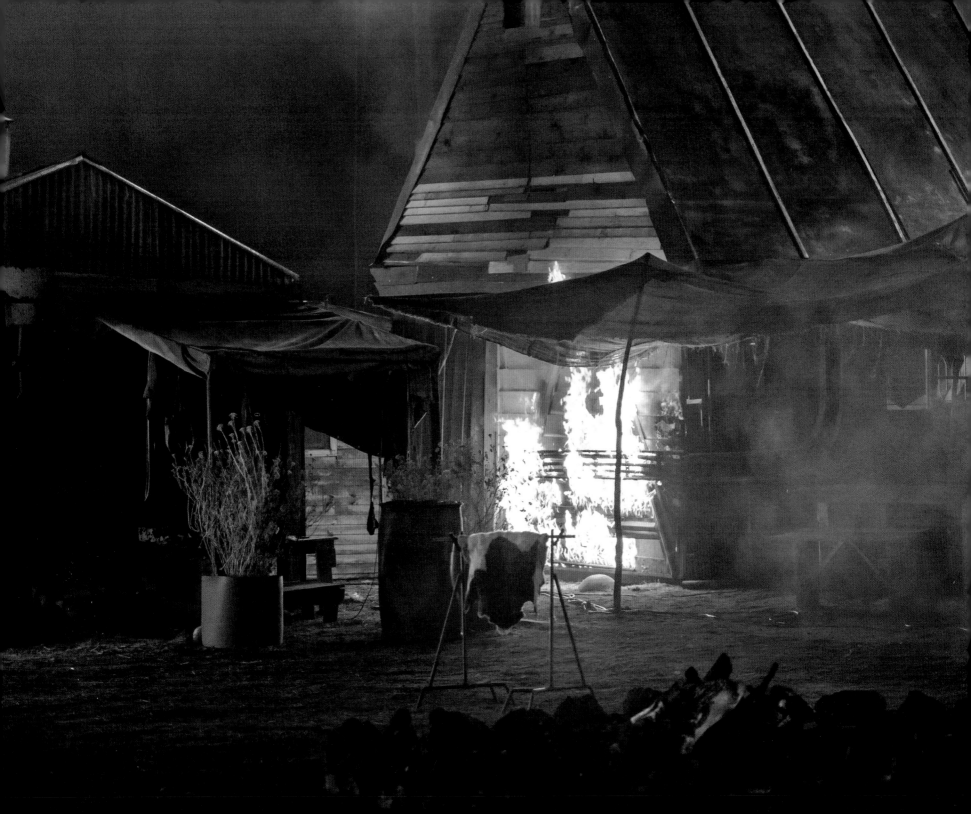

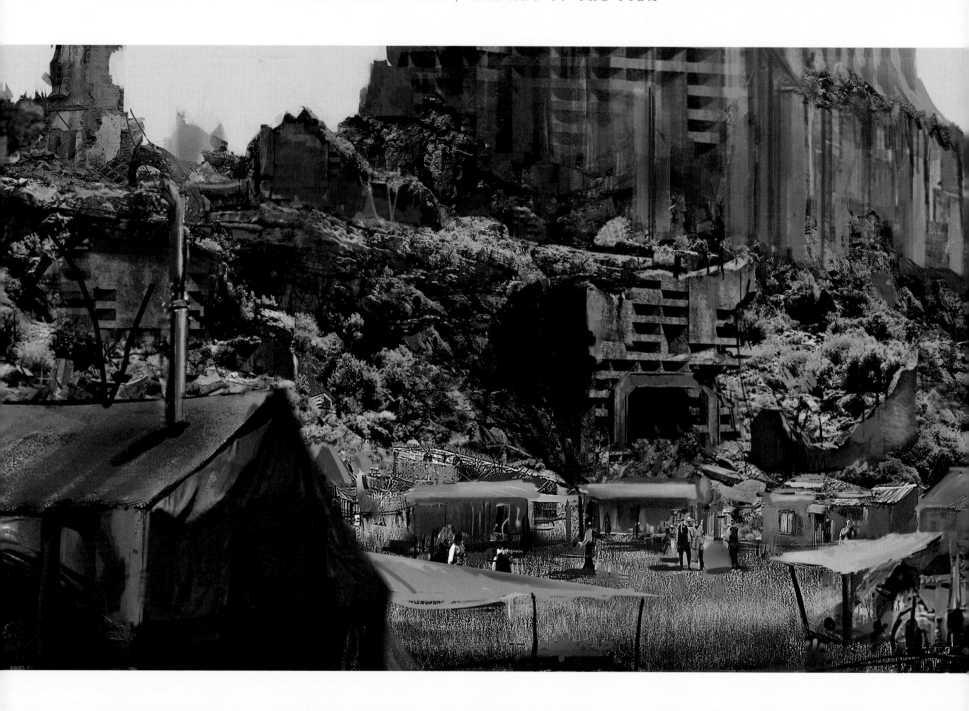

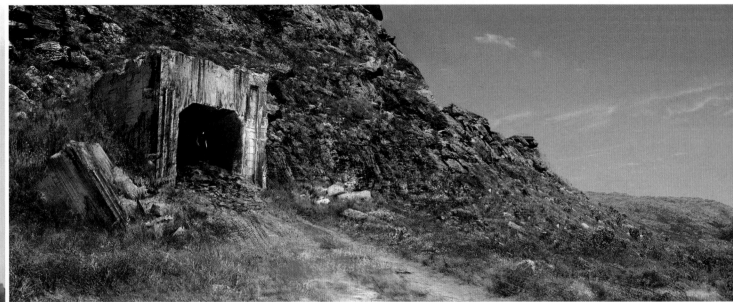

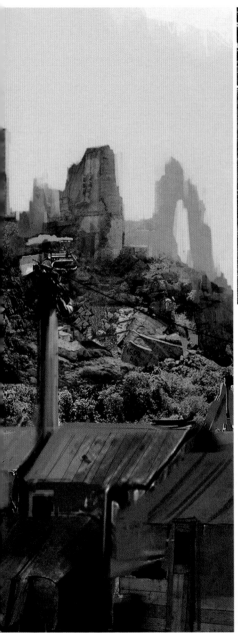

THE LAST OF THE PORTALS

The Manni village sits beneath the eroded face of one of the last portal buildings, and its angles are still sharp despite centuries of wear. These concept illustrations explore different treatments for the portal building's exterior, though all share a similar design element of monolithic brutalism. The final design (right) needed to stand in contrast to the fragile dwellings below it.

Following spread: Inspired by these concept illustrations for the Manni village's portal hub, the crew found a shooting location beneath the bleachers of a rugby stadium. They dressed up the site with rubble and an aged patina.

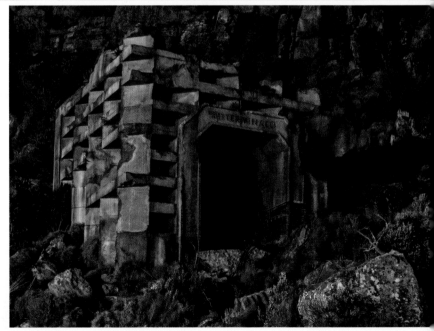

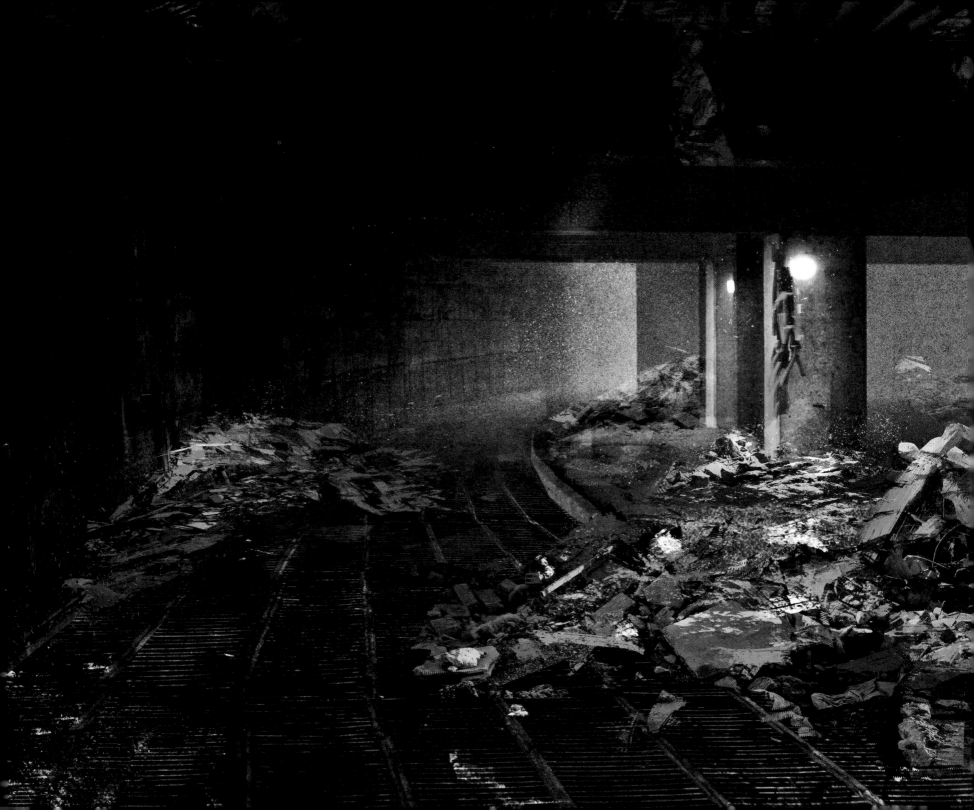

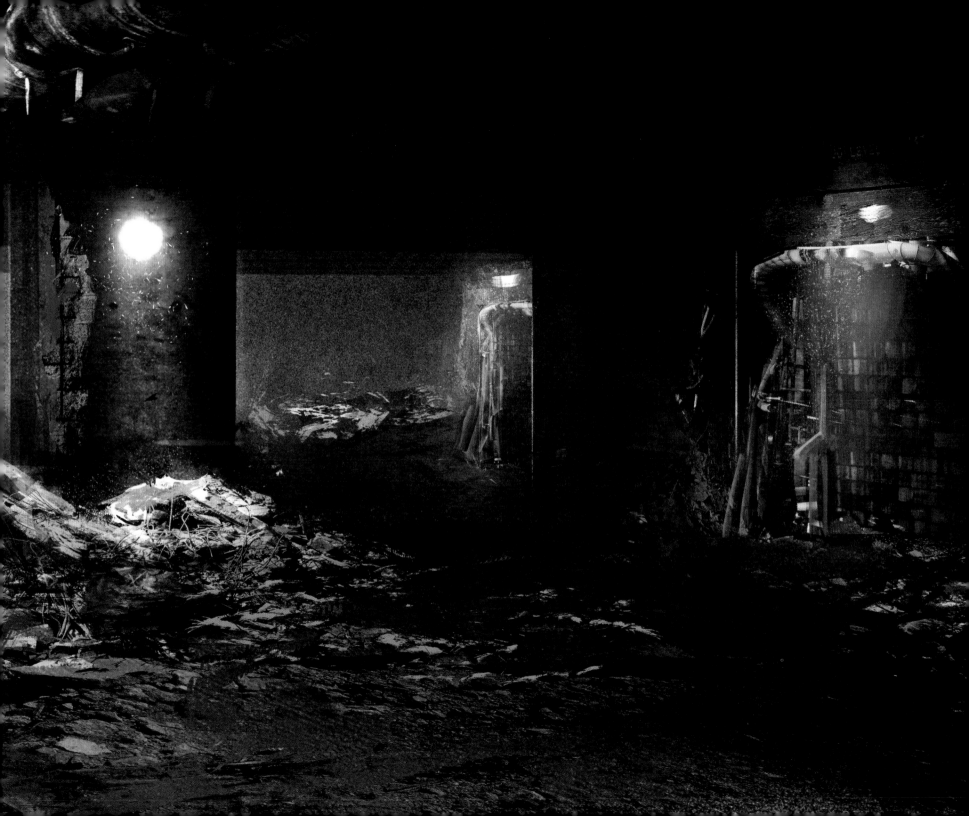

DEVAR TOI

THE END OF THE WORLD

The Devar Toi settlement is organized around a dogan, an ancient outpost of technological militarism. The Man in Black has refurbished this dogan to help him launch an attack on the Dark Tower.

Following spread, left: If their clothing is any guide, the children held prisoner at the Devar Toi have been plucked from different timelines and historical eras. All of them are proficient in the psychic "shine" that is capable of weakening the beams of the Dark Tower.

Following spread, right: The Man in Black selects children to serve as beam breakers. The task will consume all their psychic energy and leave them spent, lifeless shells.

Pages 114–115: Old and new designs coexist uneasily in this concept piece. The dull-metal dogan appears to merge into the rock of the mesa itself, while the tiny, uniform cabins contrast with the surrounding natural landscape.

Neat rows of peaked rooftops might fool you into thinking you're viewing a sleepaway camp, but an anachronistic industrial fortress will quickly dispel that fantasy. For the children unlucky enough to be bunking at Devar Toi, it isn't a vacation.

Inside the structure, button-pushers answering to the Man in Black select children from the artificial settlement to serve as psychic warriors. It is they who will destroy the six beams of reality originating from the Dark Tower.

"The breaker building is an ancient outpost that predates the world," explains Glass. "It's tech that's even older than the tech found in Mid-World."

The cheery Devar Toi settlement has been engineered by its masters to put its kidnapped victims at ease, though its eerie perfection has precisely the opposite effect. "It's like what we do with pet fish or birds," says Glass. "They're in a cage, but we try to make them comfortable by putting a plant or a rock in there. Here they give them houses, playground equipment, and a nice green lawn. It's a veneer of comfortableness they've created for these children."

When it came to hair and makeup, Prigge enjoyed the juxtaposition of carefree surroundings with hidden horror. "It appeared to be a happy place on the surface," she says. "The kids were outside playing, so I gave them this sun-kissed look. But I also gave them the disturbed eyes."

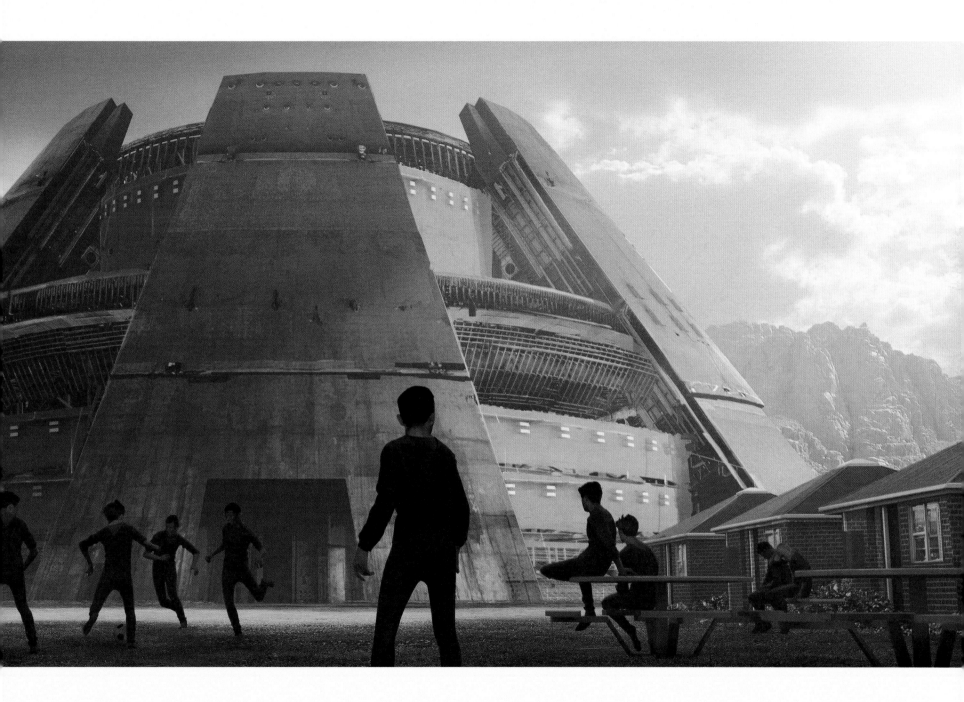

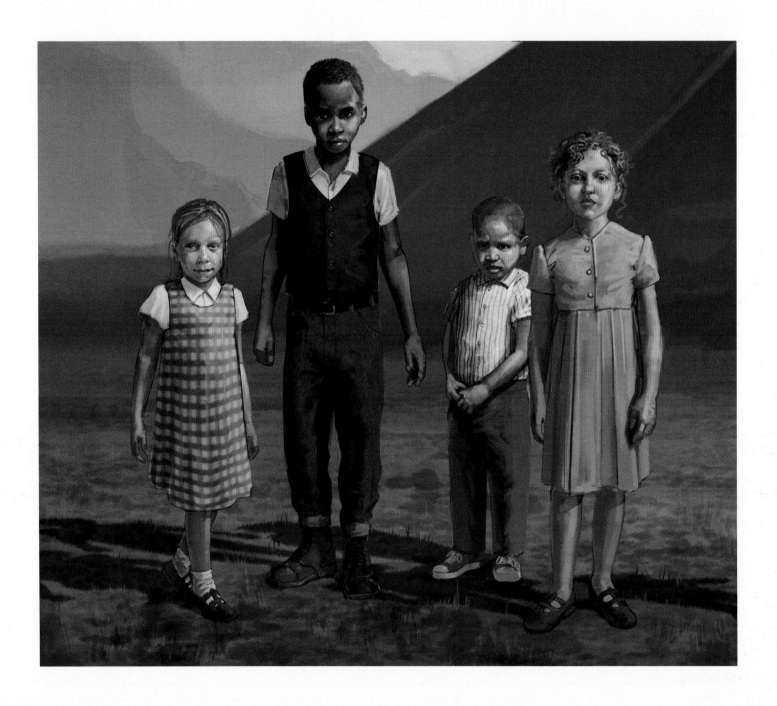

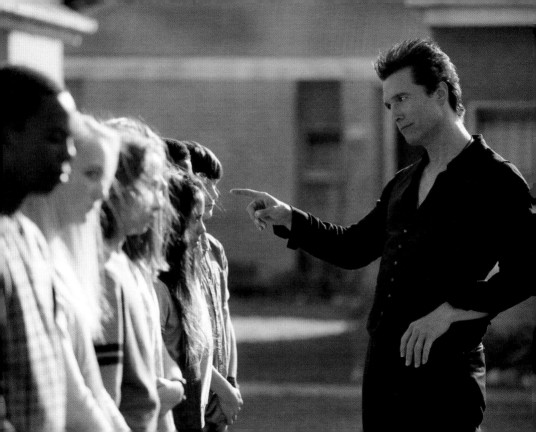

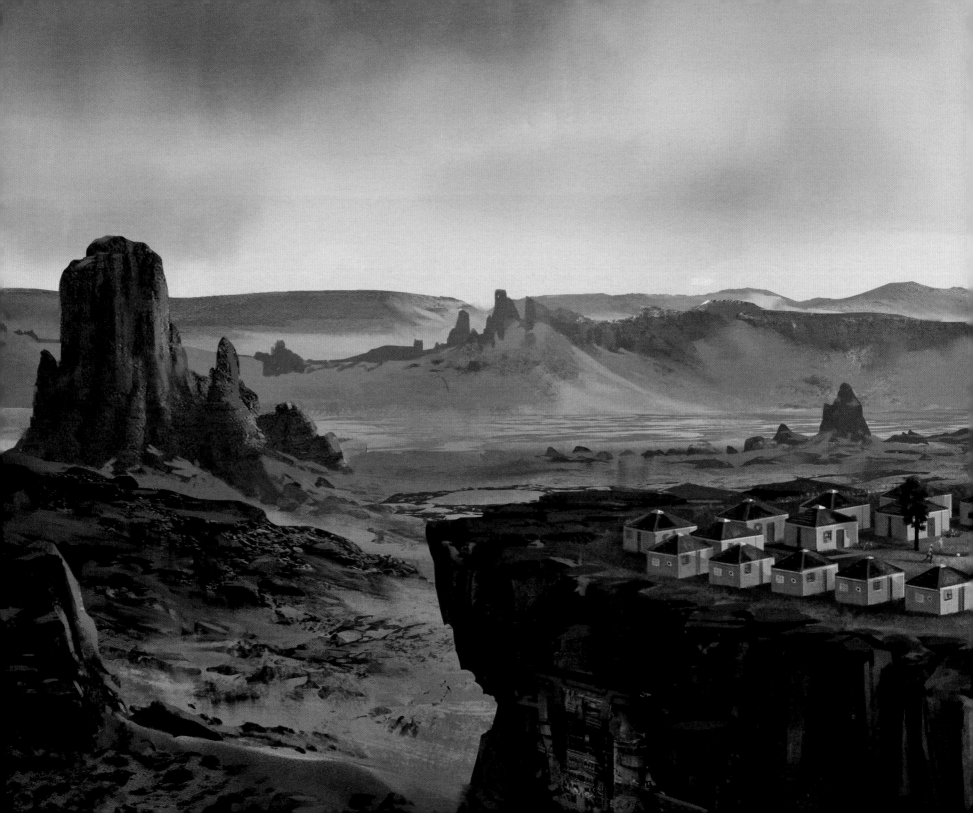

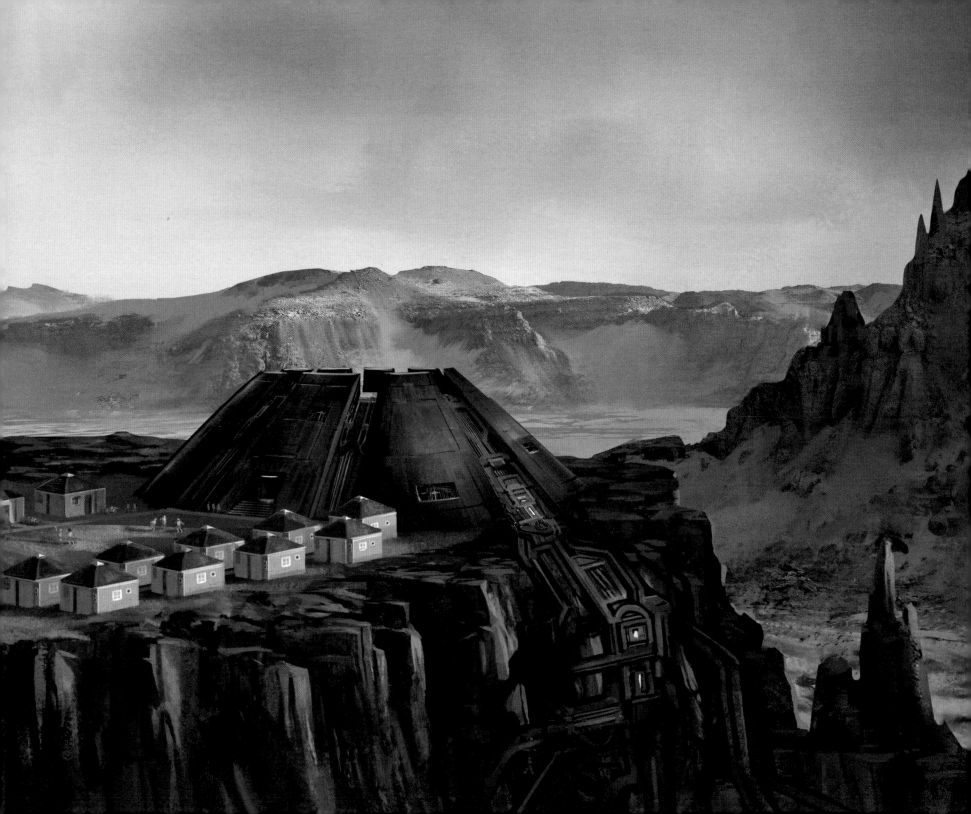

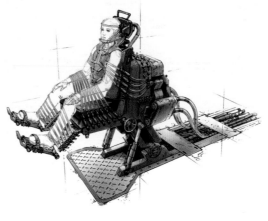

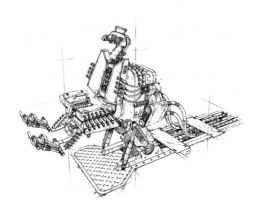

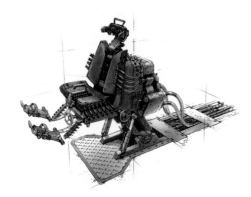

FRONT ROW SEAT

Designs for the Breaker Central chairs went through multiple stages, including sketches, computer renderings, and 3D models.

Opposite: Breaker Central's tech has more of an organic, darkly sinister feel in this concept illustration.

BREAKER CENTRAL

ℵ

The inside of the dogan fortress is a hive of unsettling machinery of uncertain purpose. This is where children who possess sufficient levels of "shine" are forced to hurl psychic spears at the Dark Tower. Their objective is to bring down the Tower and usher in the reign of the Crimson King. Accordingly, this space is known as Breaker Central.

"It's supposed to be older tech, which I'd describe as 'diesel tech,'" says Glass. His team leaned toward computer monitors with vintage cathode ray displays, inspired by the clunky hardware seen in *Alien* and the villainous House Harkonnen of David Lynch's *Dune*.

In filming Breaker Central, Videbæk sought to craft visual cruelty. "We moved away from nat-uralistic lighting and moved to harder, stronger shafts of light, illuminating these kids strapped into chairs," he says. "When the psychic energy builds up, it's these hot blue, almost burning white beams that hit the kids. It looks impres-sionistic and otherworldly, like something you could have dreamed up in a nightmare."

Fran Kranz plays Pimli, a brainiac computer coder plucked from our reality by the Man in Black to toil as a Breaker Central wage slave. His favorite part of the shoot was filming on the Breaker Central set, thanks to how real it was—and unreal. "It was timeless," he says, checking off a list of visual motifs that includes the Death Star and He-Man's Snake Mountain playset. "It was all over the place. Which was wonder-ful, because in the Dark Tower universe there's nothing you can't use."

Pimli, who finds himself in over his head, can't help but exude a somewhat sympathetic aura to audiences. "Walter found him and tasked him with the job of running this to break the beams," says Kranz. "He's totally persuaded by Walter and his charms. He essentially drinks the Kool-Aid. He becomes part of the plot to destroy the world and make way for the Crimson King, who, as I see it, is the devil."

Summerville gave Pimli's costume a warmly familiar vibe—a temperate contrast with Tirana, his coldly reptilian co-worker.

"Pimli is from Earth, and he's a disheveled computer-techy guy," she says. "The environ-ment and colors inside the lair are cold and the colors are cold, and so Pimli is layered with car-digans to keep warm and to protect himself. He's terrified of Walter but also a bit in awe of him.

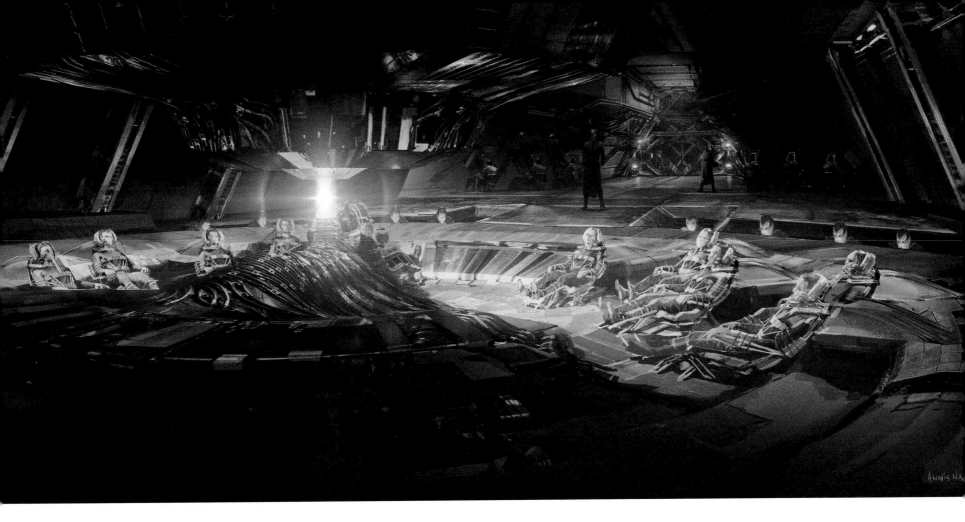

"Tirana is a lieutenant in Walter's army," Summerville continues. "She has a uniform—like a dress but with a uniform feel, in a dark Bordeaux color with high riding boots. Beneath her skin, she's a reptile, but she's chosen a pretty face. Her hair is severely pulled back and braided to look like a snake's tail."

Abbey Lee, who plays Tirana, channeled her character's cold-bloodedness into her on-set portrayal. "It was a strange challenge, keeping in mind that she was not human, to find ways to react to things that were happening," she says. "I focused on acting less emotional and more instinctive, more in the way that animals react."

Breaker Central staffers like Pimli and Tirana log long hours hunched over bulbous workstations. "Nikolaj encouraged us to find pieces of the set that we were drawn to," says Kranz, relating how the filming schedule resulted in a live-in relationship with the set as the eclectic became everyday normality. "If we found a button or a rusty keypad we were enchanted by, he would say, 'Great—we'll get in close during filming, and we'll find that.'"

For Lee, the mechanical guts of Breaker Central carried an entirely appropriate air of chilly sterility. "A lot of the time it was quite cold with all the steel and machinery on set, plus it was winter in South Africa," she says. "It was helpful for the temperature to help set the mood of it. My character has a natural coldness to her, and being in a room full of metal helped with that feeling of discomfort."

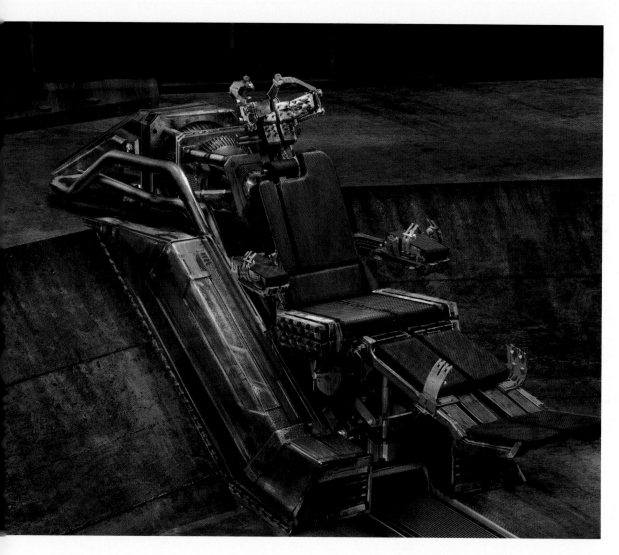

To one side of the Breaker Central control room sits the Man in Black's private office. Its central position and its symmetrical accoutrements give it the vibe of a thinking man's throne room. "It's like it belonged to the university president from Hell," says Kranz. "It's filled with old books and collectibles from Walter's travels throughout the universe."

The design of the Breaker Central set made it the perfect environment for hiding Easter eggs within its nooks and crannies. Sharp-eyed viewers might spot Stephen King's novel *Misery* sitting on Pimli's desk—a metafictional nod to fans.

"Having a Stephen King book in frame feels a little cheeky, but it's actually very true to the spirit of the books," says Kranz, who notes that the Dark Tower series is explicit about its connections to the wider canon of King's influence, including *Salem's Lot, The Shining*, and many, many more. "Pimli is a fish out of water in this supernatural experience, so the book is also a visual metaphor," Kranz explains. "The protagonist in *Misery* is captured. Pimli is living that, whether he realizes it or not."

Pimli's keepsake, like Pimli himself, is a castaway—separated from its place of origin by a wide dimensional ocean. But as Walter has known for years, the wonders of New York City and the "Keystone Earth" that houses it are just a portal-hop away.

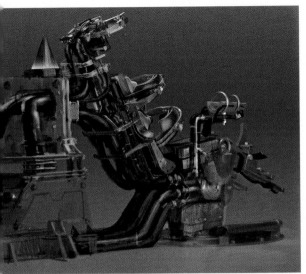

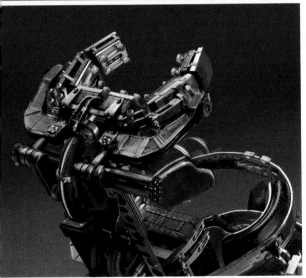

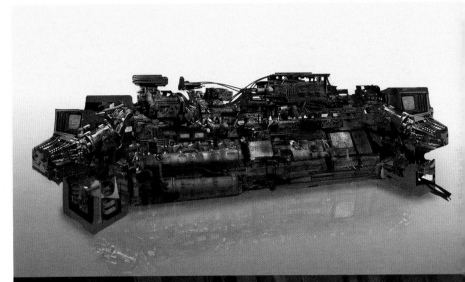

The Breaker Central chairs incorporated elements of medical examination equipment and high-voltage electrocution devices into their design for an overall disturbing look.

Opposite and Left: Three studies of Breaker chair rigging. "The leader chair is where all the focused psychic energy goes," says Glass. "The machine focuses and amplifies it, and then it hits the beams and breaks them."

Right: Viewscreens and unidentifiable circuitry filled up the walls and aisles of Breaker Central. The tech looked almost alien, with weird protrusions and unfinished surfaces. Referring to these viewing machines, Glass explains, "We called them weirdo consoles, because people were always looking into them and spying on kids in parallel universes."

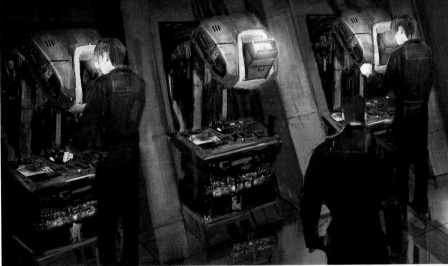

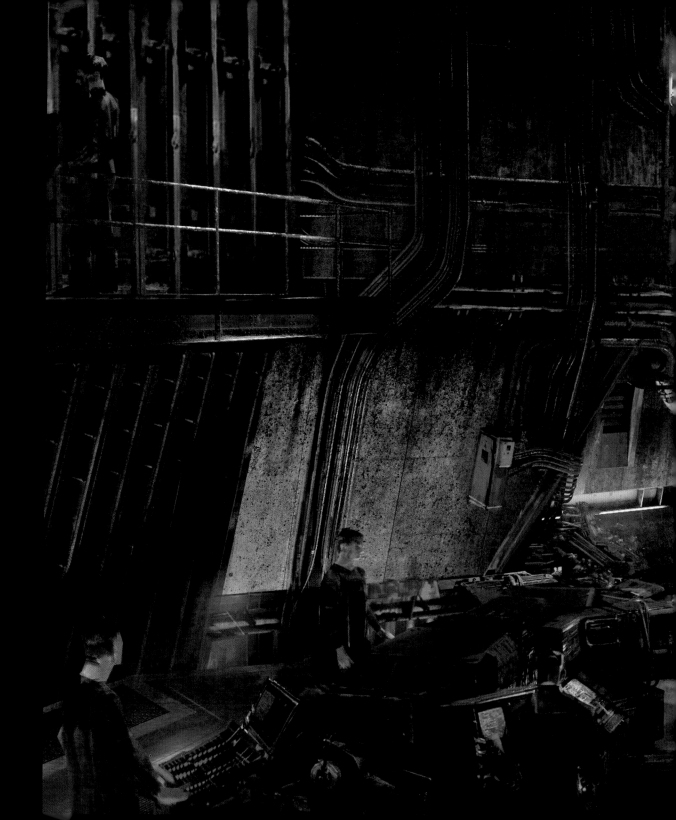

BRINGING DOWN THE SKY

The guts of Breaker Central are laid out
for all to see in this conceptual piece.
The ring of chairs and their kidnapped
occupants would obviously be the
centerpiece of the set, but the designers
also added an adjoining room lined with
bookcases to serve as Walter's study.
"We wanted Walter to seem like a man of
sophistication, taste, and travel," says
Glass. "The study helped warm him up a
bit. It's juxtaposition, like, 'Is he studious?
Is he a researcher? Is this someone we're
supposed to like?'"

Following spread: Two views of Breaker
Central and the captives who are forced
to power it through the strength of their
"shine." Most of the equipment inside is
new, installed for the specific purpose of
taking down the Dark Tower and its reality
beams. "The dogan has been there a long
time, but this is stuff that Walter brought
there himself," says Glass.

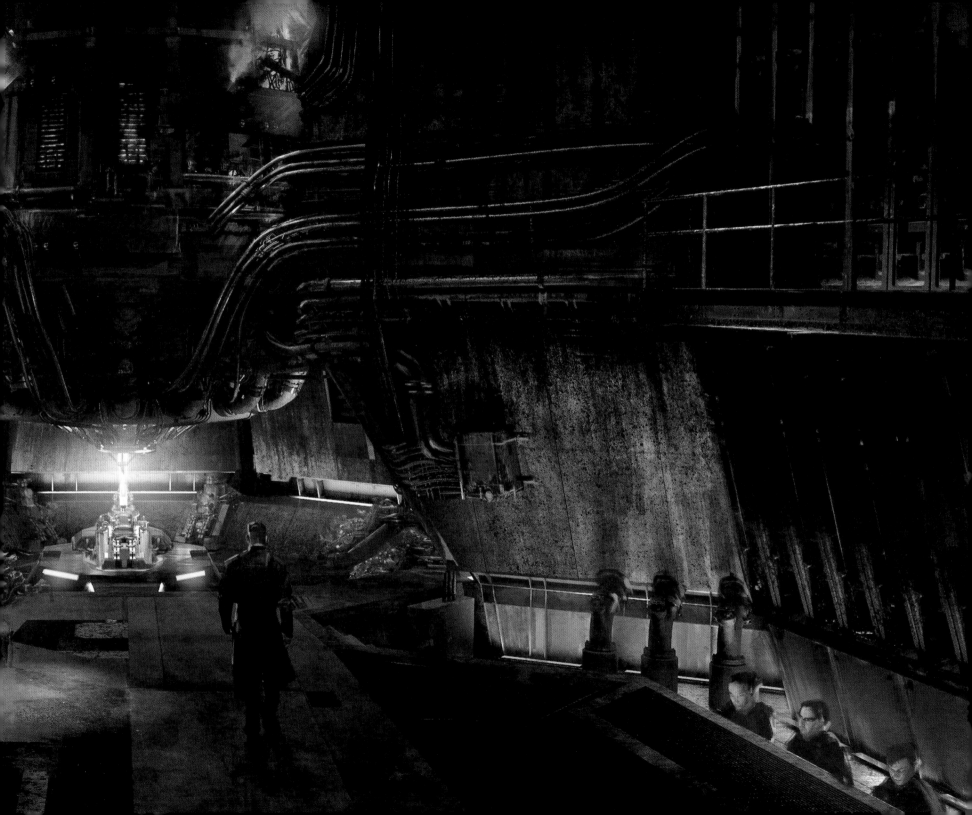

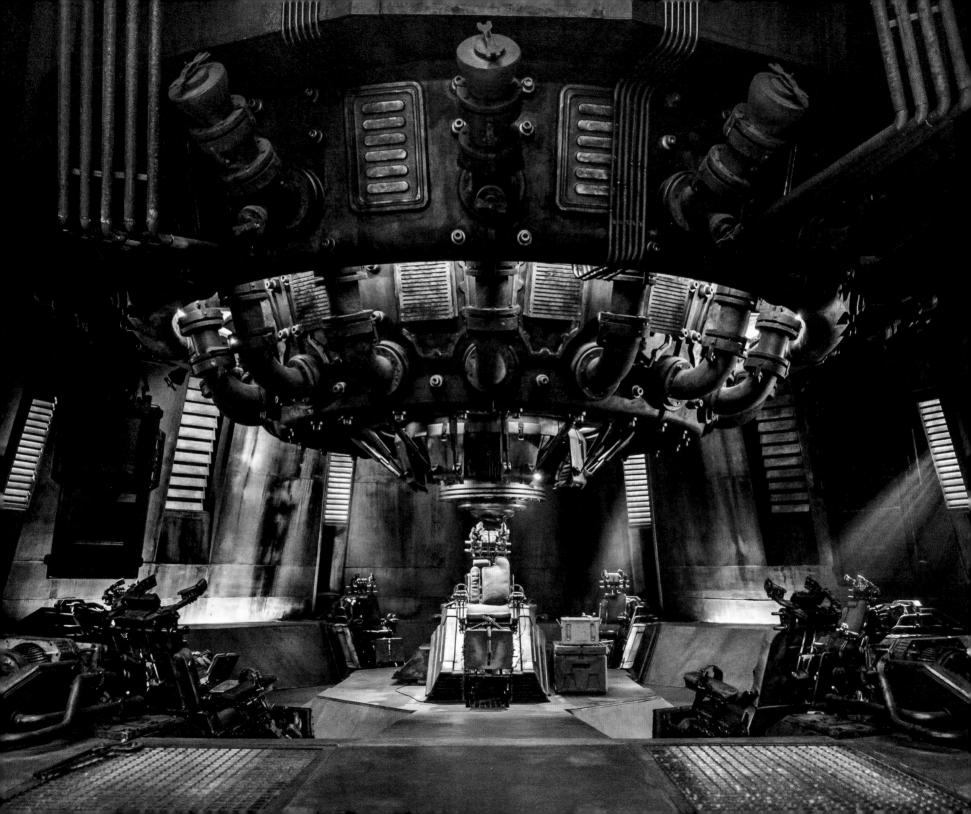

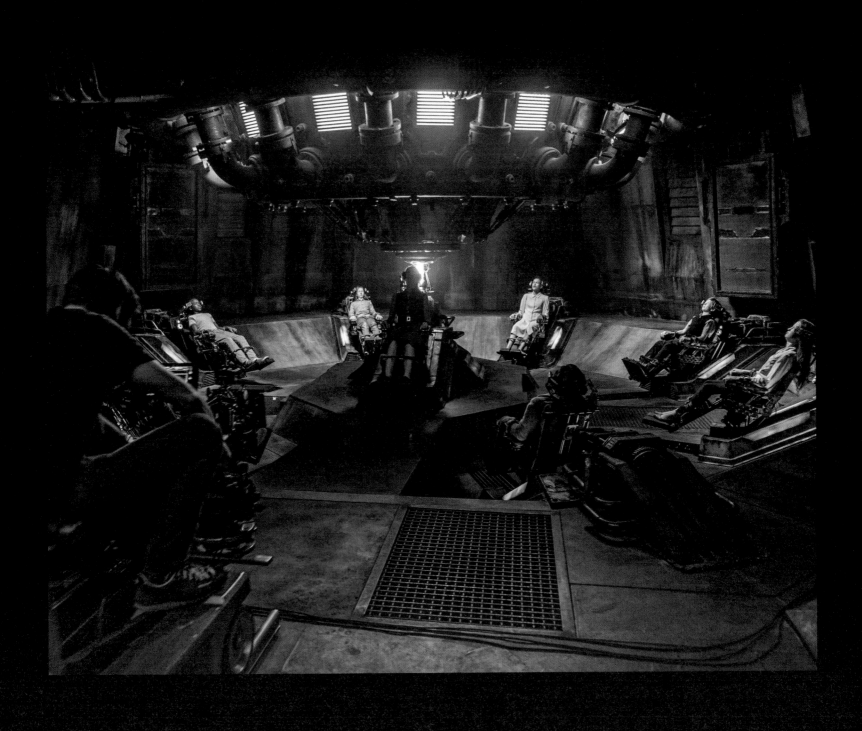

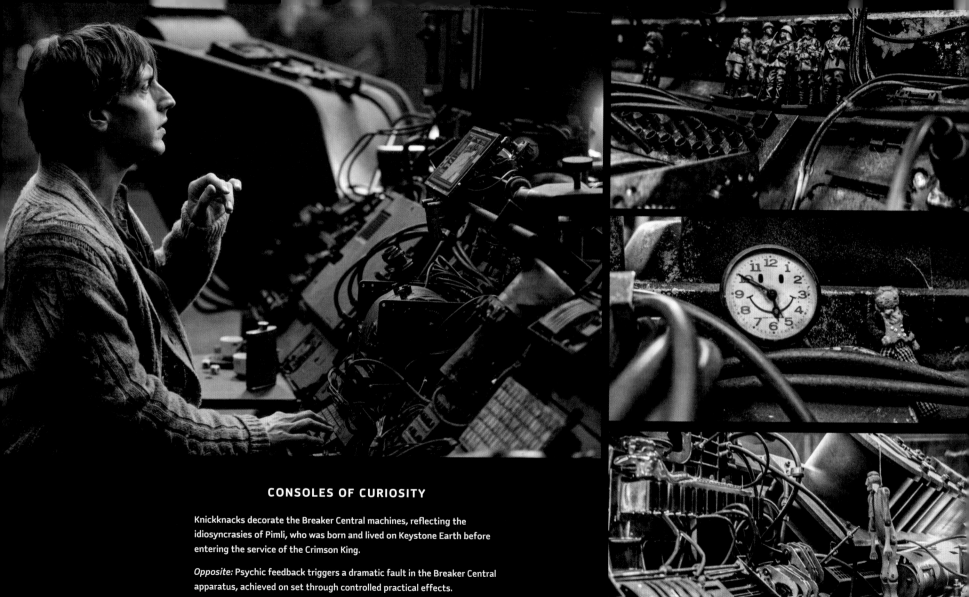

CONSOLES OF CURIOSITY

Knickknacks decorate the Breaker Central machines, reflecting the idiosyncrasies of Pimli, who was born and lived on Keystone Earth before entering the service of the Crimson King.

Opposite: Psychic feedback triggers a dramatic fault in the Breaker Central apparatus, achieved on set through controlled practical effects.

Following spread: This concept piece shows the Crimson King's sacred altar, which at one point was going to be part of Breaker Central.

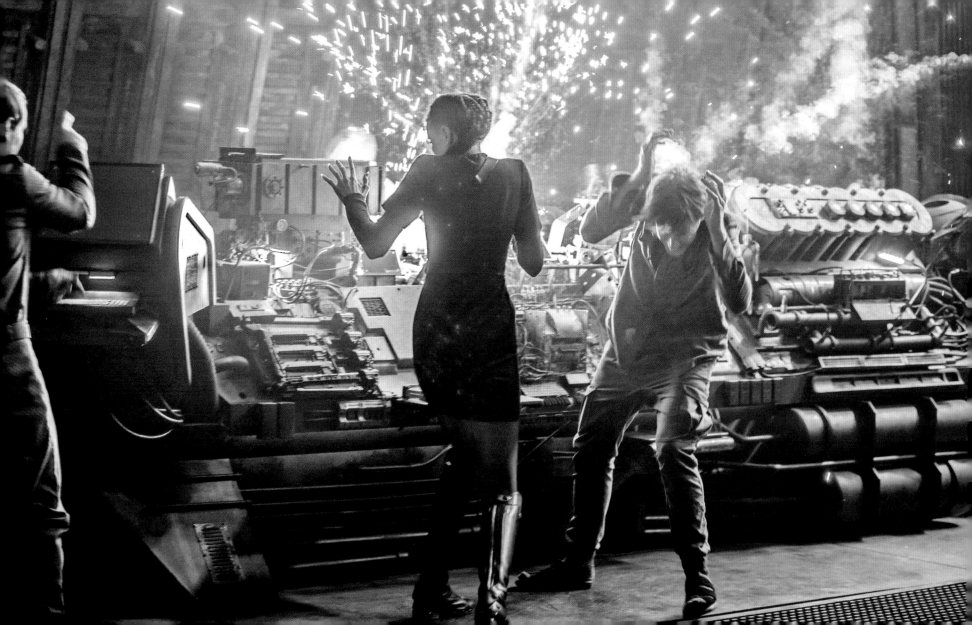

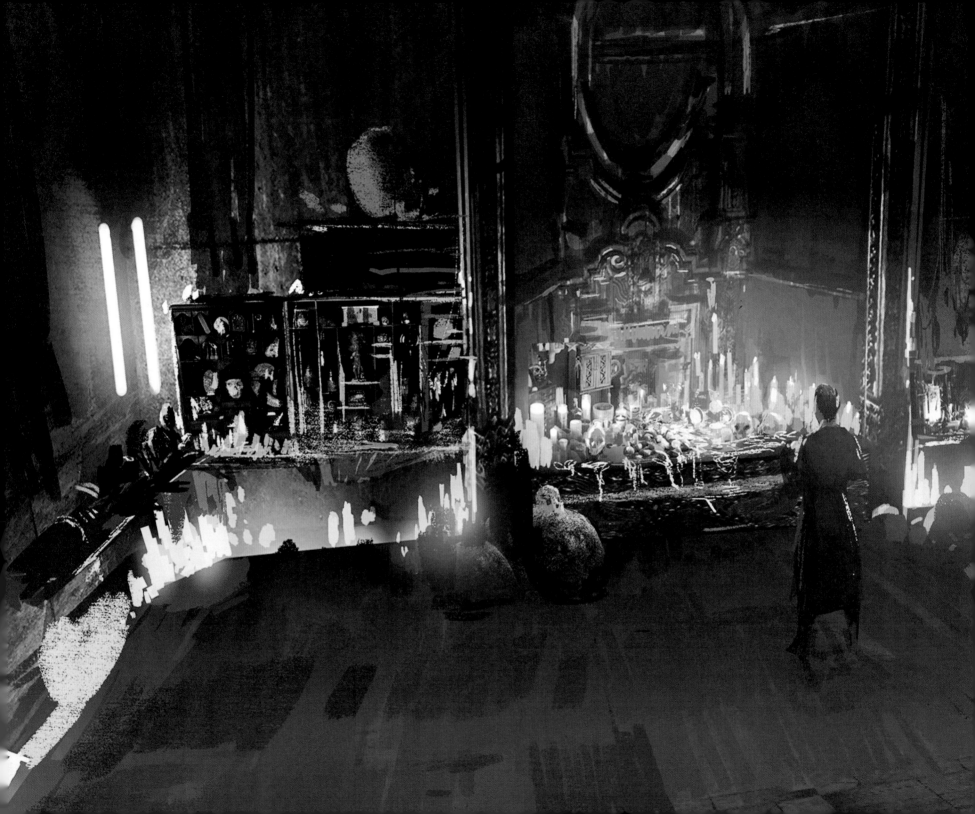

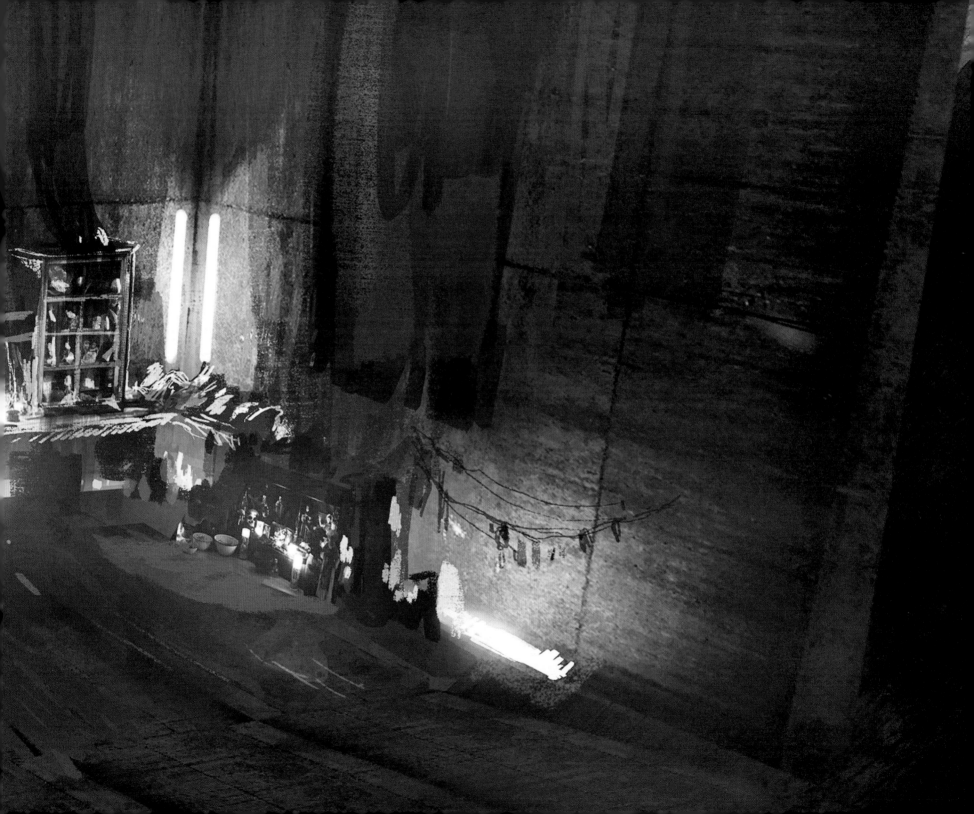

PART IV

Portals that link Mid-World with our own have left Keystone Earth vulnerable to infiltration by malevolent entities.

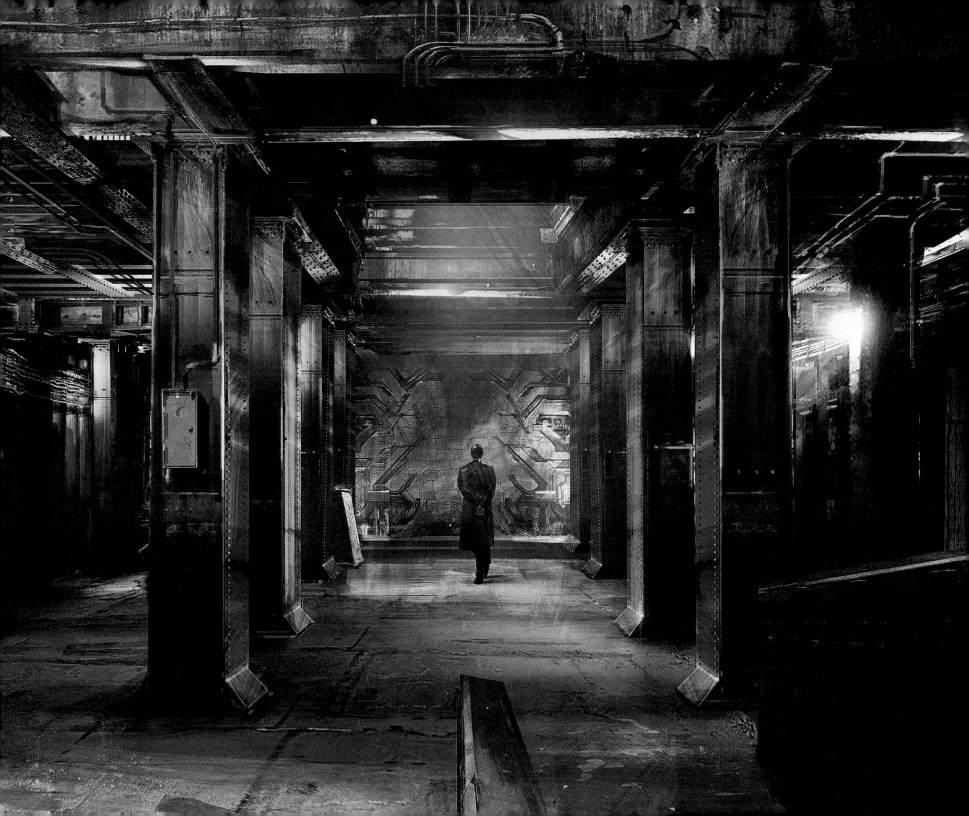

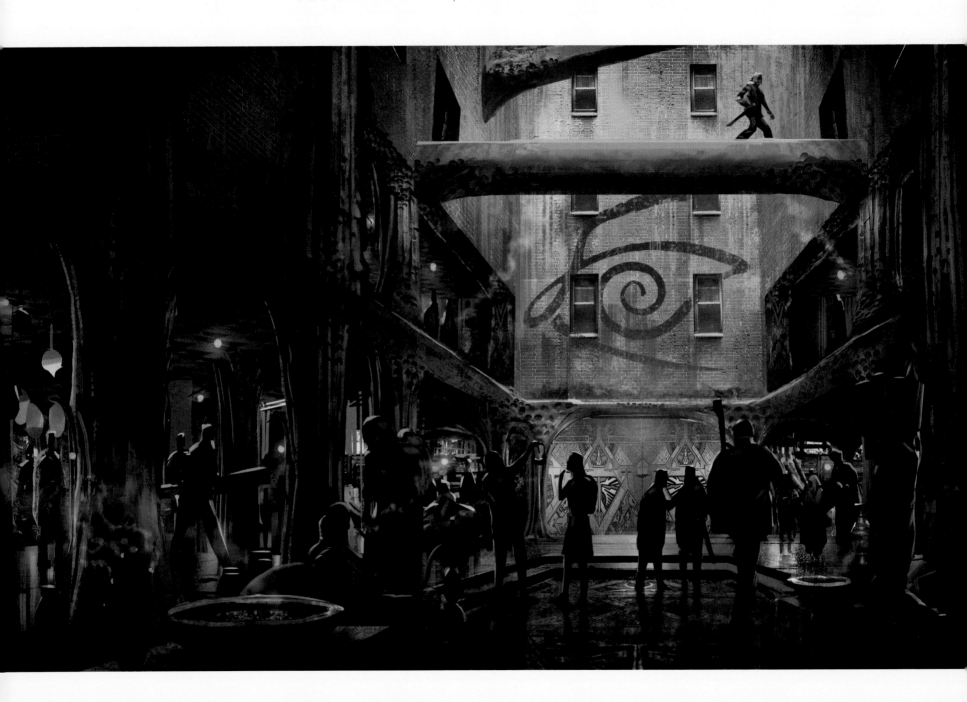

KEYSTONE EARTH

For us, it is simply Earth—a place of telephones, taxicabs, and all-around ordinariness that's the only home we've ever known. But to savvy Mid-Worlders like the Man in Black, our realm is but one of many and bears the label "Keystone Earth."

Faint echoes of a shared history and culture can be found in both Mid-World and Keystone Earth. And still more Keystone Earth variants exist on thousands of different planes simultaneously, each permutation boasting a unique, slightly reshuffled population. The Man in Black has already raided many of these realms to capture children with "shine." On Keystone Earth, Jake Chambers appears to pack the psychic punch that Walter has been dreaming of.

Teleporting doorways in the Dixie Pig restaurant and a crumbling Dutch Hill house provide limited access to Mid-World, but the dimensional bleed is spreading. By the time the movie opens, all of New York is suffering from the effects of Walter's efforts to bring down the Dark Tower.

The psychic violence has begun to split the tectonic plates supporting NYC and our Earth, and the great city's days are numbered.

Concept art for the interior of the Dixie Pig is dominated by the blood-red insignia of the demonic Crimson King.

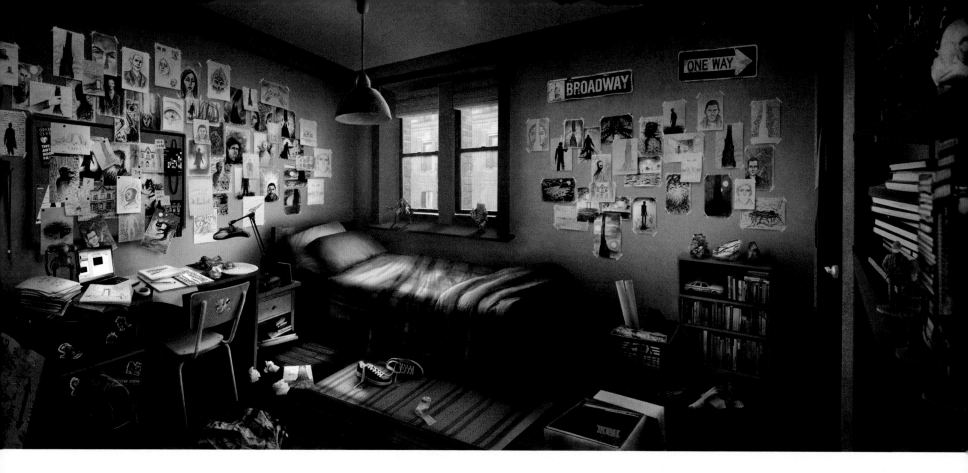

JAKE'S APARTMENT

What looks like the normal clutter of a teenage boy's bedroom becomes more ominous under careful study. The pictures taped to the walls are the external projections of Jake's nightmares, each sheet a distorted interpretation of the Gunslinger, the Man in Black, the Dark Tower, and other visions of Mid-World.

Jake's apartment was one of the few New York City locations shot on a Cape Town studio set.

The apartment's unremarkable furnishings clash with the Mid-World visions glimpsed in Jake's fever dreams, expressed in a mosaic of sketches—the Gunslinger, the Man in Black, the Dark Tower—haphazardly plastered on the walls of his bedroom. Katheryn Winnick plays Laurie Chambers, Jake's mother, who struggles to find common ground with her troubled boy.

"Laurie worries whether her son is of sound mind," Winnick says. "Her son is having trouble at school, while Laurie is struggling, herself, with her new husband. Simultaneously, she is under the moral pressure to make the right decisions."

Jake's new stepfather can't fill the hole left by his birth father, a firefighter who died under tragic circumstances. Winnick admits that behind her character's motivations is a strong dose of clear-eyed practicality. "Her first husband was the true love of her life. She jumped into a new relation-

ship to provide for the financial needs of her family." Winnick adds, "Laurie is trying to maintain some kind of normalcy for her son, while trying to make ends meet. If she'd had a little more time, I'm not certain she would have ended up with her current husband."

Winnick established a rapport with Tom Taylor, appreciating her on-screen son's ability to convey dread and desperation. It is the scale of Jake's trauma that finally breaks through to Laurie.

"One of my favorite scenes is where Jake is in his bedroom after the people from the clinic try to grab him," Winnick adds. "That's the point where Laurie's perspective of her son changes, as she no longer hears the voice of her child, but that of a young man coming into his own. Having raised him, she knows her son so well to the point where she questions her own sanity, 'What if he's right?'"

Following spread: A close-up look at Jake's scribblings. The twin-moon sky on display in many of the drawings is the clearest indication that the visions of Mid-World are coming from a realm impossibly distant from New York City. Several of the drawings focus on the Man in Black and his apocalyptic goal: the shattering of the Dark Tower.

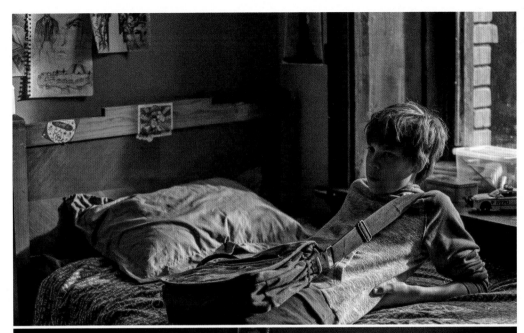

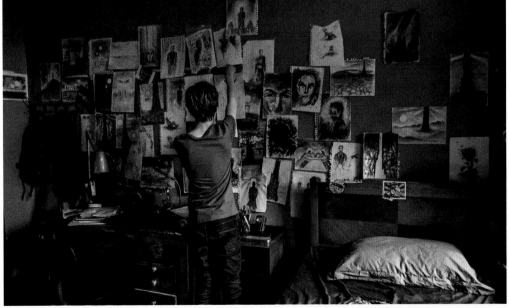

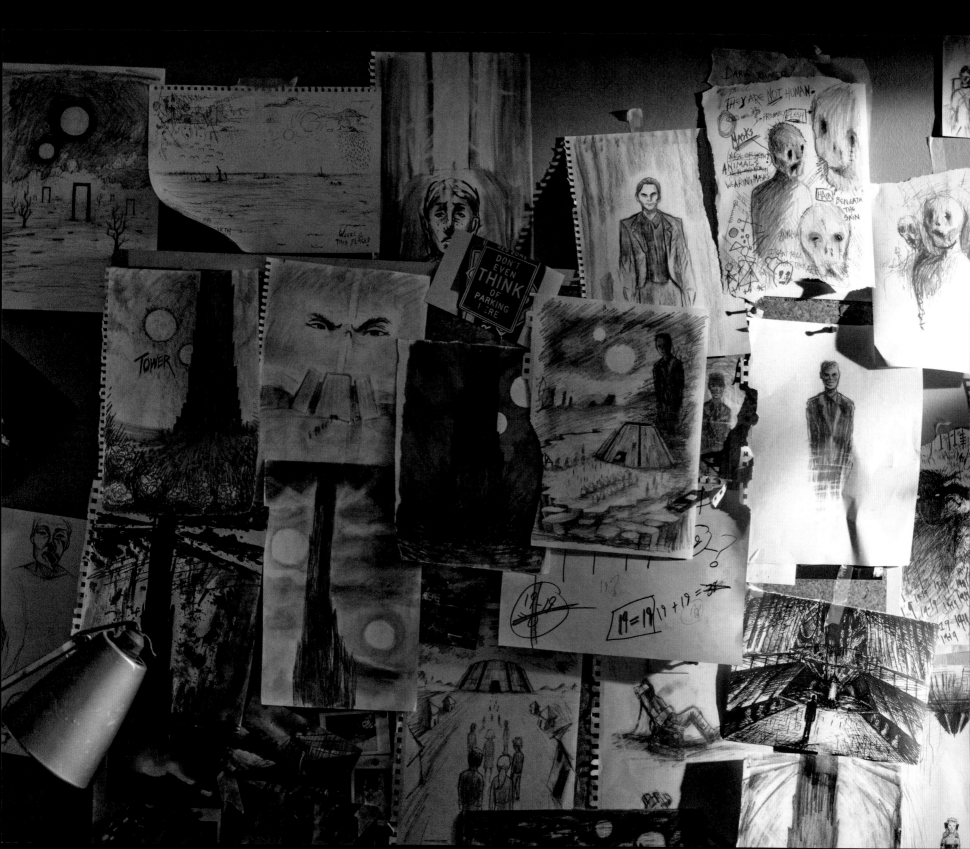

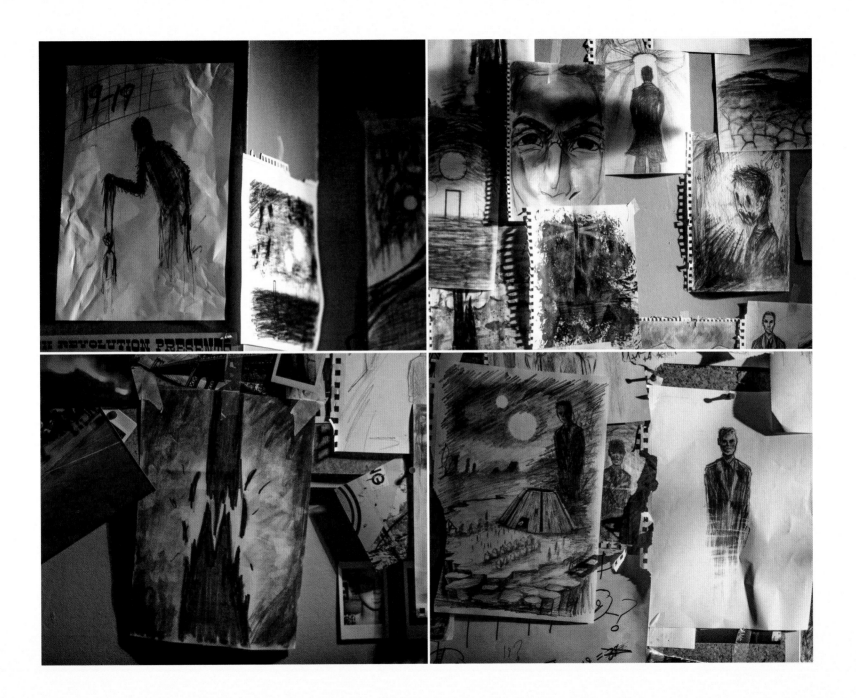

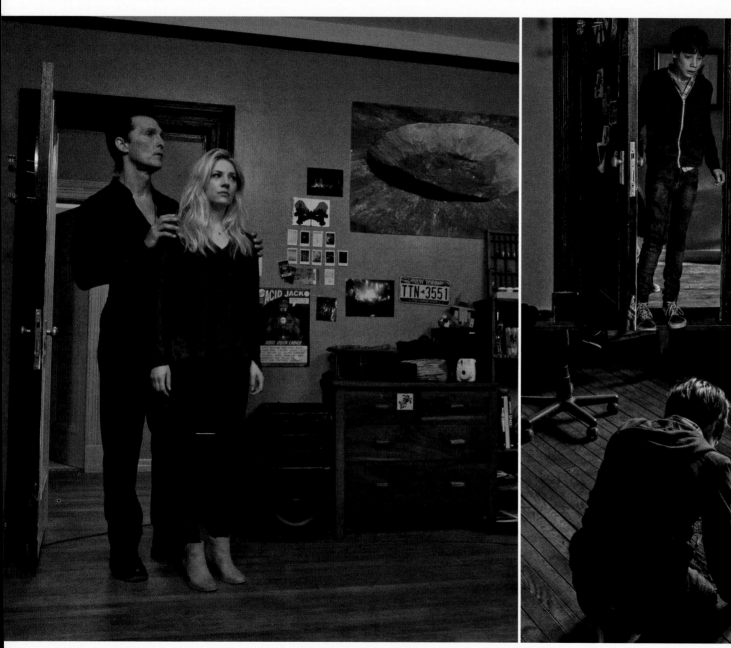

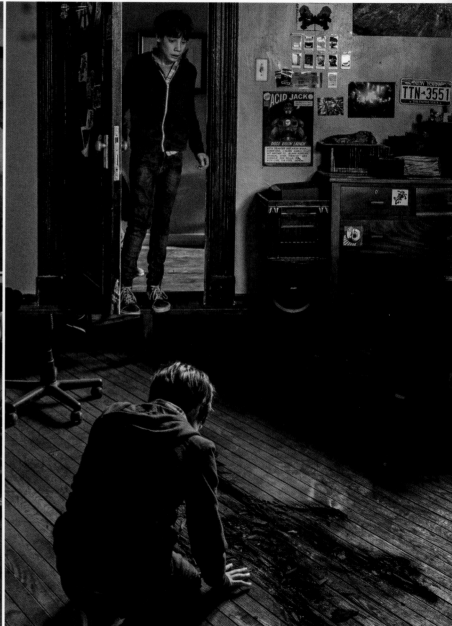

Winnick's Laurie Chambers shares a scene with Matthew McConaughey's Walter. Their close encounter doesn't end well, and when Jake returns to the apartment after his stopover in Mid-World, he discovers this smeared message.

DUTCH HILL

This run-down house in Brooklyn's Dutch Hill neighborhood contains the secret to interdimensional travel. Naturally, its gatekeeper tries to discourage the unwanted from getting too close.

From the sidewalk, the house at Dutch Hill, with its boarded-up windows and "Beware of the Dog" signs, loudly declaring to the curious that they should just keep on walking. And should this camouflage fail, something far worse than a watchdog lurks inside.

"The portal was there long before the house was built," says production designer Christopher Glass. "The portal was built hundreds of years ago, and later the house was built around the portal. It's basically hiding in plain sight."

Jake's exploration of the house's interior evokes apprehension and fascination at the same time. "I grew up in an area with abandoned houses," says Glass. "It was always fun to go in them and explore."

A real-world home in residential Brooklyn stood in for the exterior, but the interior required careful construction on a Cape Town soundstage. "The house itself comes alive and goes wild," explains executive producer G. Mac Brown. "To make it do the things we needed it to do, it had to be built."

Though Jake senses a malevolent miasma inside the house, he can't pinpoint its source. Turns out the danger is all around him, in the form of a demon guardian inhabiting the plaster walls and wooden floorboards.

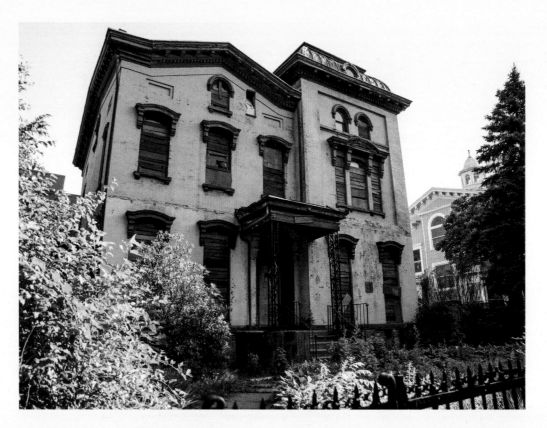

"The house is boarded up, so it's darkly lit, and we just go with Jake and feel our way through the rooms," says director of photography Rasmus Videbæk. "When he finds the control panel and punches in the numbers, the whole thing changes. He's caught in a bright expressionistic light that flickers as he sees weird worlds through the doorframe. It's a harsh, almost godlike light."

Jake's intrusion is exactly what the Dutch Hill demon is there to prevent. The ancient defense system screeches to life as the guardian spirit turns the architecture of the house into splintered claws of wood.

"The house comes apart at the seams," says visual effects producer Cari Thomas, whose team of animators conjured the demon in postproduction. Their additions complemented on-set footage of Taylor as Jake, captured months earlier.

"We had four guys, dressed from head to toe in green, who grabbed Tom and carried him around," explains visual effects supervisor Nicolas Aithadi. "And Tom was very convincing, even though it was a funny thing to be carried around by four green ninjas."

Glass and his team determined the physics of the creature during early brainstorms. "The

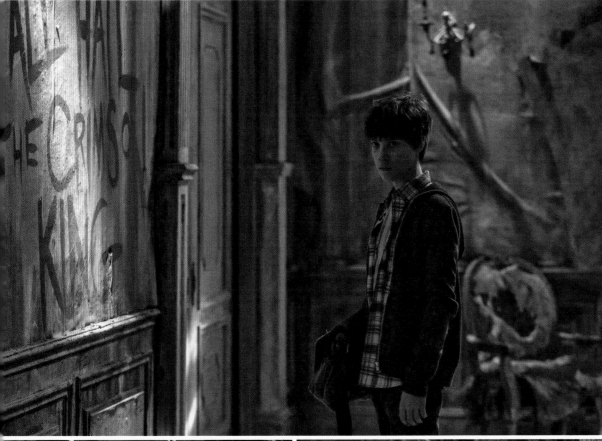

wood should never feel rubbery, like it's bending," he says. "It should be breaking into shards and splinters. And wood has to be touching other wood to come alive, so as soon as a piece comes off, it just falls, because it's not part of the pile anymore."

When animating the demon's final form, Aithadi couldn't include any materials that wouldn't be found in a turn-of-the-century residential teardown. "Planks, nails, anything like that," he says. "The entity acts through the house, and it creates a snake-like shape of whatever makes up the house. Things are falling off of it and things are getting sucked up into it. Everything is alive."

Top: Jake is undeterred by the words "All Hail the Crimson King" scrawled upon the walls of the Dutch Hill mansion. *Below:* The period-appropriate details of the house's exterior trim and interior furnishings don't exactly look otherworldly, something feels off about the environment even when its Mid-World connections aren't on full display.

Opposite: The exterior of the Dutch Hill mansion is intentionally foreboding, acting as a kind of camouflage to disguise the demon guardian living within its walls. The filmmakers considered the dimensional portal at Dutch Hill to be far older than the house that surrounded it, with an eerie history that dated back centuries.

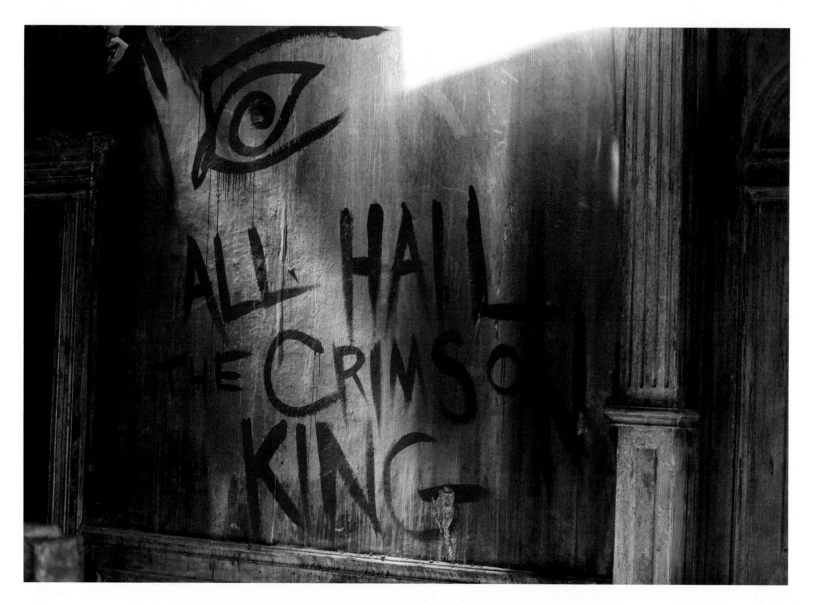

More than random graffiti, the cultish slogan on the wall is the clearest indicator that Dutch Hill is a place of danger.

Opposite: Wallpaper and wooden boards split apart to reveal an alien structure of curious design.
"That tech means that there's a portal there," says Glass. "It's the tech that can bend space and time."

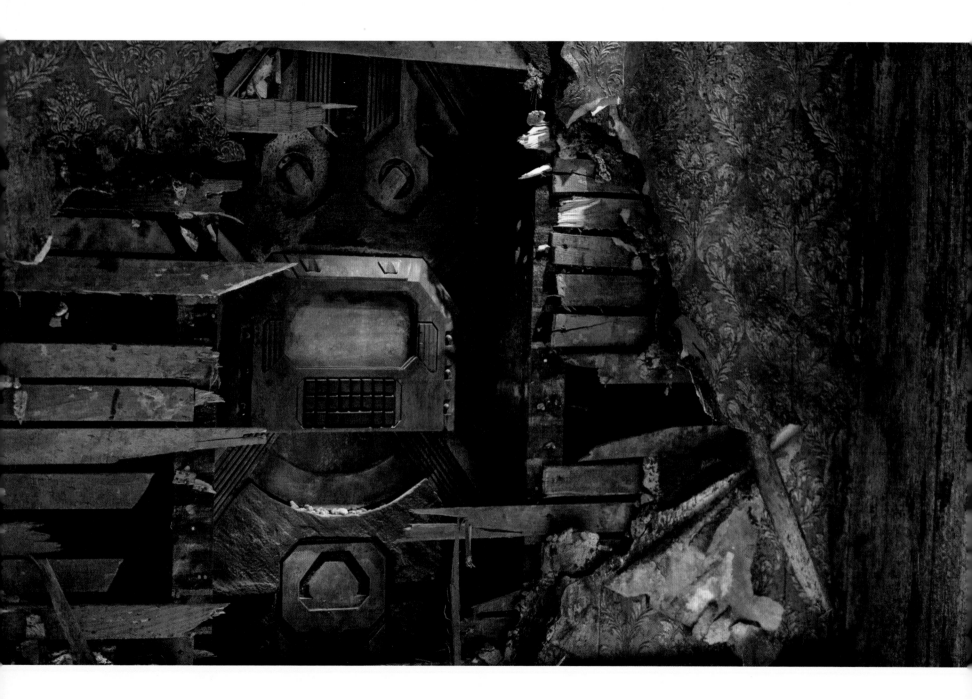

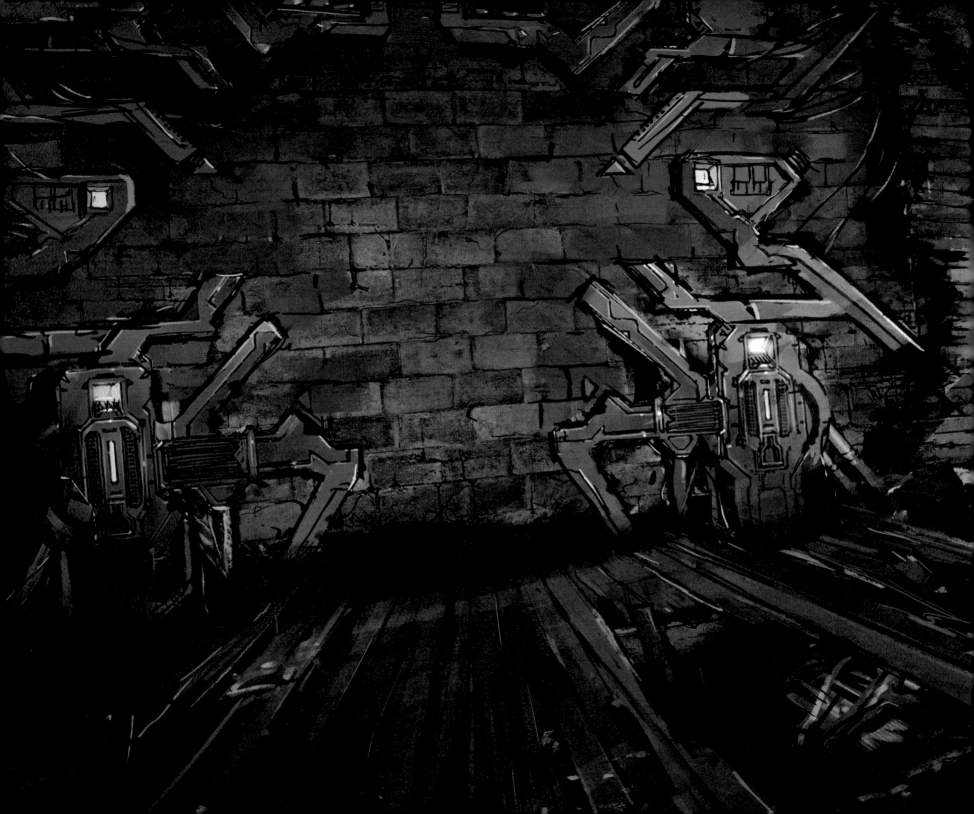

THE PORTALS

The Dutch Hill sequence is only the audience's first experience with a trippy dimensional crossing. Other portal hubs are squirreled away across Mid-World and in dark pockets of New York City. There's one in Breaker Central, another near the Manni village, and one in the basement of the Dixie Pig. The hubs vary from refurbished to neglected, but all share a universal design fingerprint from their long-vanished builders.

"This technology is on a higher level than any technology in Mid-World," says Glass, pointing to the symmetrical, sharp-angled patterns that frame each portal's entryway. "It is both more ancient and more futuristic."

On set, the effect of a powered-up portal was simulated with bright lights and blowing fans. But for the final film, Aithadi needed to invent a phenomenon that has no earthly analogue. "The portals were one of the most difficult things to do," he admits. "It's very easy to get lost in a hole surrounded with light, that old-school 'stargate' kind of thing. We went through a long phase of finding a more interesting way."

The design team proposed laws of portal science governing how the gateways might cycle through various endpoints before establishing a hand-shake with their destination realm. The whole process is powered by colossal machines buried mostly out of sight but constructed at a scale that Aithadi likens to the room-size computers of the 1950s.

"The portal itself is made of simulated particles of different elements," explains Aithadi. "The machine opens a hole as your world is atomizing and being sucked inside it. You see glimpses of your destination in a very abstract way—a red planet, a blue planet. The machine has to punch a hole through all the dimensions in order to reach your destination."

The tech is miraculous, but not without terrifying peril to life and limb. "When the light is green and the portal is lined up, you can go through," says Aithadi. "But there's a moment before it aligns where it's kind of a mess and you can't see where you're going."

Stepping into a misaligned portal, he warns, is a very bad idea. "It's like a wood chipper. An energy wood chipper."

An early treatment for the Dutch Hill dimensional portal.

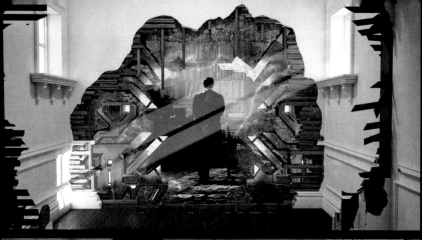

These three studies explored how the dimensional portal might assert itself within our own reality.

Opposite: The Dutch Hill portal set took shape on a soundstage in South Africa's Cape Town.

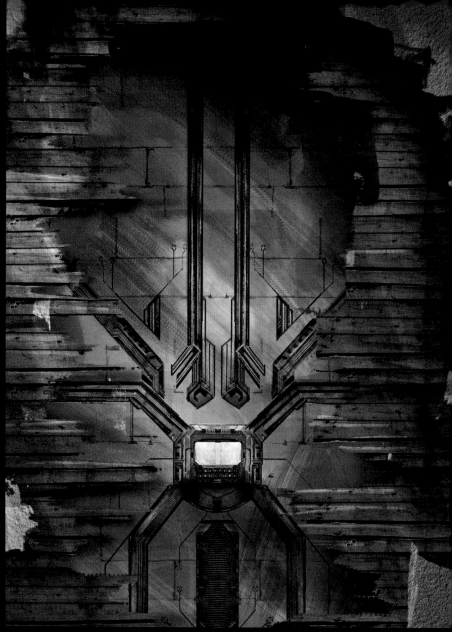

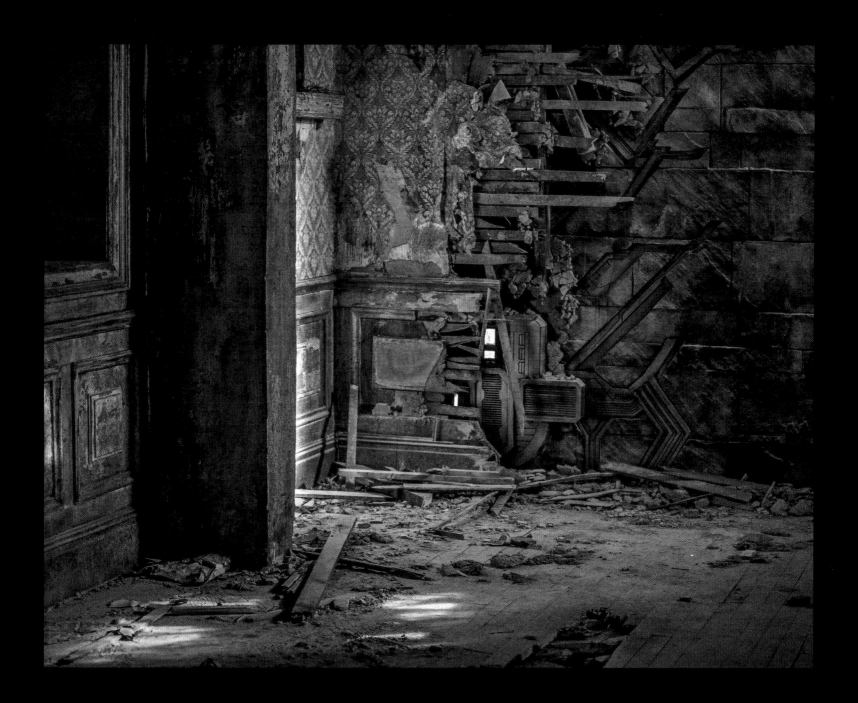

CONSUMED BY THE GUARDIAN

"These are explorations of the way the Dutch Hill wood comes up and attacks Jake," says Glass. "These brainstorms were to figure out the dynamics of how it moves, and the physics of it." A demon spirit at Dutch Hill keeps the dimensional portal safe from intruders, and to do that it will animate anything within the mansion's physical construction, from floorboards to ceiling fixtures. Tentacles of broken boards move with minds of their own and become boa constrictors when a victim is in their clutches. "It's like a guard dog," says Glass. "If you're unauthorized to use the portal, it will attack you."

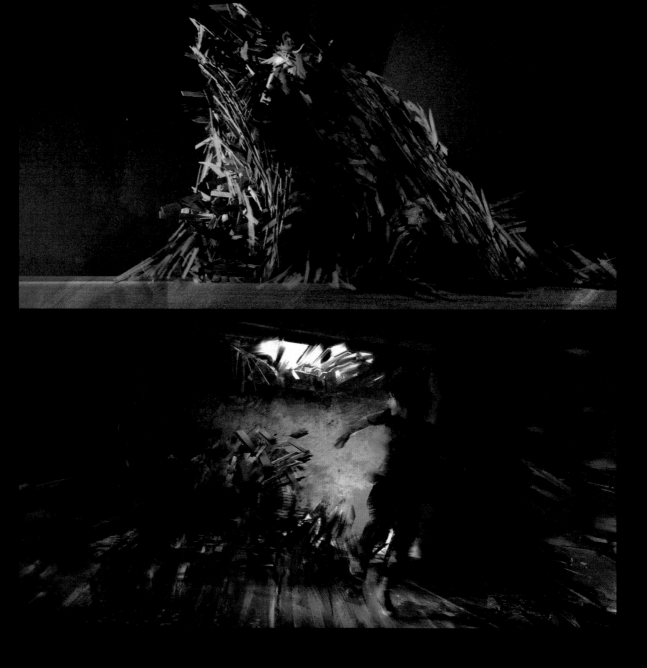

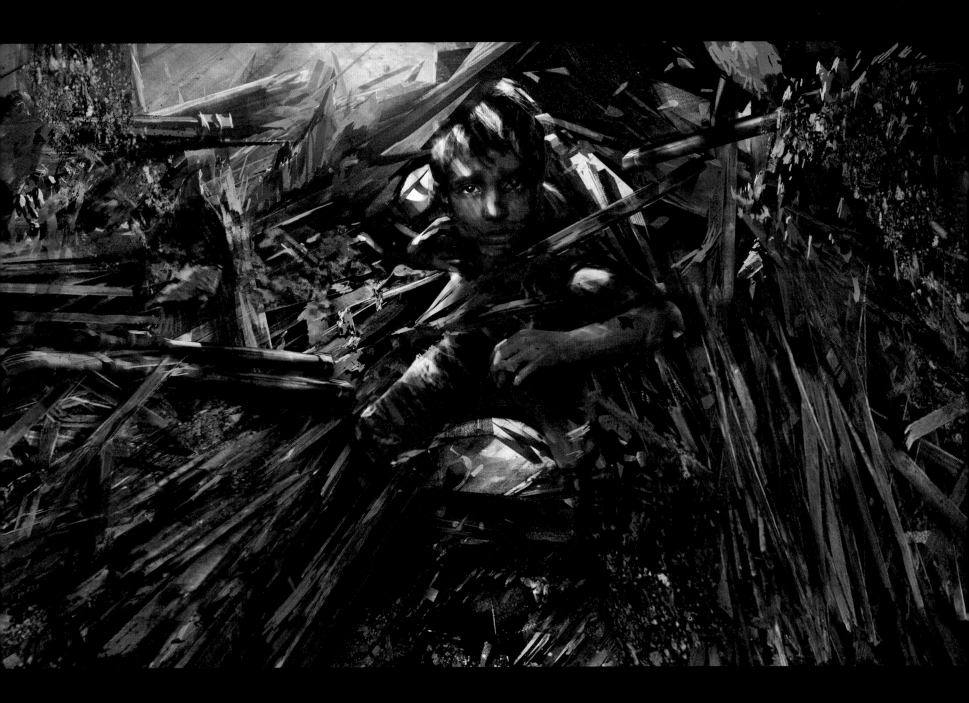

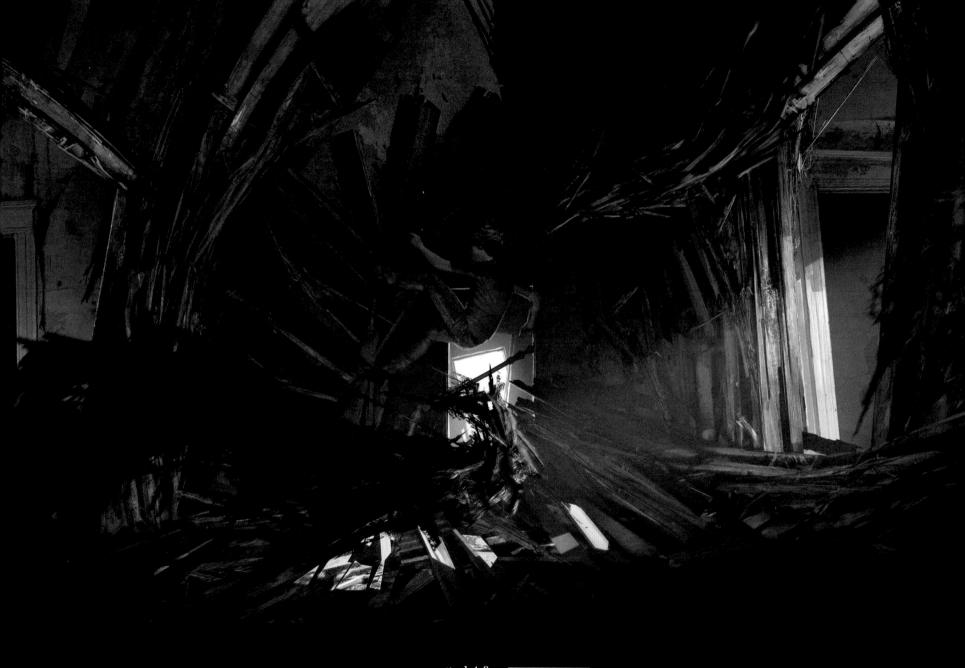

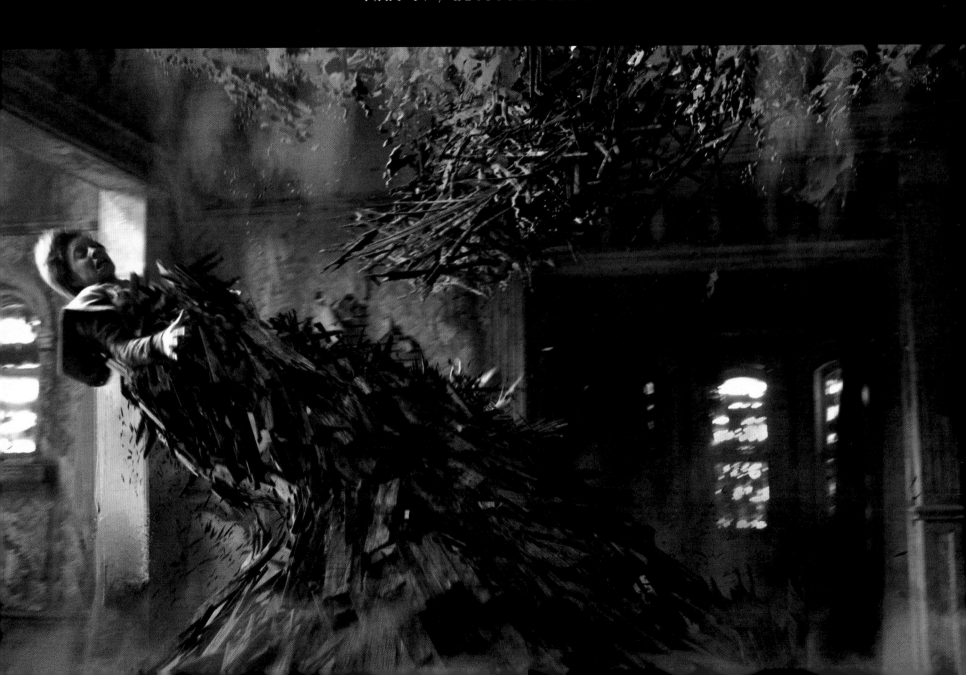

NEW YORK CITY

South Africa provided a wealth of creative filming solutions, but the streets of New York City could be played only by the Big Apple itself. The script's NYC story beats included a rooftop chase as Jake escapes from Sombra agents, a bus in which Roland attracts a few curious stares, and a knockdown brawl between Roland and the Man in Black's top thug. Because this version of New York is suffering the aftershocks of Walter's assault on the Tower, the crew frequently dressed the surroundings in rubble.

Brown recalls that the New York shoot took about eight days, during which the crew needed to convincingly simulate an earthquake. "Nik would make jokes: 'Just shake the camera and pull a few things over, and you've got an earthquake,'" he says. "Of course we weren't doing that, but he gave us that kind of allowance of thought."

The movie's emphasis on practical, in-camera solutions sets it apart from other cinematic epics and lends credibility to the world-building.

"Some movies are such an onslaught of buildings falling apart and bridges coming down that you're kind of numbed," says Brown. "That's not the world this movie is playing in. We wanted to make it look huge without huge visual effects shots, and we ended up bringing in a lot of rubble and broken cars."

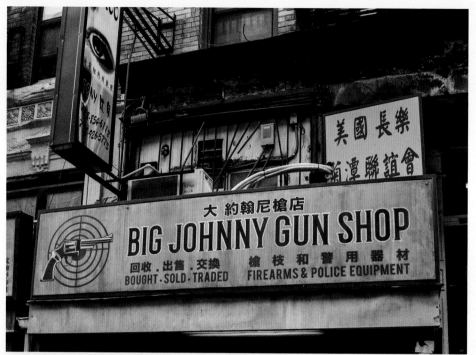

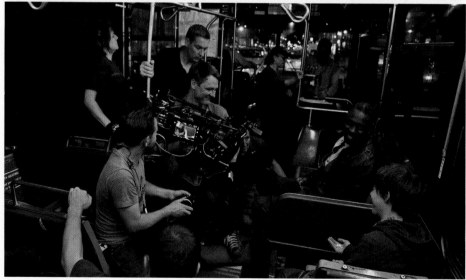

Special effects supervisor Max Poolman led the execution of the on-set tremors, beginning with a scene in which an earthquake rattles Jake's school. "We put vibrating motors into the school benches and boxes on the ceiling to drop dust and debris on the kids," he says. "It was a working school, so we only had an afternoon and a night to do it. Friday night to get it together, shooting on Saturday."

Jake is a native New Yorker, but Taylor hails from the United Kingdom. Taylor employed a voice coach to help blunt his natural English accent, but he found the big city to be an organic teacher. "It's just about getting used to the noise," he says. "Being in New York, you feel like a New Yorker already. You just pick up the vibe from everyone around you."

Idris Elba, no stranger to NYC, quickly discovered that his Mid-World getup helped put him into an appropriately fish-out-of-water mind-set. "I felt like I was the guy who forgot to go home the night after Halloween," he says.

The production crew prepares for a sequence in which Jake makes a vertical descent via a fire escape.

Opposite, top: The gun shop where Roland restocks his ammo and runs into the Man in Black.

Opposite, bottom: Elba and Taylor shooting in New York. After Jake's strange sojourn among the exotic biomes of Mid-World, location shooting in New York City helped ground the film in the familiar.

THE DIXIE PIG

It might have an Earth-based address, but behind the bland brickwork of the Dixie Pig is a nightmarish spread of riffraff collected from Mid-World and the realm of chaos ruled by the Crimson King. Videbæk sums up the Dixie Pig's mission statement: "It's as if Hell had an embassy on Earth."

The Dixie Pig needed to mix design elements from multiple realities into a sickening stew of wickedness. "It was a hard nut to crack," admits Videbæk. "Because what is it? We cut from Jake, where everything is in the normal world, to this interior representing the Man in Black and the Crimson King. And at the same time, its people can go out on the streets and blend in."

Glass cycled through numerous concepts for shaping the Crimson King's earthly HQ. "The early idea was that they had taken over the courtyard behind the buildings, making their own weird world on a city block in New York," he says.

That approach fell away as soon as the crew scouted Cape Town's Werdmuller Centre, a 1970s shopping mall that had been abandoned for years. Designed in the modernist style with angular ramps and open light wells, the market provided them with a multilevel blank canvas.

"It opened up so many ideas," says Glass. "It freed up a soundstage, and it gave us a much bigger set than we ever could have built on a stage."

Getting Werdmuller fit for filming meant sweeping up broken glass, hauling away dangerous hardware, and erecting a roof to shield the production from the elements. "We did a complete rehab," admits Brown, who oversaw the space's rapid transformation from vacancy to ghoulish vibrancy. "The amount of work was a huge undertaking. It was the hardest thing I've seen done by any art department."

In dressing the interior, Glass's team took inspiration from Hong Kong's infamous Walled City of Kowloon, the high-rise slum demolished in 1994. "There were whole townships within a single skyscraper," says Videbæk. "Ours was like a sci-fi version: a lot of people with small jerry-rigged boxes all over the place, and cables running wild from one place to another."

Glass agrees: "It's a mix of markets selling things the Taheen might want, and also a place where they fund themselves by doing illicit trade and dealing with contraband and endangered species on the black market. It's an outpost for the Taheen and vampires on Earth, so it functions as a consulate and a safe house."

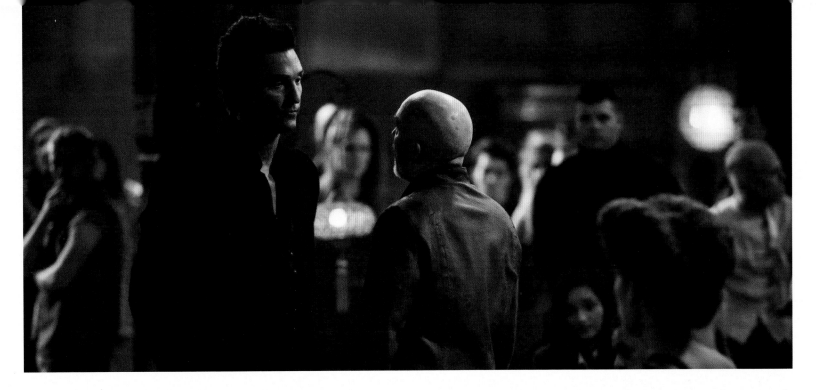

With the bazaar sharing the same air as a satanic shrine and a decadent lounge that resembles a Victorian opium den, Glass found the Dixie Pig to be a grab bag of oddities boasting a near-inexhaustible visual variety. "There's a weird fish market with aquariums, and there's a place for learning how to speak human. There's an altar to the Crimson King. There's a 'hair room' that we didn't even have concept art for; it was one of the things we came up with for when Roland enters the building from the rooftop."

Videbæk rattles off more Dixie Pig eccentricities, highly aware that his goal as director of photography was to lead viewers through the busy environment. "There are interesting things on every floor," he says. "Mask shops for them to disguise themselves, for example, and the headquarters where we meet the Man in Black. We're in this filthy, murky world, so

there's a lot of practical lighting to illuminate the weird things, and then we have this shaft in the middle, like a skylight. The mix of lighting gave it the feeling of a chaotic place with a lot of people doing strange stuff."

Poolman needed to rig the Dixie Pig for practical effects, including plenty of rapid-fire gunplay. "We had all these different weapons working," he says. "We had a guy with a high-caliber rifle shooting at Idris, so we had explosions all around the lead actor, detonated with squibs in the walls. In the bar, we squibbed up the bottles and walls and tables. We had explosions going across in the building as well."

Glass calls the Dixie Pig "the hardest set in the whole movie. Finding it, building it, scheduling, painting, doing the stunts, doing the set decoration for all the little things in there, it was like fifteen sets in one."

Jackie Earle Haley, who plays Sayre, the Dixie Pig's boss, declares the finished product both convincing and immersive. "When you walked onto that set, it was like Halloween on steroids."

Sayre (Haley, right, with McConaughey), the boss of the Dixie Pig, is one of the few people willing to stand before the Man in Black without first bowing and scraping.

Opposite, far left: A decorative metal pig above the entrance to the Dixie Pig explains the venue's name, but the hand-drawn symbol of the Crimson King is a more accurate descriptor of what lies inside.

Opposite, right: Concept art of a "lobstrocity," a creature that at one point was planned for a Dixie Pig cameo. "One of the [fish] tanks would get shot and you would see it spill out," says Glass. "It was an Easter egg, a nod to fans of the books."

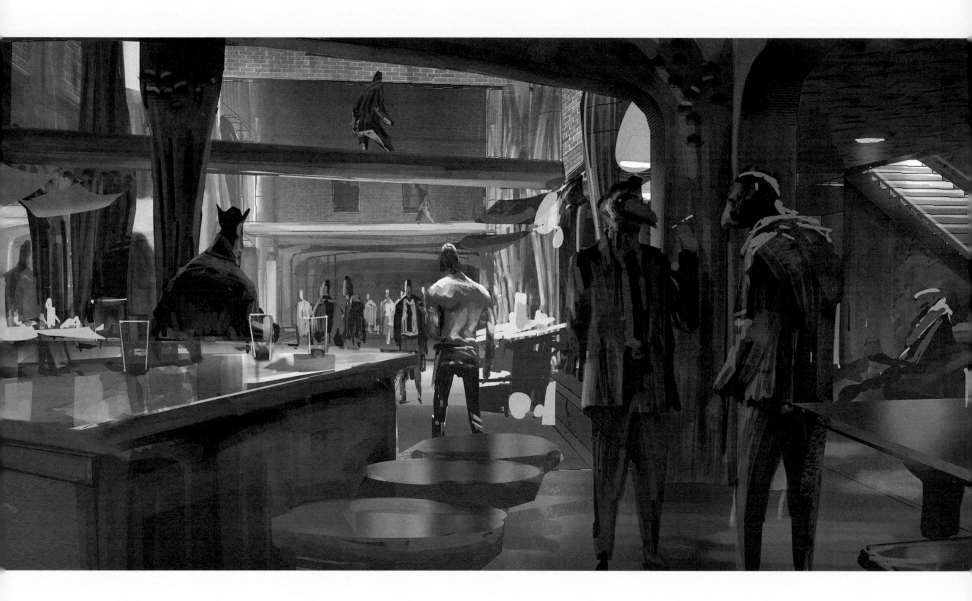

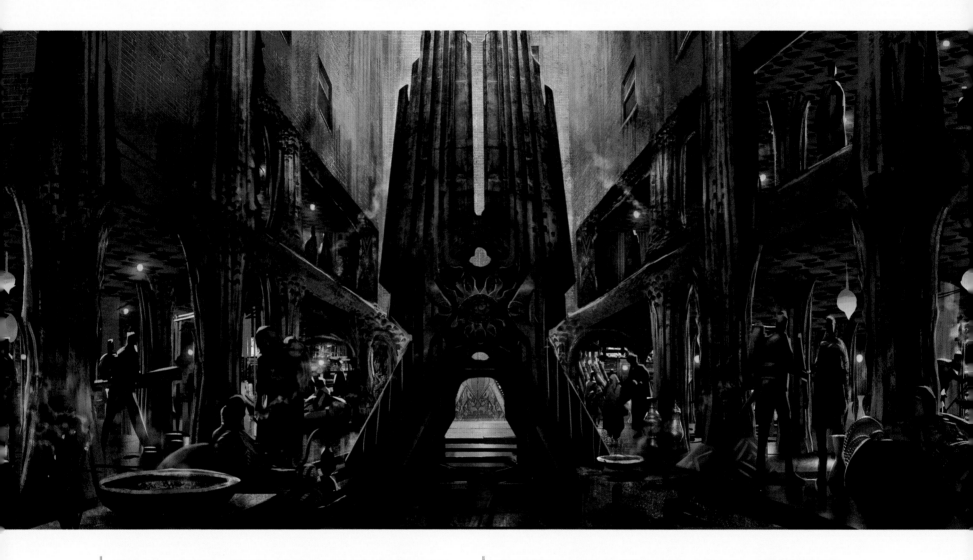

Previous spread, left: The multilevel insanity that comprises the Dixie Pig needed to accommodate many functions, from business planning to wild debauchery.

Previous spread, right: A collapsed ceiling offers a weighty contrast with the detailed patterning on the far wall, which lets in delicate pinpricks of light.

Above: A bizarrely organic altar is the centerpiece in these conceptual designs for the Dixie Pig's interior. While toned down in the final version, the altar is evidence of the death-cult religiosity that motivates the Man in Black and his amoral minions. "We created an altar to the Crimson King as a central focal point," explains Glass. "Early on, Walter had an altar in the Devar Toi [in Mid-World], but we took it and moved it to the Dixie Pig. We were looking for something that could be a central focus and be more than just a bar or club."

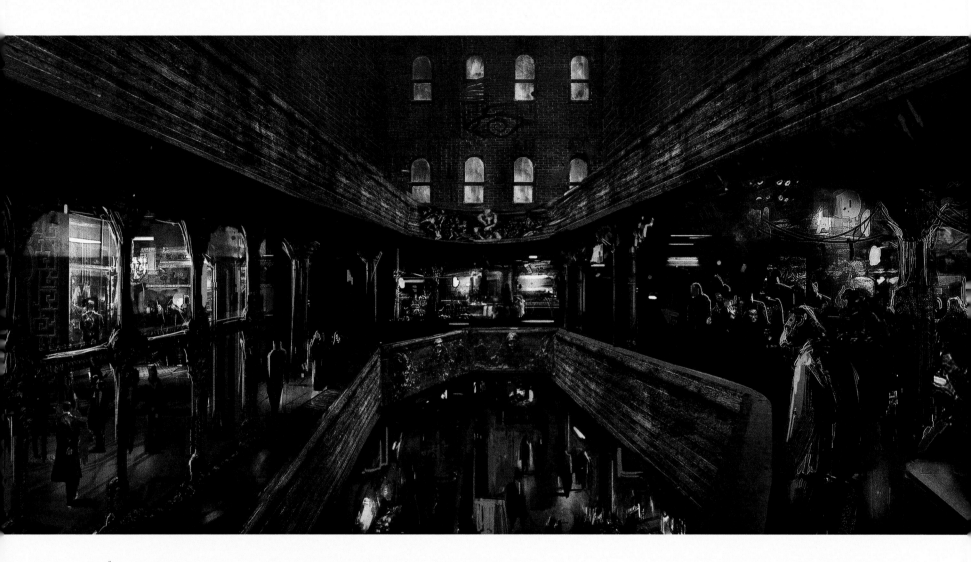

Werdmuller Centre, an abandoned shopping mall in Cape Town, became the real-world backdrop for the Dixie Pig. The concept illustrations of the Dixie Pig emphasize wide-open spaces and multilayered elevations, factors that Werdmuller had in place already.

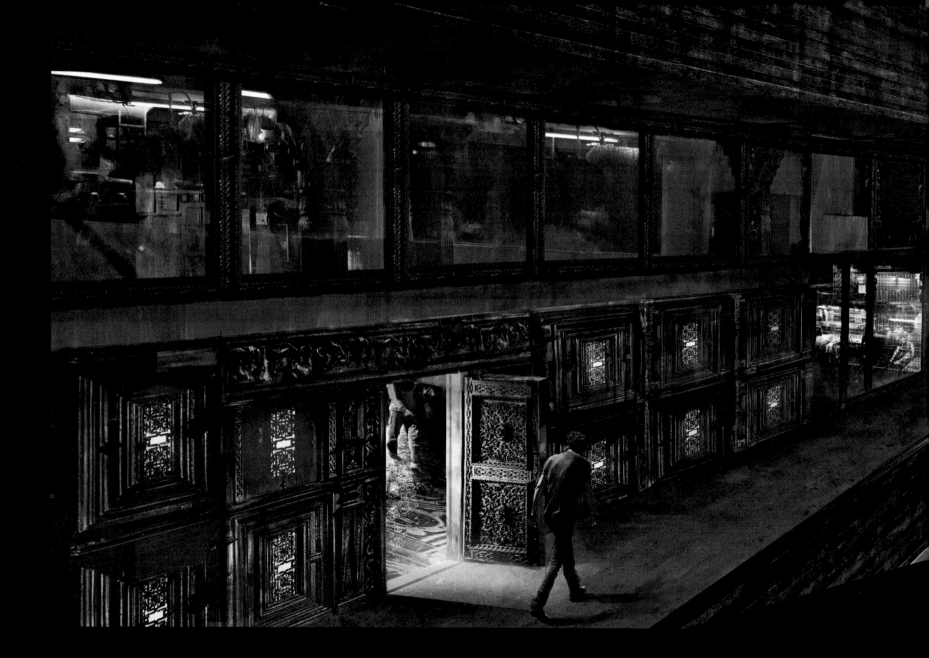

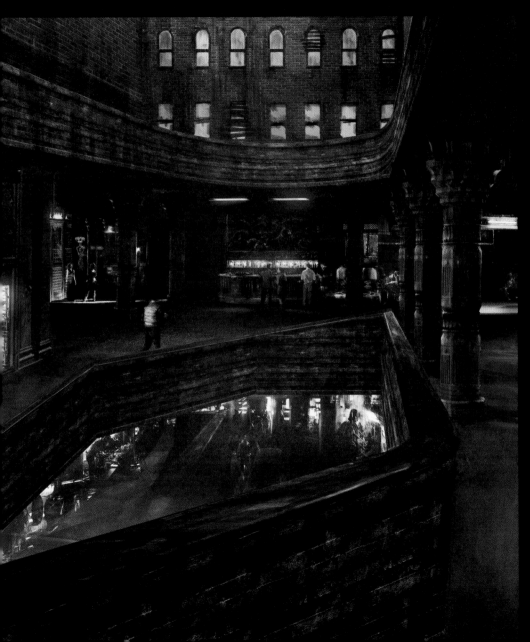

Opposite: From any point in the Dixie Pig, its inhabitants can get an angle on what's happening on the floors above and below them.

Top and Bottom: Two views of the empty interior of the Werdmuller Centre in Cape Town. The production crew chose the space for its stark architecture and dramatic central lighting.

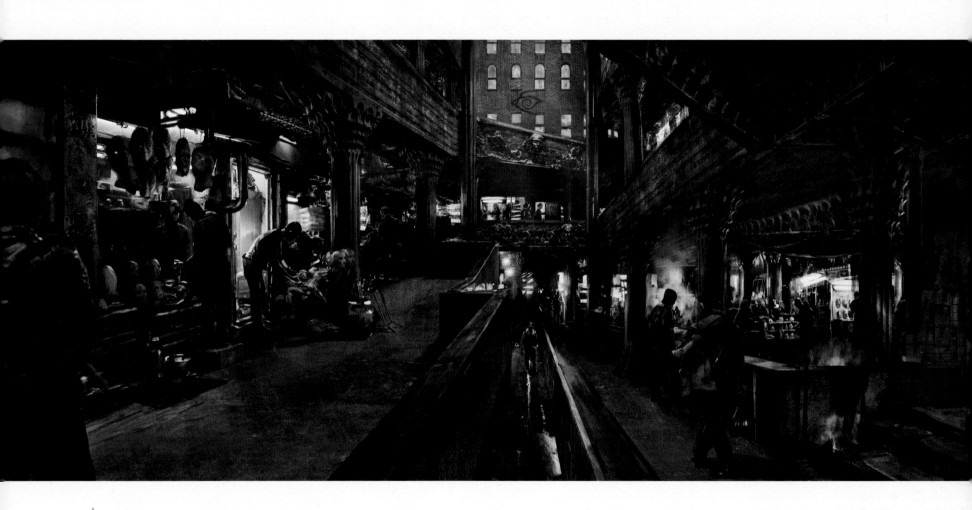

A conceptual vision for the fully dressed Dixie Pig set in
which every inch crawls with movement and every alcove
is stuffed with strange parcels and relics.

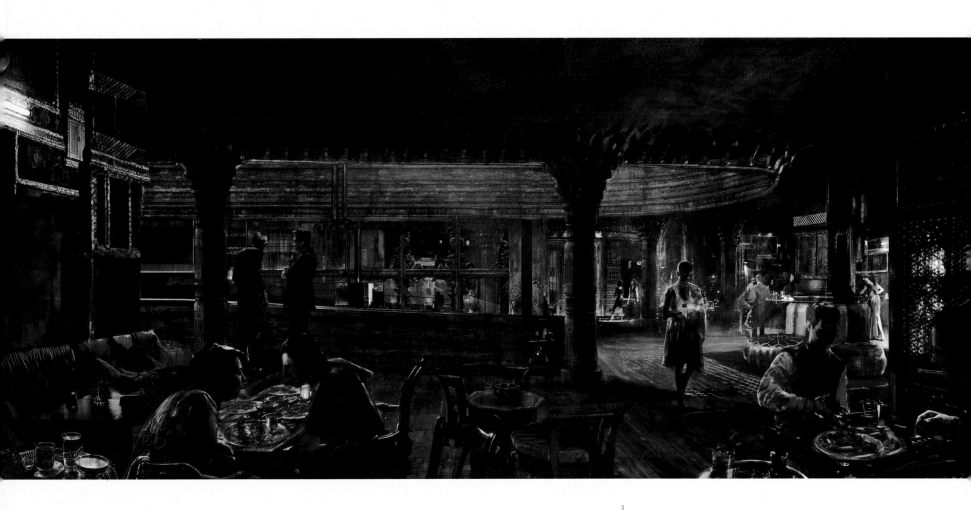

The bar provided a natural gathering place for the Dixie Pig's patrons.

Above: Walter is a man of vision. The grand plans taking shape in Breaker Central will usher in a new age of hellish insanity.

Right: This tell-tale angular geometry indicates the presence of a dimensional portal within the Dixie Pig.

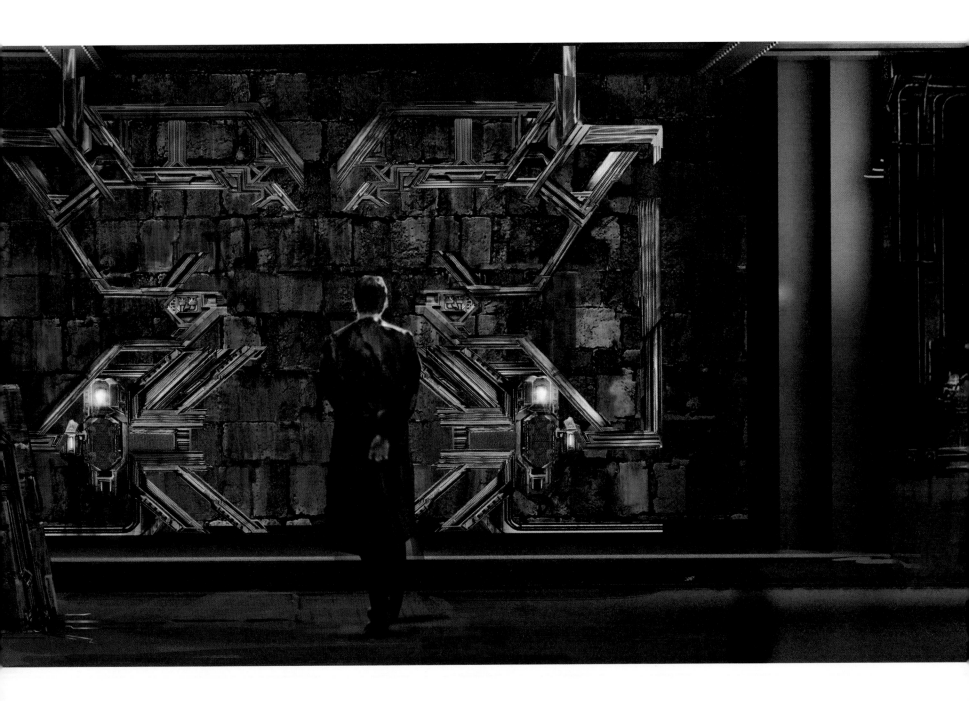

AGENTS OF THE CRIMSON KING

Monsters are real in the world of the Dark Tower, and they rub shoulders with human beings every day. Some are Taheen, a race of beast-headed chimeras based on rats, crows, and snakes. A few are Can-Toi, a hybrid race of evolved Taheen, also known as Low Men. Still others are classical vampires, those immortal blood-drinkers of folklore. In the battle they hope to bring about, they will serve as the foot soldiers in the Crimson King's army.

For the Taheen or the Can-Toi, strolling down a New York City sidewalk is off-limits without a convincing disguise. Fortunately, full-face masks are able to dupe most humans, but even this remarkable handiwork falls apart under close scrutiny. One telltale giveaway is a raised seam running down the length of the neck.

Some Taheen are dedicated warriors and trackers. "They're like Walter's special forces," says Glass, pointing out that the Taheen trackers don't necessarily need to wear masks because they operate in Mid-World. They still do, though. "We ended up covering their faces, because we found they actually looked scarier that way," he says. "Less is more."

Costume designer Trish Summerville created a dozen outfits for the Taheen trackers. "I draped each costume by hand, with a couple of people in my department hand-sewing them.

We made hoods, masks, shoes, and head wraps, so no skin or fur was exposed," she says. "Our aging and breakdown department then made them look like they'd been out in the elements, living on the land and covering all this terrain."

A handful of Taheen received fully computer-generated animal faces during post-production, but Taheen are seen only behind humanoid disguises. "When they put the mask on, they fit into the real world, with a hint of what they were underneath," says hair and makeup supervisor Nadine Prigge. "For example, Tirana was a lizard. I did a bit of lizard scaling on her eyelids, and I tried to create a hairstyle to inform the shape of her real head."

Aithadi points out that Taheen races can be furry, feathery, or scaly, but for clarity he tried to focus on a single look. "We mostly concentrated on hairy characters," he says. "We didn't want to introduce too many different faces, and we wanted to keep a consistency to the Taheen. If you have a hairy character, it's easy to make them look like a werewolf, and if you remove some of the hair, it easily goes into the vampire world. It was important to find a balance, to make a species that was unmistakable."

The Dixie Pig's background characters were sourced from casting calls looking for extras with interesting faces. "Really light eyes, or an interesting bone structure or skin tone," says Summerville. "Something we could work with through makeup or hair or costuming to fit different categories."

Prigge elaborates: "They would be normal-looking people, but there would be something uncomfortable, something to give you the feeling

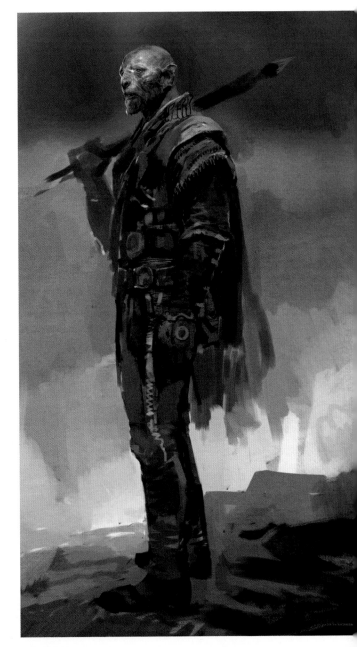

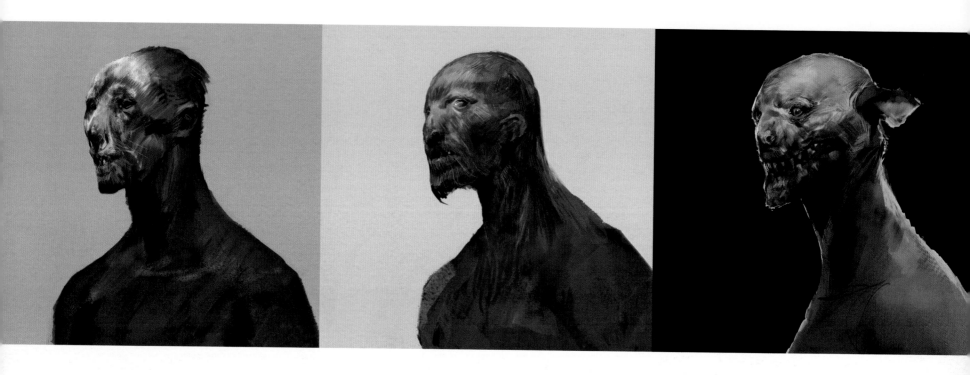

that the mask didn't quite fit. Maybe too much makeup, or hair that looked like a wig, or a hairstyle or lipstick color that was just off. I used prosthetics to block out eyebrows and put in cheekbones. It always had the feeling of not being quite real."

As if the Taheen and the Can-Toi didn't have enough taxonomic variety, the Dixie Pig also houses multiple flavors of vampire. The Crimson King's human-passing agents wear intentionally unremarkable everyday clothing. "First we made uniforms for all the Sombra employees—the two that try to abduct Jake and others you see on the street looking to kidnap kids with the shine," Summerville says. "Then

we did a group of construction workers and maintenance men who could also blend into society. We did a corporate look, all suits and ties, for people who could be politicians or work in banks. And there's some who are involved in sex and drug trafficking, so we had a group of people that were dressed like that. Many subcultures of daily life and the dark side of society were represented."

Maintaining the variety of the villainous horde was a huge job, involving production design, costuming, makeup, and visual effects.

"It was a tapestry of the underworld," says Prigge, filled with "a great, eclectic mix of designs and characters."

Previous spread, left: Three concepts for how Taheen would look in concealment. No matter how good their disguises are, Taheen stand out due to strangely shaped faces and off-putting mannerisms.

Previous spread, right: A Taheen tracker in its natural state, with no need for a human disguise.

Above: Various studies of Taheen bone structure and facial features, spanning a continuum from nearly human to fully animalistic.

Opposite: A close-up study of a Taheen tracker with associated full-body costuming sketch.

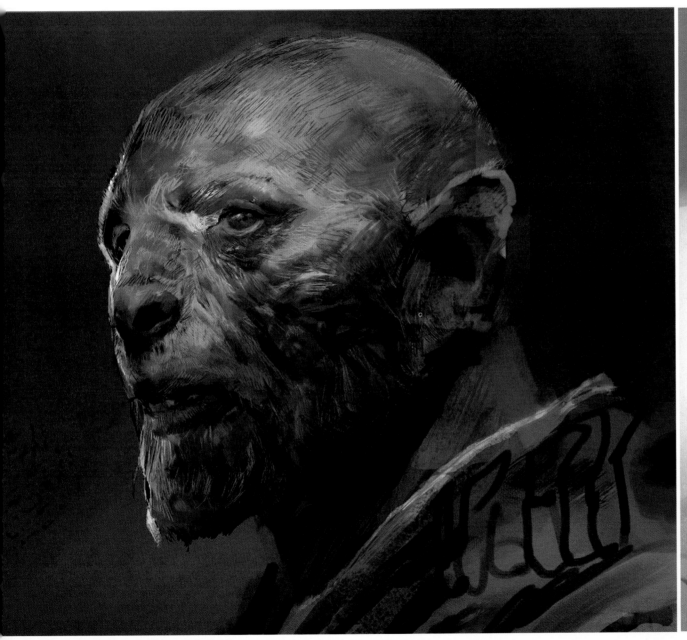

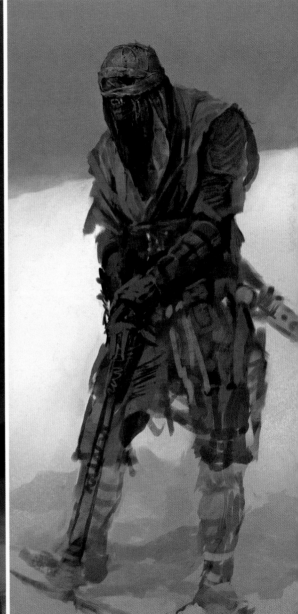

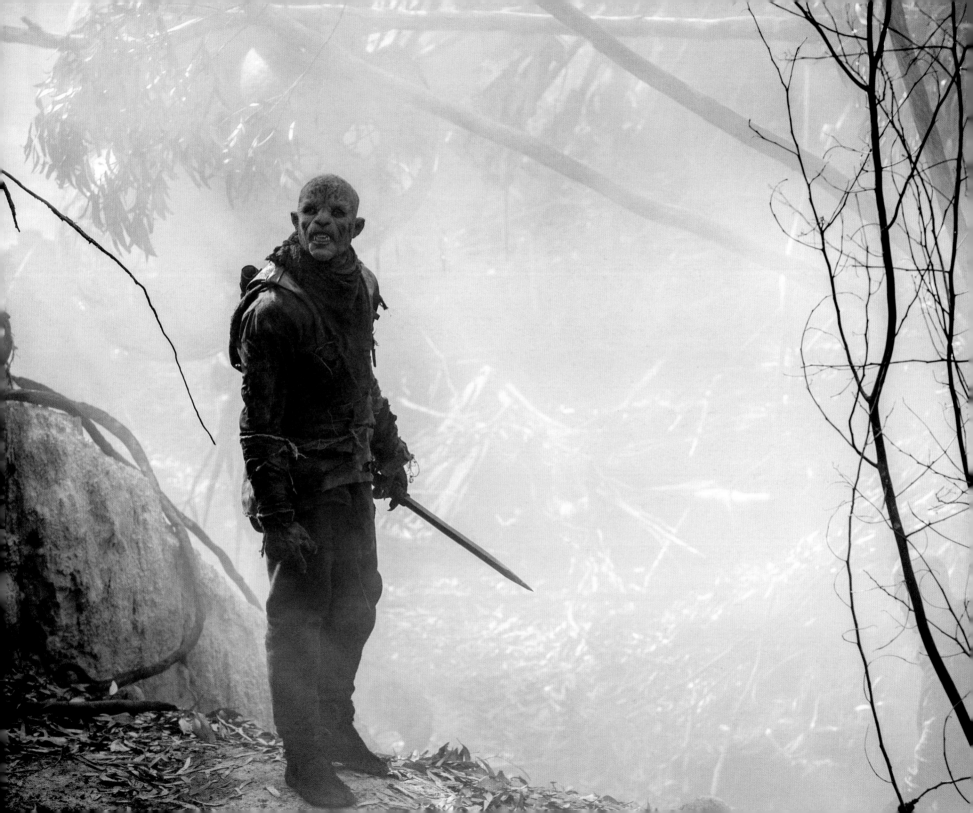

DEATH SQUAD

Taheen trackers are assigned to hunt down the Gunslinger and Jake, eventually catching up with the pair at Manni village. The Taheen possess catlike senses and wrap themselves in loose-fitting clothing suitable for both travel and combat. Unflagging in their persistence and lethal at close quarters, they carry blades but are just as dangerous when using their claws to slash and rend. Costuming concepts experimented with both bulky and slim looks, balancing the need of the trackers to carry all their gear with them against the practical advantages of unencumbered fast attack. The Taheen eschew heavy armor and use hooded cloaks to hide in the shadows.

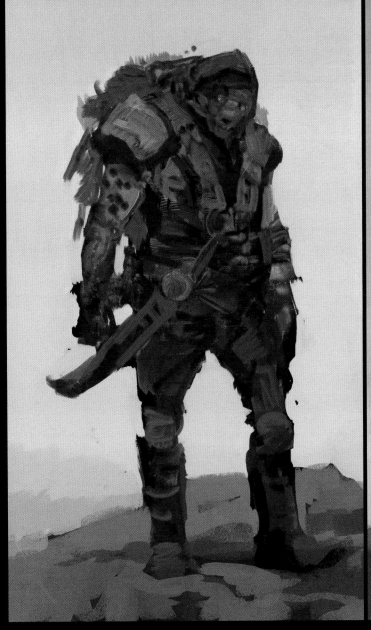
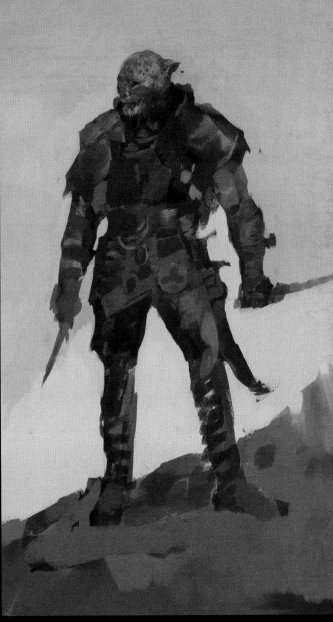

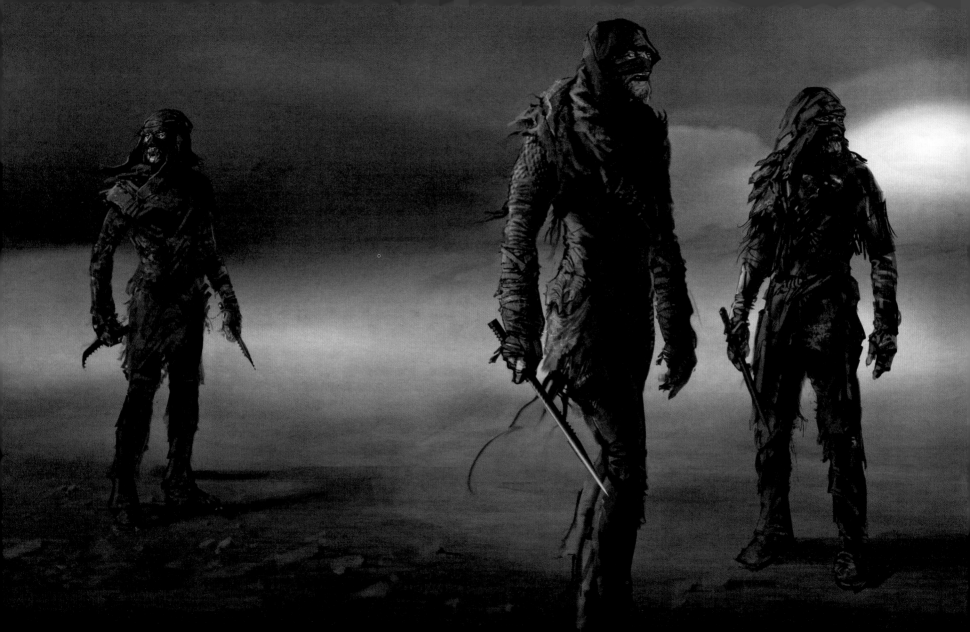

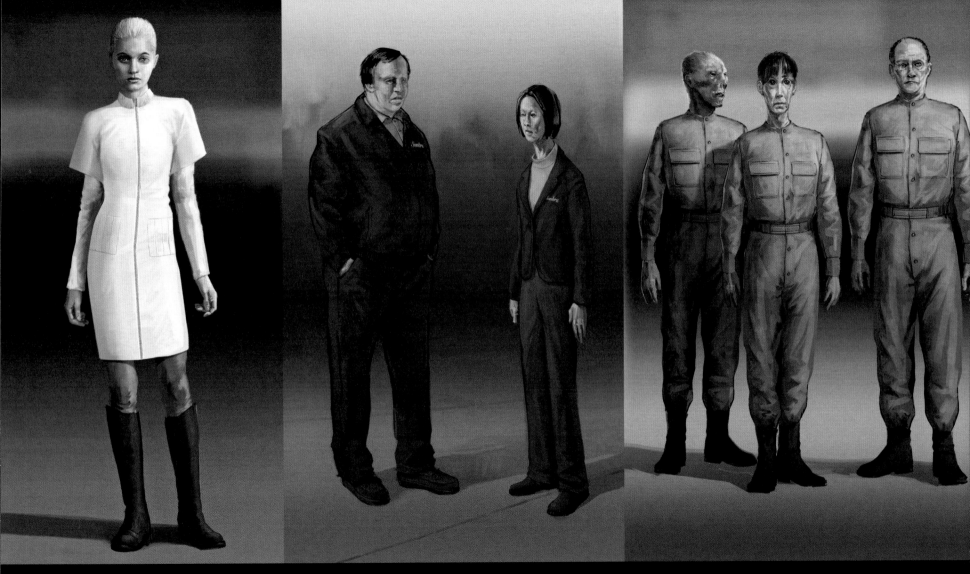

Three studies of disguised Taheen. Tirana (left) is one of the Man in Black's highest-ranking officers. Toby and Jill (center) visit Jake's New York apartment in an effort to take him into custody. Three uniformed Taheen techs (right) stand ready to operate the equipment in Breaker Central.

BECOMING TAHEEN

Some of the Taheen came to life through elaborate makeup and prosthetics. Beginning with facial casts of the Taheen actors, makeup artists fashioned form-fitting prosthetics and crafted glove-like applications for any hands that would be visible extending from sleeves. Catlike Taheen received detailed touch-ups including spots patterned after the coat of a fast-moving cheetah or similar big cat. Prosthetic teeth and colored contact lenses completed the predatory look.

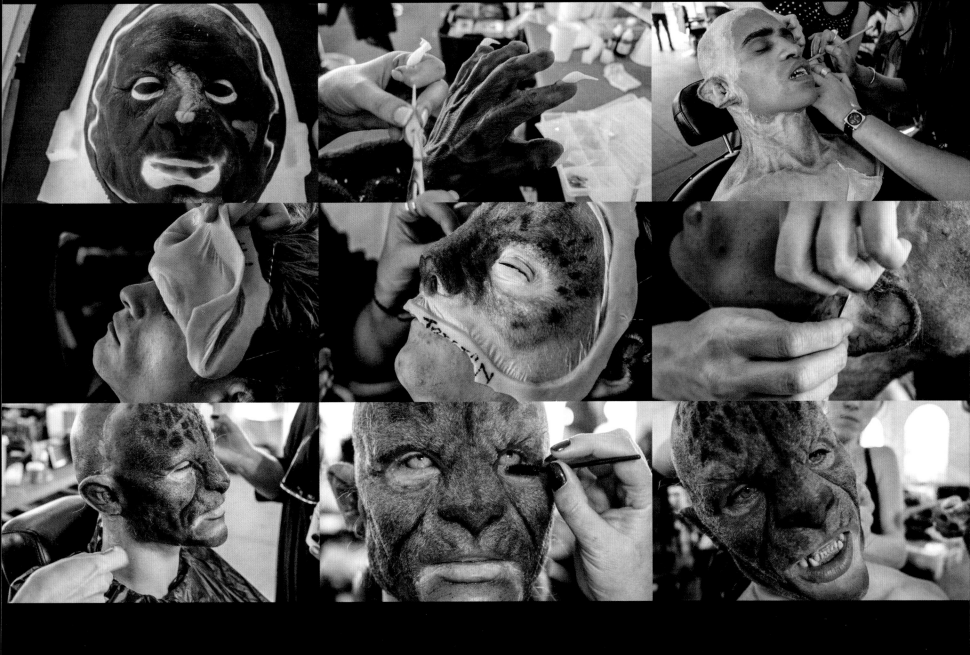

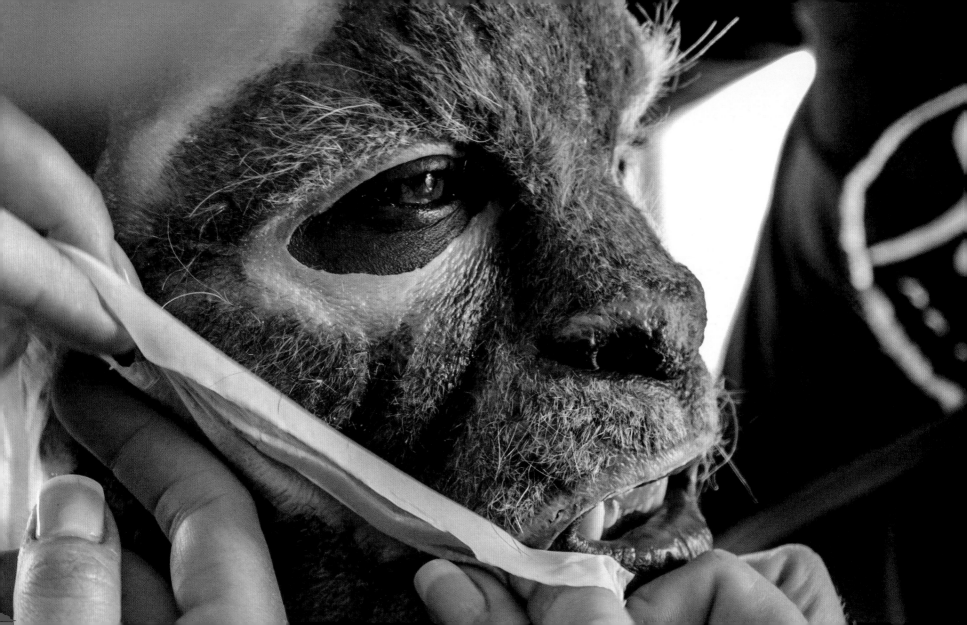

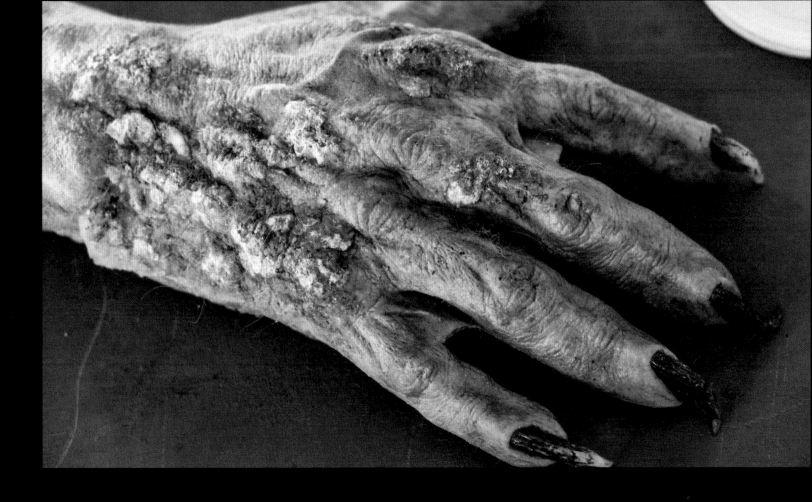

NIGHT OF THE VAMPIRE

In the Dark Tower mythos, vampires exist
alongside the animal-headed Taheen,
with both filling roles as spies and
assassins for the Man in Black. Elaborate
makeup and facial prosthetics helped
the actors achieve a more vampiric look,
in which grooved, blistered skin took
the place of the trimmed fur of the
feline Taheen. Jagged fangs became
a core feature for the vampires, with
scabs and swellings on the skin.

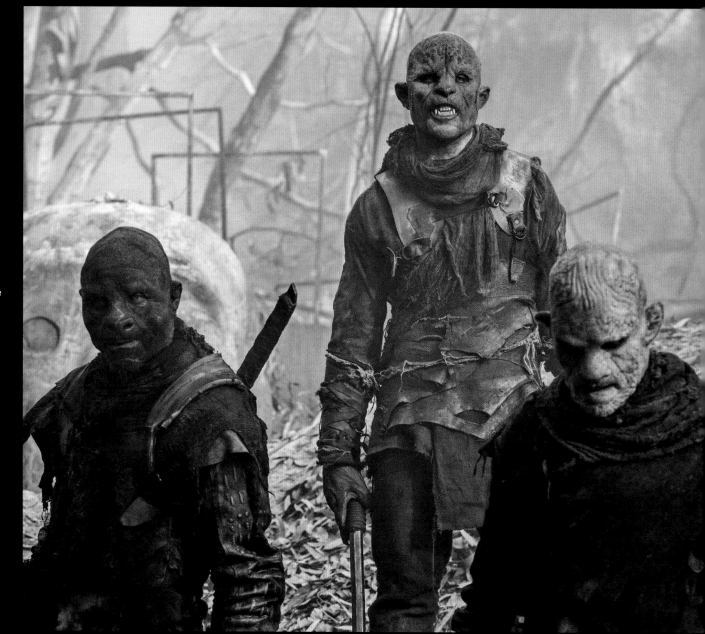

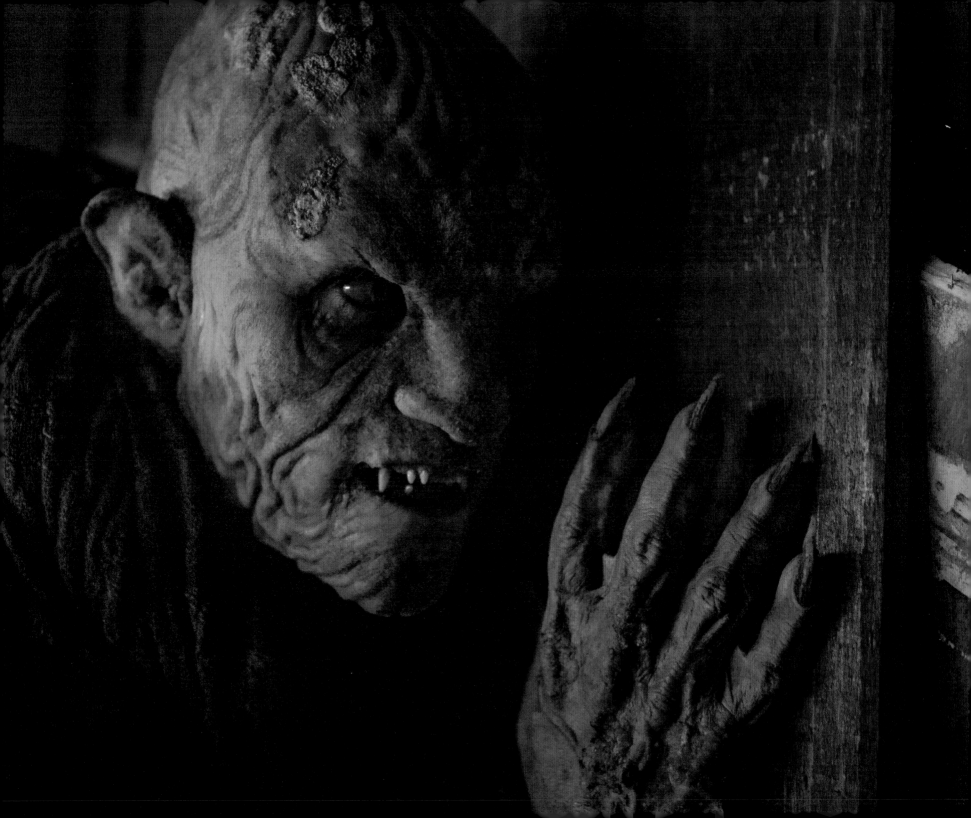

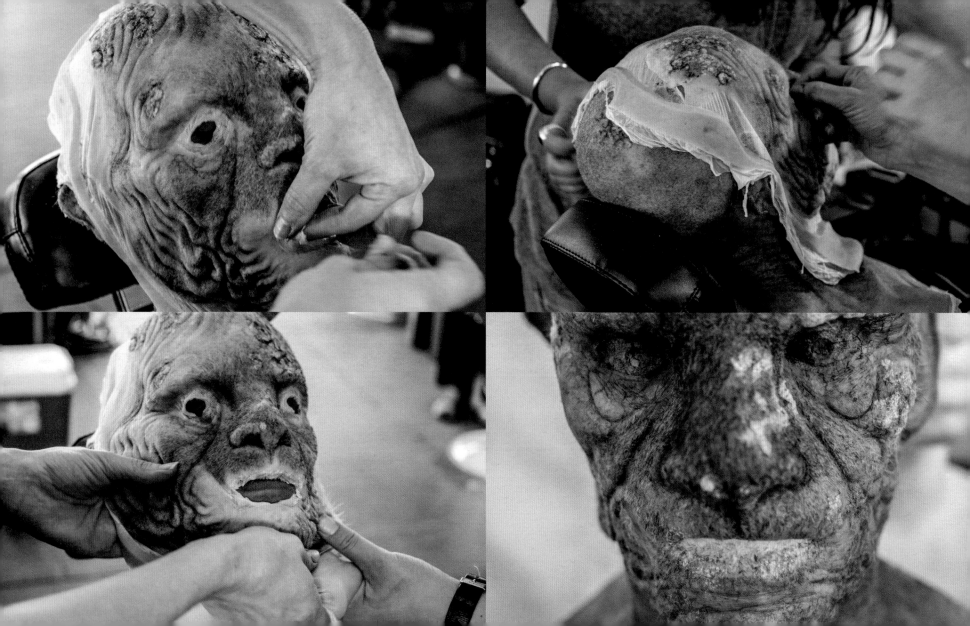

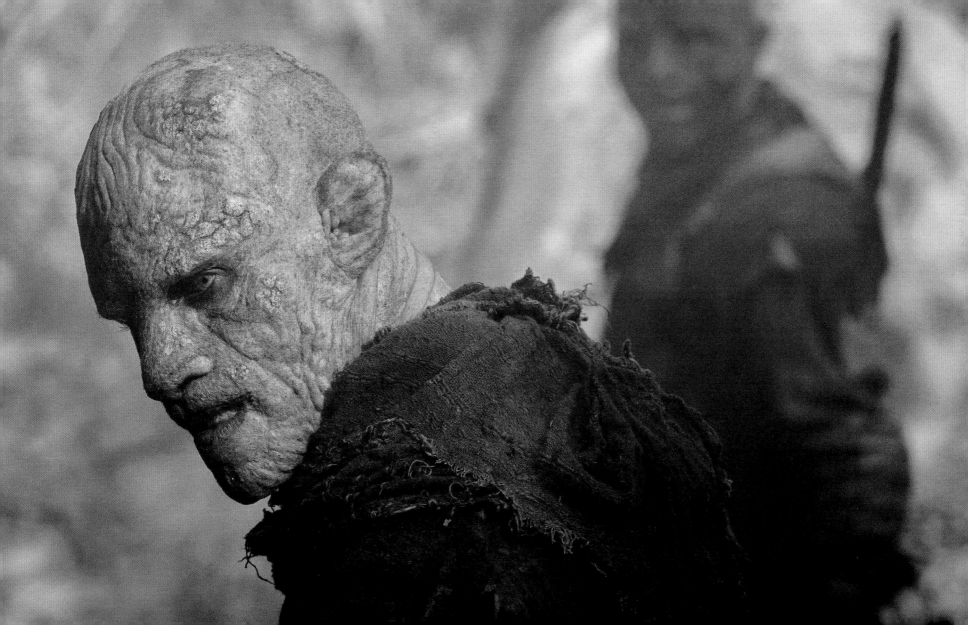

SAYRE

Sayre is the boss of the Dixie Pig and a centuries-old Can-Toi whose face bears the marks of a thousand battles.

Haley stepped comfortably into the skin of this inhuman enforcer. "Sayre reports directly to Walter, and his purpose is to serve the Crimson King on Earth," he says. "He's the head of the Dixie Pig and all of the Taheen, Can-Toi, and vampires that reside there, and it's our job to protect the portal."

Summerville crafted a unique outfit for the villain, mixing NYC styles with subtle Taheen ornamentation. "Sayre runs Walter's lair on Earth, with vampires and creatures and Taheen and human thrill-kill cultists," she says, "so it was about making him acceptable so that he could walk out of the club and interface in the normal world. I did his jacket in a reptile-like dark green, and I added scarification detailing down the sleeves."

Prigge tried to emphasize Sayre's alertness and his dangerous demeanor. "We used a short beard to chisel his features," she says, "and I gave him contact lenses, for eyeball tattooing that looks a bit freaky."

Haley as Sayre. His character is an evolved Taheen known as a Can-Toi, and he exudes centuries of confidence in his position as the Dixie Pig's top dog.

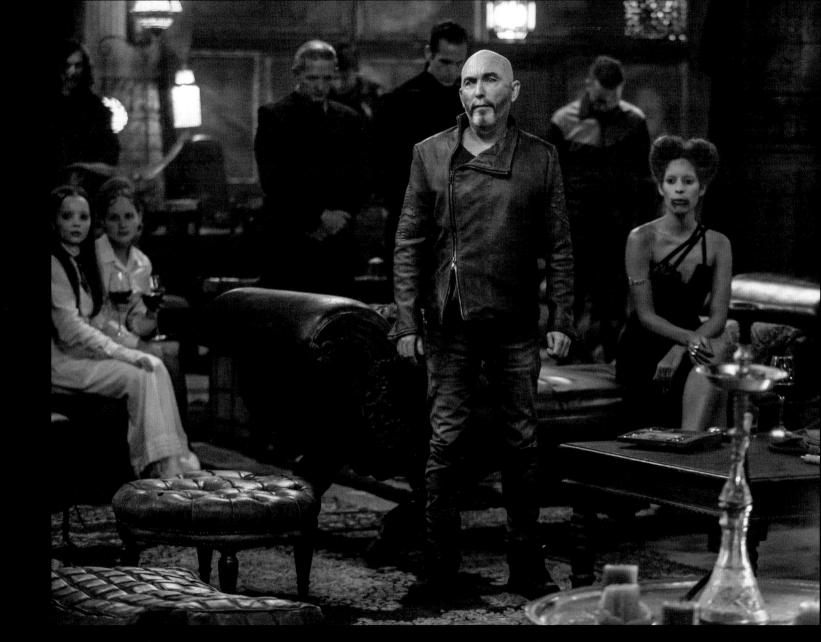

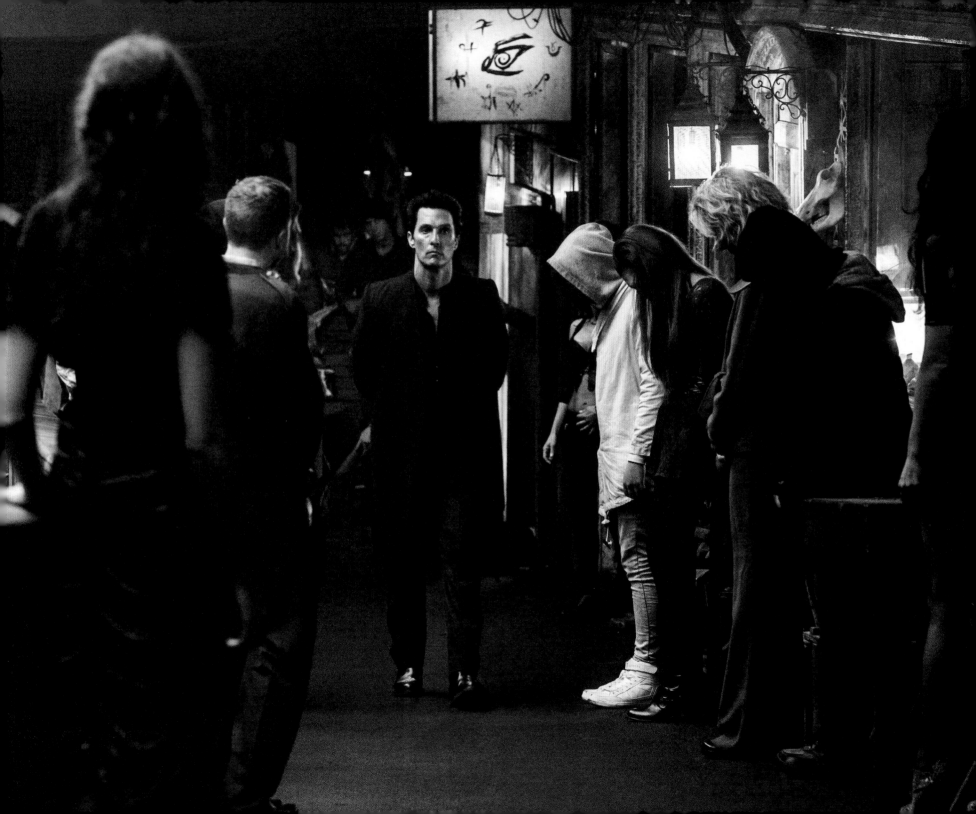

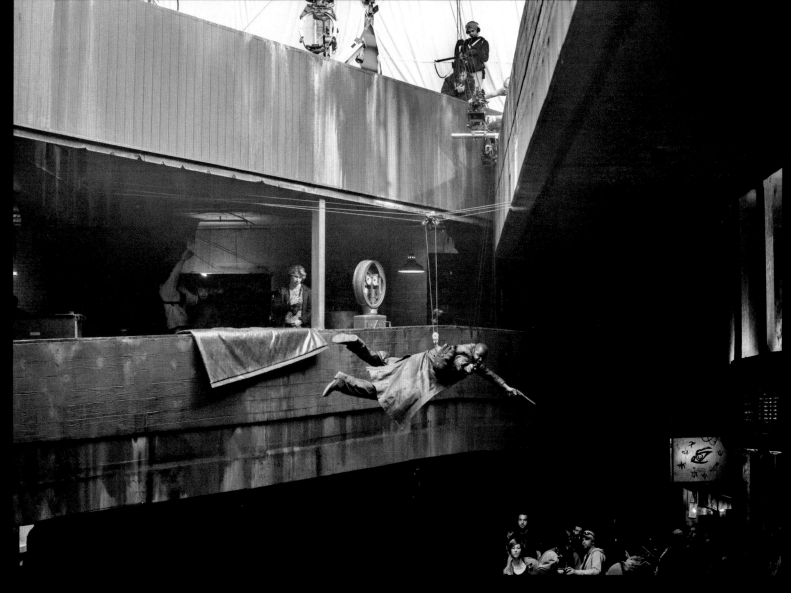

The multilevel Dixie Pig offered a diverse environment for staging creative action sequences. Here, Elba's stunt double takes aim while hanging in mid-air on a wire rig.

Opposite: The Man in Black strides with icy purpose through the Dixie Pig. Vampires, Taheen, and other monsters show respectful deference as he passes.

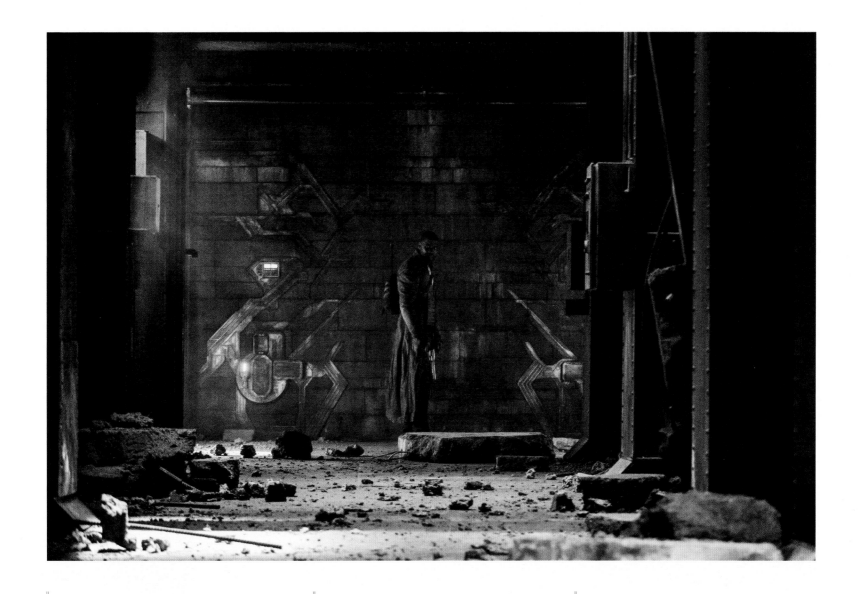

Opposite: The Man in Black prepares for a final showdown with his longtime nemesis, the Gunslinger.

Above: The Gunslinger surveys the massive wreckage near a portal gateway.

Following spread: The Man in Black and the Gunslinger face off in this concept art.

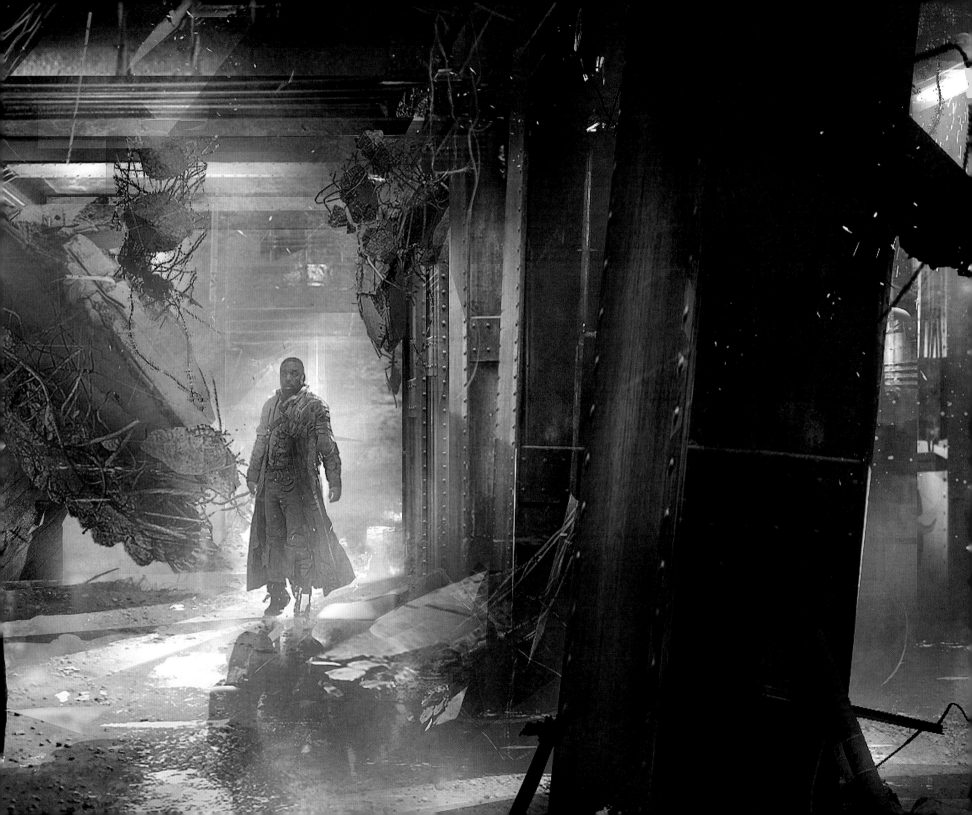

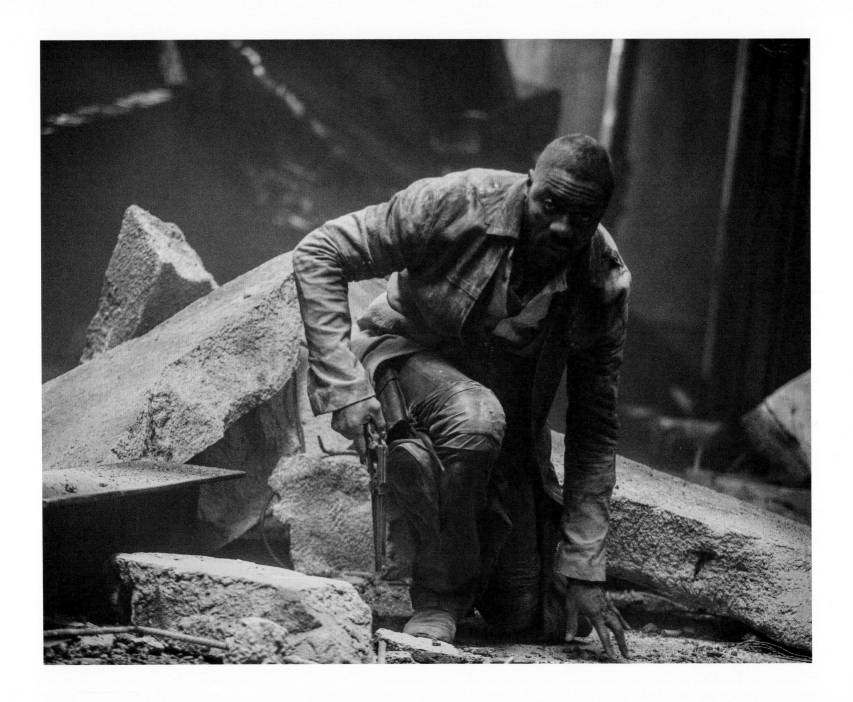

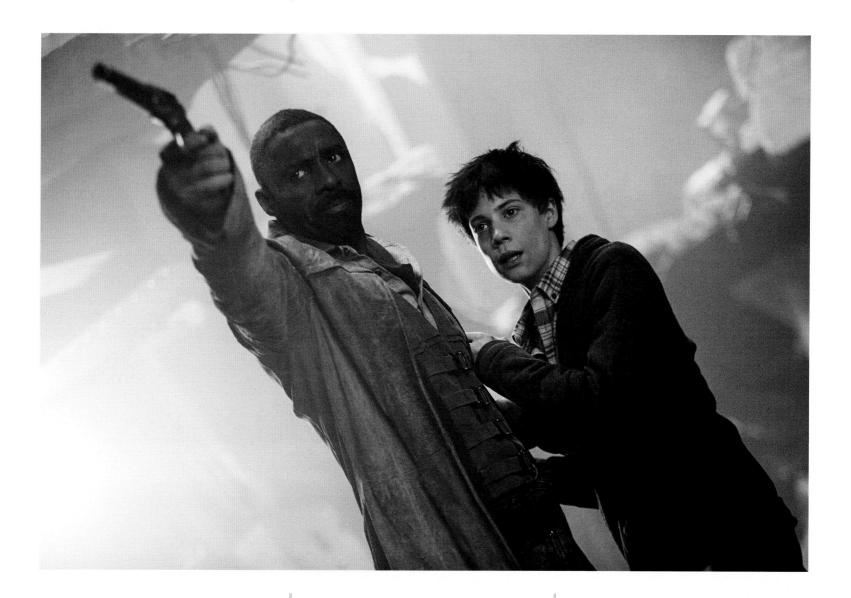

Opposite: Roland, looking somewhat worse for wear, isn't about to give up.

Above: Roland's connection with Jake gives the exhausted Gunslinger the motivation to go on. In Roland's eyes, Jake is well on his way to becoming a Gunslinger himself.

PART V

Details of the final Dark Tower can be seen in this striking image,
which was taken directly from the film.

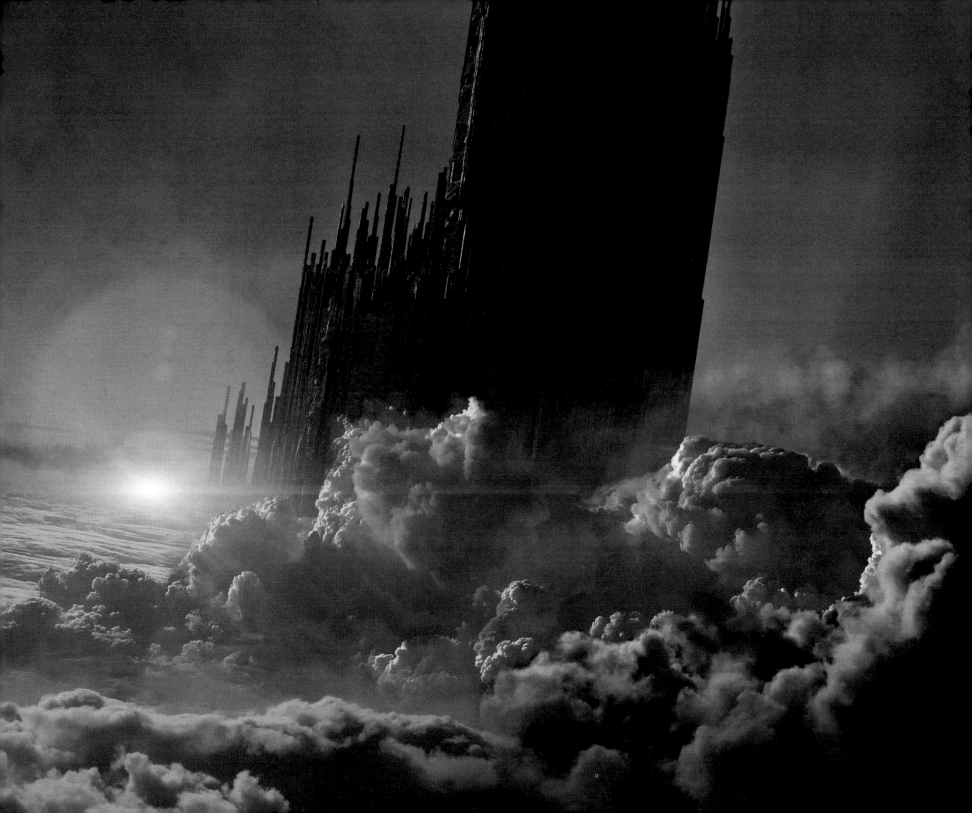

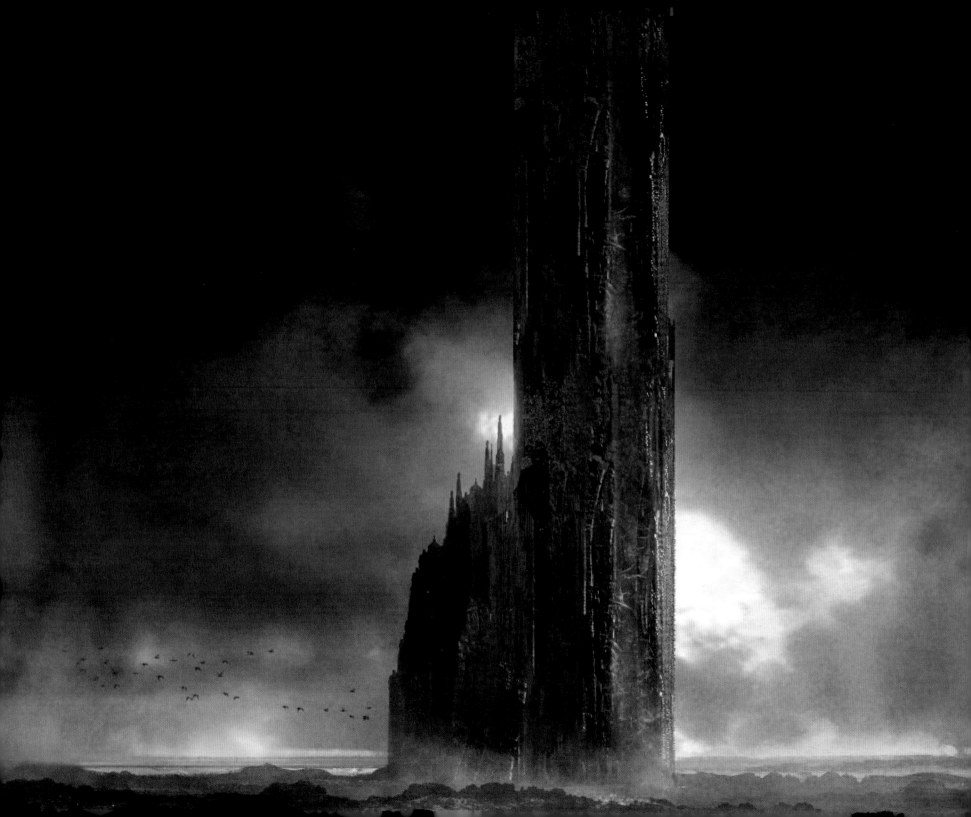

THE
DARK TOWER

The aura of the Dark Tower saturates every aspect of its namesake film. The Man in Black seeks to raze it. After he rejects cynicism, Roland commits himself to the Tower's preservation.

Roland's journey wasn't that different from the one the filmmakers took.

"We talked about that many times," says Ron Howard, acknowledging the Tower as a metaphor for his team's ambitions. "Because it really has been a quest for us, a creative quest, with its own twists and turns. And I suspect that it always will be."

Visual effects supervisor Nicolas Aithadi helped craft the Dark Tower's big-screen incarnation, aware that the task meant sculpting the holiest of holies in the realm of Mid-World. "We wanted to make it so big you would never see the top," he says. "The base is so massive, and we don't know where it stops—or if it ever does."

Also a mystery is the Tower's precise location. "The Dark Tower is nowhere near anybody, so what we tried to put into images is that the world around it doesn't look like anywhere else in the film," says Aithadi. "When Jake and Roland are walking through Mid-World, we didn't want it to feel that the Tower might not be all that far."

By the end of the film, Roland has turned his course in the direction of the Tower's magnetic pull. The journey there will span multiple stories, shared among multiple mediums. A Dark Tower TV series is currently in the works.

"It's challenging material, and it requires creative ambition and a willingness to take risks," says Howard. "That's part of the excitement, part of the thrill. That's what it will always be when we're in the Dark Tower universe."

The Dark Tower stretches out of sight surrounded by a moody mix of haze and angry storm clouds.

Following spread: A vision of the Tower's destruction—an act which would bring about the end of the universe.

CREATION'S STAKE

The Dark Tower is more than the name of
a book series or the title of a film, though
in Stephen King's metafictional reality it is
simultaneously both those things while also
being the in-story anchor that ties together
every universe both real and imagined. It's
impossible to overstate the Tower's impor-
tance in preserving the orderly multiverse
from the forces of demonic destruction.
In his plot to kidnap Jake Chambers, the
Man in Black wants to break the beams
and breach reality's last line of defense.

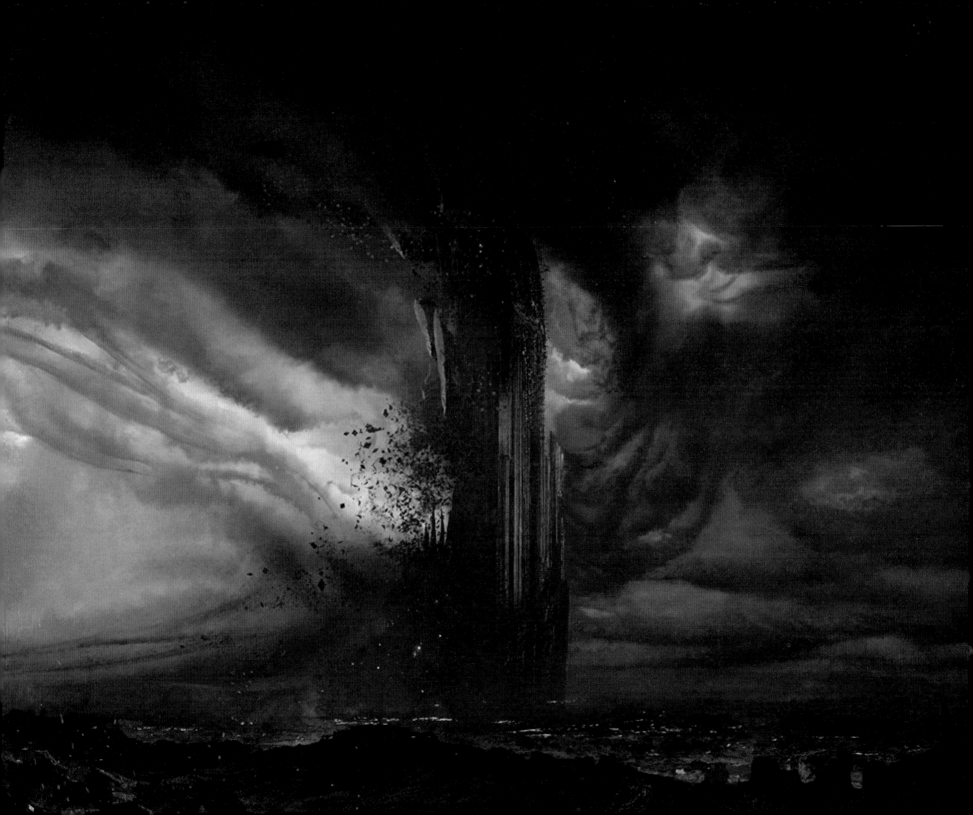

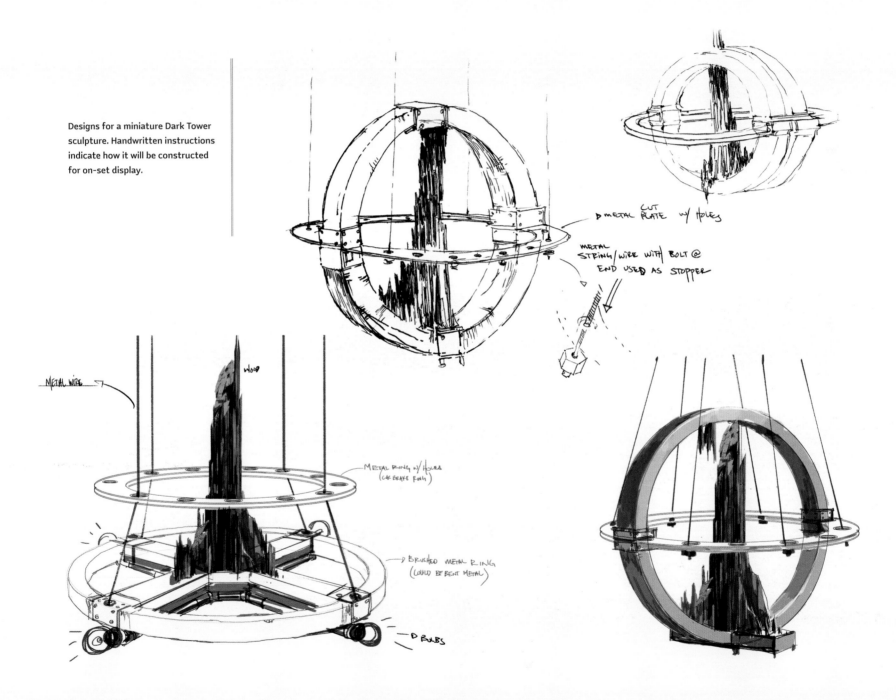

Designs for a miniature Dark Tower sculpture. Handwritten instructions indicate how it will be constructed for on-set display.

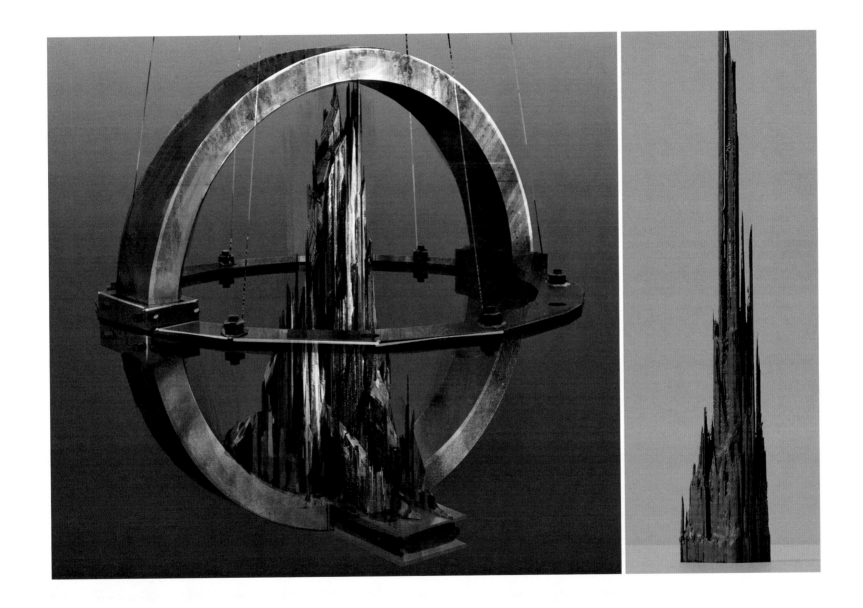

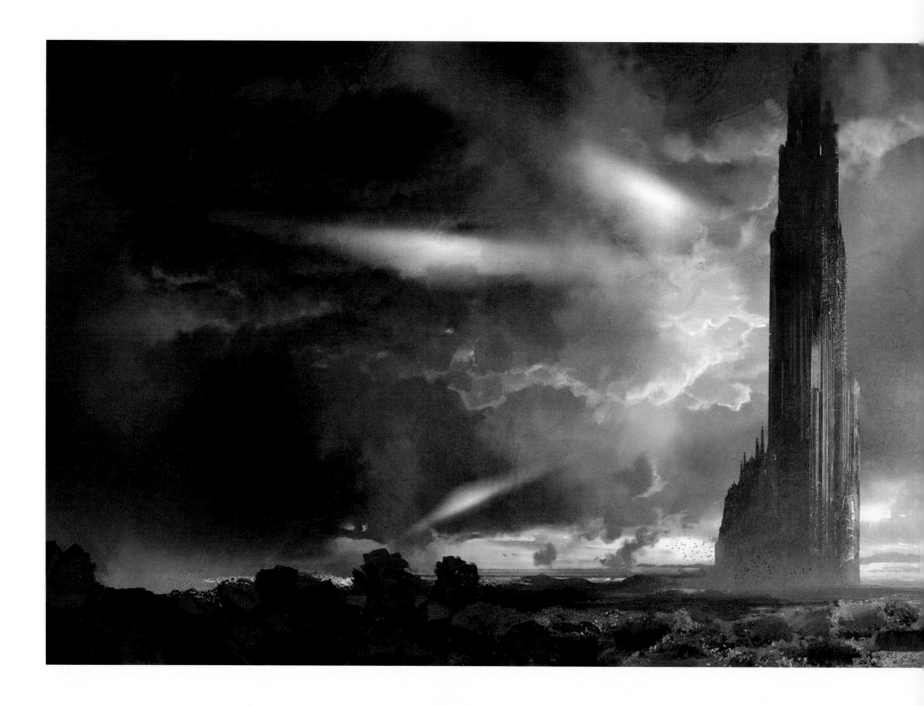

EXPANDING THE LEGEND

ᛞ

Multimedia storytelling is particularly apt for broadening the Dark Tower mythos, but it all has to start with the movie. This film is the first installment in what could become a much larger mythology. "The story has really just begun," says director Nikolaj Arcel.

"Our film is a standalone, but it's also a soft introduction to the universe," says writer Anders Thomas Jensen. "A lot of the stories have been saved for later use." If the vision seems ambitious, proliferating streaming services and zealous fandoms are evidence that there's never been a better time for telling a multifaceted multimedia epic.

"The mediums are blending in really exciting ways," says Howard. "This is great news for fans and for creative teams, even if it's a bit of a headache for rights owners. If you just want to tell great stories, you can find exactly the right platform and build from there. I'm excited at the prospect of developing aspects of the story on television for all that it has to offer: intimacy, immediacy, and long-form character development."

And yet, even when dealing with a time-skipping, universe-hopping adventure, there's still one more factor at play in The Dark Tower's labyrinthine cosmology. In the novels, Stephen King frequently makes references to his other works.

"I was having a field day with those," admits screenwriter Akiva Goldsman. "There was no shortage of 'inside baseball' references. I thought the more the movie can suggest a connectedness with the larger Stephen King universe, the better."

Producer Erica Huggins stresses the subtlety of their approach. "We've embedded Easter eggs that will be recognizable to Dark Tower fans, but without getting so inside that you're no longer speaking to the larger audience," she

The Dark Tower seen in a more serene setting, bathed in angelic light and surrounded by a sea of blossoming flowers.

says. "But social media and the Internet have inspired entire subcultures of these things that interest people. We live in a world where everything is possible."

However, as Howard is quick to clarify, it's a little early for fans to expect a Stephen King cinematic universe. "You can't just set aside the rights issues," he says. "It's a longer-term question. But if we have some evidence that we're onto something with these adaptations, there are a lot of ways to tell this story."

Ultimately, says Howard, the *Dark Tower* movie is merely a jumping-off point. "We're proud of the story we're telling, but if you know the Dark Tower universe, you know there's so much more," he says. "So many more characters to draw upon, and so much more conflict to play out. We hope to explore it on television and the big screen."

The Dark Tower might be an indefinable squiggle on the horizon, but each step in its direction reveals fresh wonders. The long journey to reach its walls isn't inconvenient—it's essential.

"The Tower becomes the thing we're searching for," says Goldsman. "It's the notion of what Stephen was trying to do. You chase the thing, and that is where redemption lies."

This concept art shows a triumphant view of the Dark Tower. Tiny specks of distant birds help put its gargantuan scale into perspective.

Following spread: An up-close concept for the Dark Tower reveals Gothic spires seemingly carved from volcanic rock.

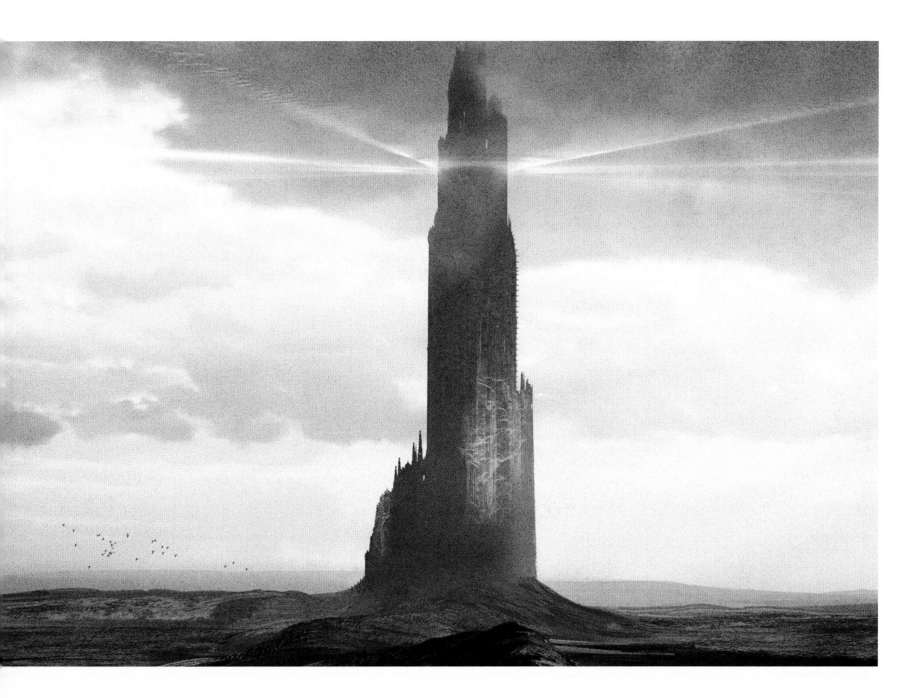

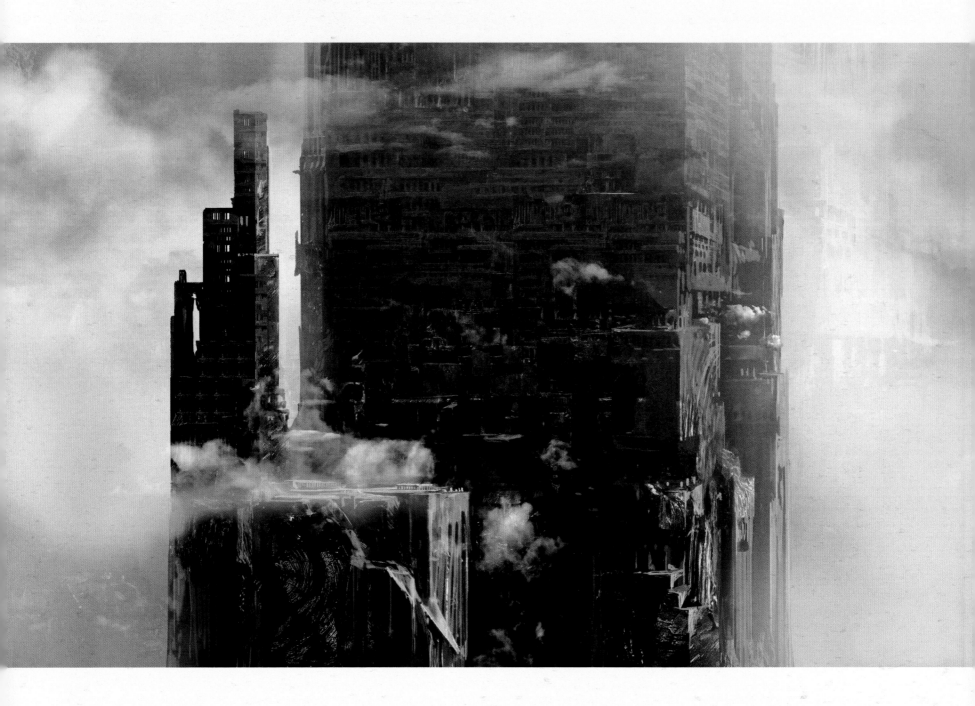

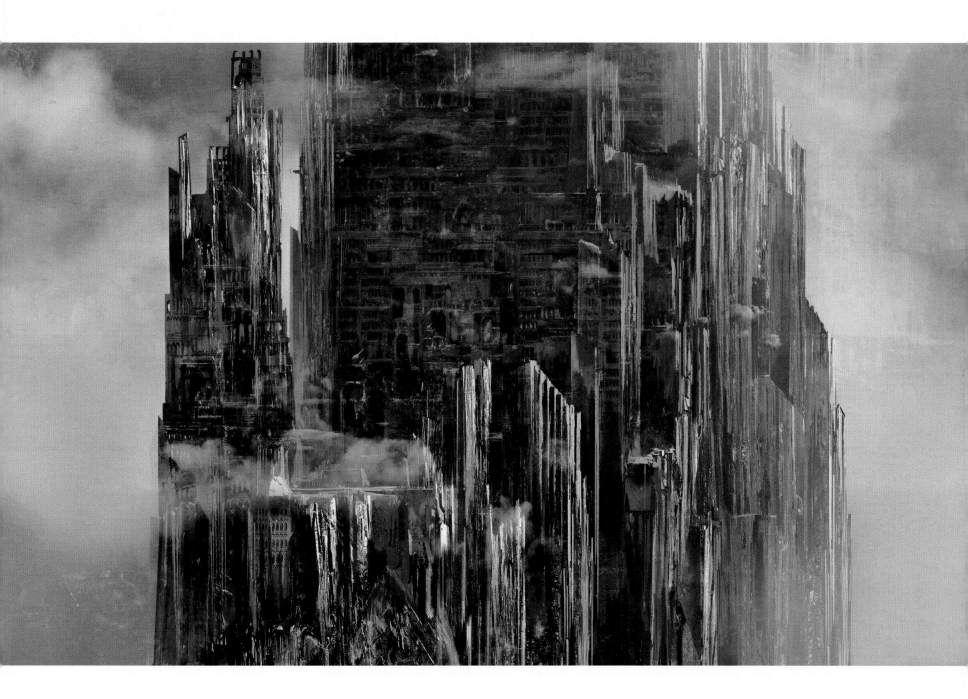

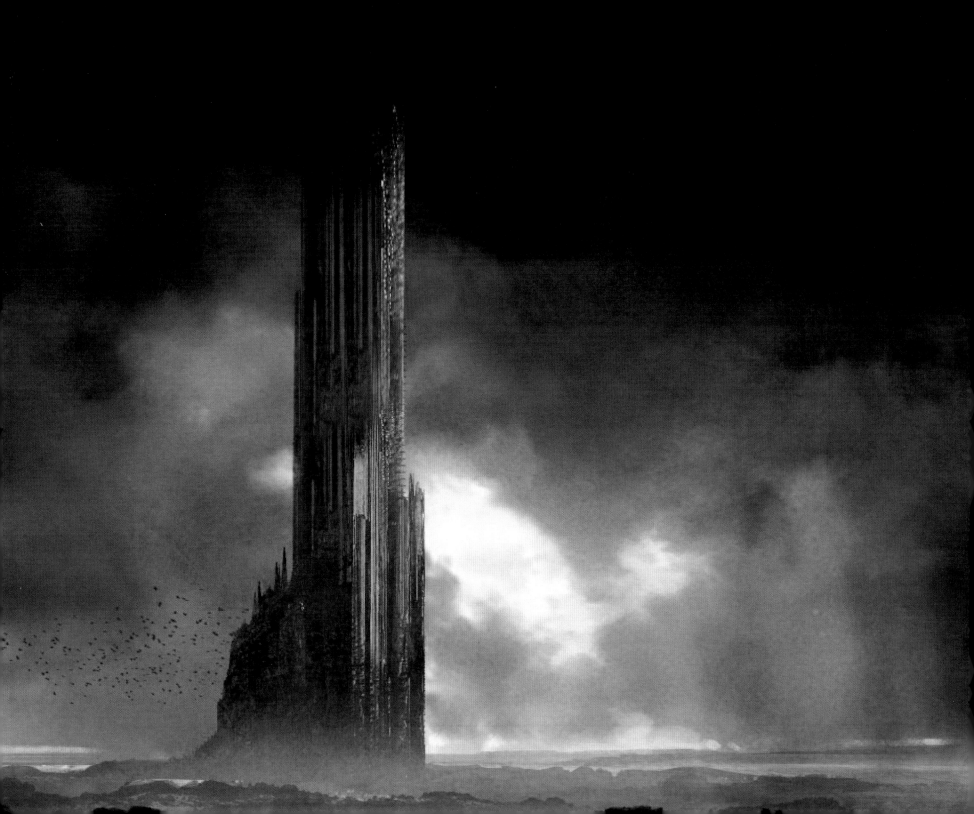

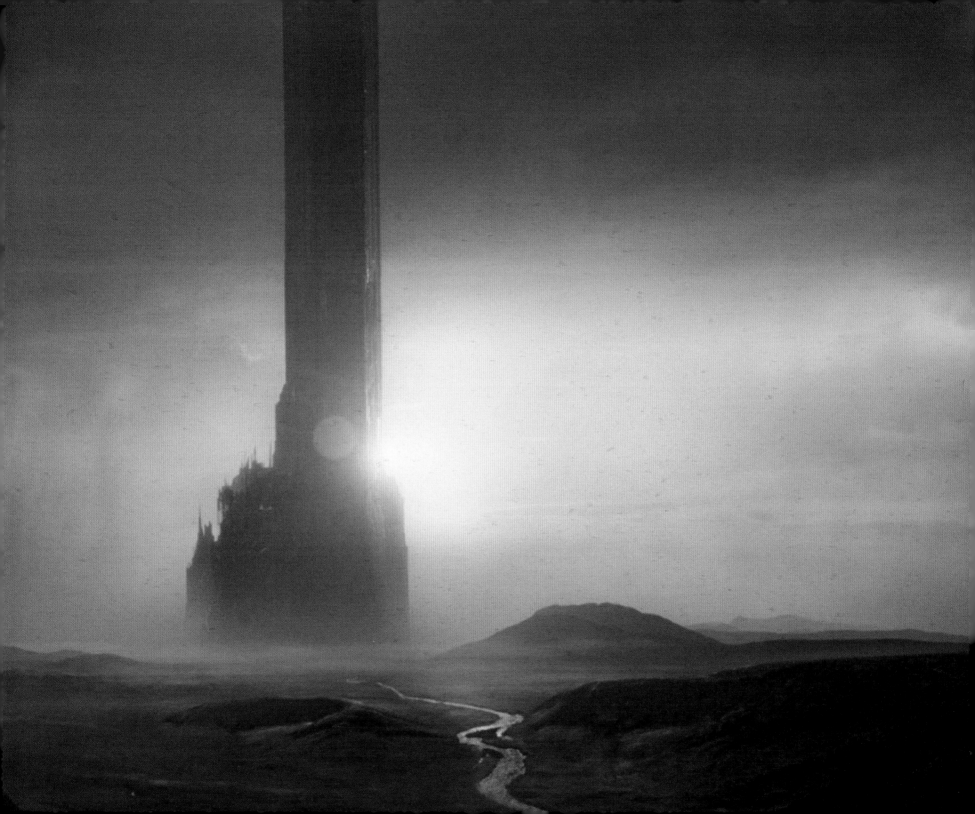

CREDITS & ACKNOWLEDGMENTS

Image Credits:

Unit photography by Ilze Kitshoff, Jessica Miglio, and Jaimie Trueblood

Rick Buoen: 30–31; **Darren Christian:** 64–65, 94, 98, 99, 100–101, 106, 107, 119 (top right, bottom right), 157, 162–163; **Keith Christensen:** 48, 49, 52, 63, 92, 112, 170, 171; **Marc Gabbana:** 116; **Christopher Glass:** 87 (left); **Ben Hibon:** 24–25; **Seung Hong:** 91, 154; **Jaime Jones:** 74–75, 192–193, 194–195, 198–199, 200–201, 204–205; **Chevon Leo:** 44, 59 (left), 142–143, 144 (top left with Annis Naeem, bottom left, right), 146 (bottom); **MPC:** 68, 88, 89, 206–207; **Manuel Plank:** 28–29, 186–187; **Annis Naeem:** 42–43, 50–51, 54–55, 96–97, 102–103, 117, 118, 119 (top left, bottom left), 126–127, 128–129, 144 (top left with Chevon Leo), 146 (bottom), 147, 152, 158–159, 160, 161; **Karl Schulschenk:** 70–71, 108–109, 114–115, 130–131, 132, 156; **Shae Shatz:** 32; **Trish Summerville:** 48, 49, 52, 63, 92, 112, 170, 171; **John Sweeney:** 76, 110–111, 148; **Justin Sweet:** 80–81, 82–83, 84–85, 86, 87 (right), 164, 165, 166, 167, 169; **Lisa Van Velden:** 59.

Produced by:

 MELCHER MEDIA

President, CEO: Charles Melcher
VP, COO: Bonnie Eldon
Executive Editor/Producer: Lauren Nathan
Senior Digital Producer: Shannon Fanuko
Production Director: Susan Lynch
Assistant Editor: Karl Daum

Design by Paul Kepple and Max Vandenberg at Headcase Design

Melcher Media would like to thank Callie, Barlow, Jess Bass, Emma Blackwood, Amelie Cherlin, Barbara Gogan, Ashley Gould, Luke Jarvis, Aaron Kenedi, Karolina Manko, Myles McDonnell, Lauren McGlade, Emma McIntosh, John Morgan, Nola Romano, Rachel Schlotfeldt, Victoria Spencer, Megan Worman, and Gabe Zetter.

Sony would like to thank Monica Guzman and her team at Sony Publicity stills department.